MICHAEL FREEMAN
THE PHOTOGRAPHER'S MIND

Creative thinking for better digital photos

ELSEVIER

AMSTERDAM • BOSTON • HEIDELBERG • LONDON
NEW YORK • OXFORD • PARIS • SAN DIEGO
SAN FRANCISCO • SINGAPORE • SYDNEY • TOKYO

Focal Press is an imprint of Elsevier

Focal Press

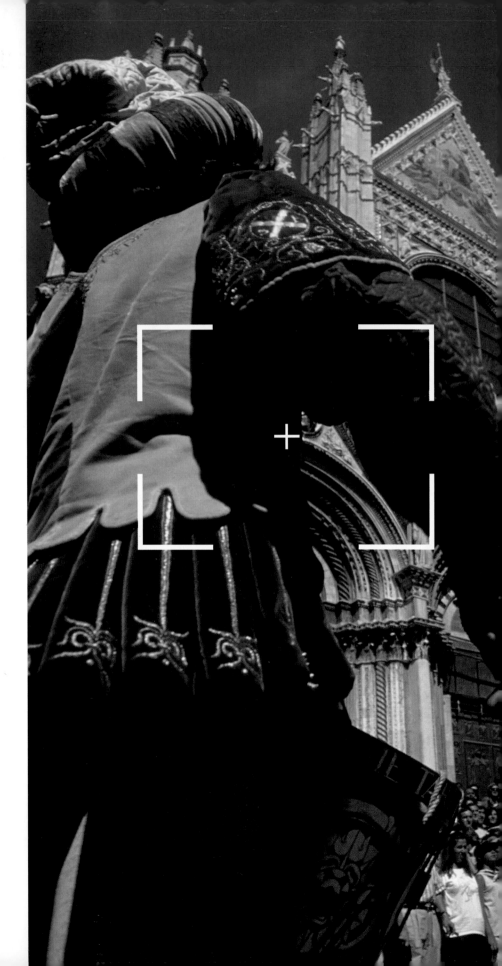

Focal Press is an imprint of Elsevier
30 Corporate Drive, Suite 400, Burlington, MA 01803, USA
Linacre House, Jordan Hill, Oxford OX2 8DP, UK

Library of Congress Cataloging-in-Publication Data:
A catalog record for this book is available from the Library of Congress.

ISBN 978-0-240-81517-6

For information on all Focal Press publications visit our website at
www.focalpress.com

This book was conceived, designed, and produced by:
The Ilex Press, 210 High Street, Lewes, BN7 2NS, UK

Publisher: Alastair Campbell
Creative Director: Peter Bridgewater
Associate Publisher: Adam Juniper
Managing Editor: Chris Gatcum, Natalia Price-Cabrera
Senior Designer: James Hollywell
Designer: Simon Goggin
Color Origination: Ivy Press Reprographics
Index: Indexing Specialists (UK) Ltd.

Printed and bound in China

10 9 8 7 6 5 4 3 2 1

CONTENTS

INTRODUCTION: DEMOCRATIC PHOTOGRAPHY

"It's all automatic. All I have to do is press the button. It's a camera that every amateur buys. [pause, points to his head] It's all in there." HELMUT NEWTON

A tradition has grown up in photography that serious comment and writing is aimed at a detached audience—people who are not expected to go out and attempt anything similar for themselves. When Susan Sontag wrote *On Photography*, I don't think she was expecting her readers to enter the fray themselves by taking photographs. She begins with the assumption that readers will be looking at already-taken photographs: "...being educated by photographs... anthology of images...To collect photographs is to collect the world." When she discusses photography by ordinary people, it is as a social phenomenon: "...photography is not practiced by most people as an art. It is mainly a social rite..." This is part of the wider tradition of art commentary and criticism. Critics and art historians like John Ruskin, Bernard Berenson and Clement Greenberg were not catering for would-be painters. And yet, understandable though this may be for most arts, photography is different. I might say recently different, because the combination of digital and broadband, coupled with a change in the status and purpose of art, has ushered in the era of democratic photography. The audience for photography takes photographs itself! Ouch. Artists are rarely comfortable with that kind of thing, but that's the way it has evolved, and I think it's good timing to bring together the reading of photographs with the taking of photographs.

Moreover, commentary on the arts has not always been detached. When Cicero wrote *On Invention* in the first century BC, and the Greek philosopher Dionysius Longinus later wrote his treatise on poetry and rhetoric *On the Sublime*, they were giving practical instruction. The arts of speaking and writing were certainly considered to be entered into by everyone with education. Well, now we have a world of photography in which millions of people are engaged, and a significant number are using it for creative expression. Learning how better to read a photograph can, and probably should, lead to taking better photographs. At any rate, that is my premise here.

The million-dollar question, of course, is what makes a good photograph? It's the question I'm asked the most often at talks and in interviews. And it's famously elusive. I could have said "well composed" or any of a number of more specific qualities, but that would be limiting the scope. If we step back for an overview, it is not actually that difficult to list the qualities of good imagery. I make it six. You might want to add a few, but I'll maintain that they would work as subsets of these. Not all good photographs fulfill all of the following, but most do:

1. Understands what generally satisfies. Even if an image flouts technical and esthetic basics, it really does need to be in the context of knowing these.

2. Stimulates and provokes. If a photograph does not excite or catch interest, then it is merely competent, no more.

3. Is multi-layered. An image that works on more than one level, such as surface graphics plus deeper meaning, works better. As viewers, we like to discover.

4. Fits the cultural context. Photography is so much a part of everyone's visual diet that it is by nature contemporary. Most people like it that way, dealing with the here and now.

5. Contains an idea. Any work of art has some depth of thought that went into it. An image needs to catch the viewer's imagination as well as simply attract the eye.

6. Is true to the medium. This is a long-held view in art criticism, that each medium should explore and exploit what it is good at, and not mimic other artforms, at least not without irony.

CHAPTER 1
INTENT

Photography is extremely good at getting straight to the point. Perhaps too good. There's something in front of the camera; so shoot and you have an image of it, with or without any thought. Doing this often enough may produce some gems, but thinking first is guaranteed to do better.

A great deal of photographic instruction focuses on how to be clear and obvious, by identifying the subject, choosing the lens, viewpoint, and framing that will most efficiently and immediately communicate it to a viewer. This is exactly what a news photograph, for example, needs—clarity and efficiency—but what's right for a photograph in one context may work against it if it is presented for a different purpose, such as on a gallery wall. Clarity is a virtue only if the job is communication, not contemplation, and if you want people to pay attention to your photography and enjoy it, you have to give them a reason to look at it for longer than a glance. This first section of this book, is therefore more about why than how.

LAYERS OF SUBJECT

Using a camera is so practical, so direct, that any question about what the subject is seems at first glance superfluous. You aim at a horse, then the horse is the subject; at a building, a person, a car, then they are the subjects. Well, this is true up to a point, but not all subjects are what they at first seem to be. Or rather, the immediate and obvious subject may well be part of something larger, or part of an idea. This is important because choosing what to photograph is for all of us the first step. Here is where intent begins, and it influences everything in the shooting and processing that follows.

But isn't this just a question of style? The object is the subject, while different photographers just treat it differently? Isn't this just complicating the obvious? The answer lies in the intent—in what you are setting out to do. If it were just a matter of coming across a scene or object and reacting to it in your own way, then yes, that would be a matter of style, which is the focus of the second section of this book. But if your choice of subject is part of something else—a project, or a photograph with a broader aim—then it belongs here, under Intent. And what you set out to show will define the treatment you give it.

Simply to talk about "subject" creates an impression that we're dealing with single, definable, free-standing objects, like the horse, person, building, or car I mentioned at the start. But many subjects are not at all so obvious and definable. That physical, three-dimensional object in front of the camera may be just a part of a larger subject, one aspect only of what the photographer is trying to capture. In many images there are, indeed, layers of subject. Level one may be the obvious, the single object that dominates the composition, but move up a level and it becomes part of something else— something larger and broader.

What, for instance, is the subject of the main photograph on this page? The obvious answer is two children dragging a goat up a grassy slope. They are Khampa nomad children in the Tibetan

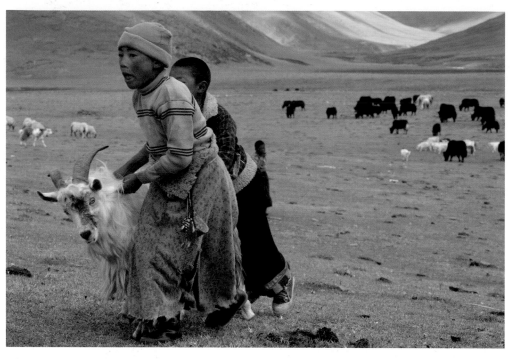

west of Sichuan, China, charged with looking after the herds of yak, horses, and goats. But the reason I photographed them in the first place, the reason why I stopped the vehicle, was that I was looking for anything that would contribute to "nomadic life on the high grasslands." This was to be a distinct section of a book project I was working on at the time, on the Tea-Horse Road from southwestern China to Tibet. It was a subject in its own right and a photo essay within the book, so for me, the arching themes of the photo essay was the subject foremost in my mind—not the actual scene in front of me. This partly explains the composition and choice of lens, with the boys moving out of frame to keep at least part of the viewer's attention on the setting. I could have used a longer focal length and tightened the composition to put more attention on the boys and their actions, but I needed instead to show where they were and what was behind and around them. I did, indeed, experiment with different framings, but this was the one that had the right balance, and worked best for me.

⌃➤ PART OF A LARGER SUBJECT
Nomad boys in western Sichuan: they and the goat are the immediate subject, but the larger subject that was the motivation for the photograph was the life of nomads in general. The other photographs here continue the essay and bring it nearer completion.

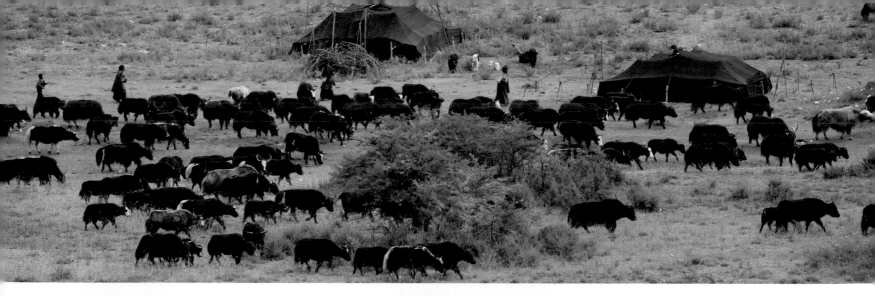

In another example, the Italian reportage photographer, Romano Cagnoni, has spent a large part of his life and career in war zones, from Biafra to Vietnam, the Balkans and Chechnya. Yet his concerns are deeper than the reporting of immediate conflict. The images that count the most for him are those with universal significance, that go beyond the journalism of a particular situation. This too is part of the search for the larger subject. As Cagnoni explained, "Another photographer close to my generation who defined his work interestingly is Abbas, who said, 'The photojournalist sees beyond himself, not inside himself, and in doing so he is not a prisoner of reality—he transcends it.'"

Images can also serve more than one purpose, so that the larger subject can depend on who chooses them and why. In the picture of the two young girls from an ethnic minority in Southeast Asia, there are two things going on. One is the life and attire of this group, called the Akha, the other is the water system as one of them fills a gourd from a bamboo aqueduct. The two subjects compete for attention: the girl in her headdress (elaborate for a child), and the water pouring. The actual subject is ambiguous and would depend on the context in which it was shown. The close-up of the same scene, showing a fallen leaf neatly put to use to divert the flow from the cut bamboo pipe, is simpler. Seeing both together establishes that we are, in fact, looking at water as the subject.

In fact, what inspires a photographer to raise the camera may be entirely without substance, something that pervades the entire scene. In this case, I'm specifically thinking about light, and most of us at some time simply find the lighting conditions so attractive or interesting that we want to photograph them interacting with something, anything. Exactly what the light is striking becomes much less important than its own quality. In the photograph of a piece of contemporary furniture shown on the facing page, the subject is clearly the light itself. Color,

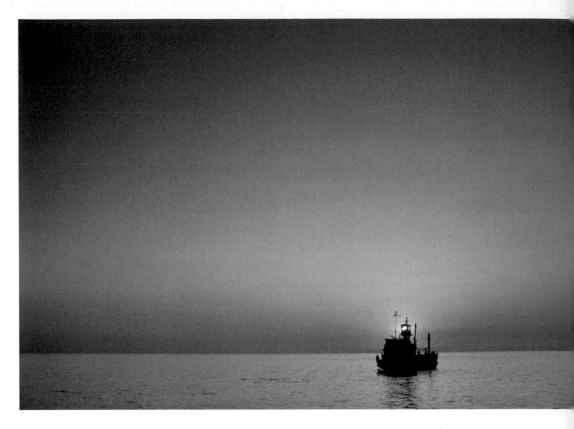

too, attracts the attention of some photographers as a subject in its own right. Even more than light, it offers the possibilities of abstracted compositions in which the color combinations themselves appeal, regardless of what physical objects they are part of.

Not so different from color is space itself within the frame—space treated as an abstract mass. In the sea picture above, with a fishing boat small and hardly recognizable at the base of the frame, the subject is less the boat than the open space of sky and sea. The vertical gradation of tone is a form of abstraction, which helps the image work for its graphic effect alone. There are a number of other images in this book that feature a small "subject" against a much larger background, and in some of these the intent is quite different—the small figure/object really is the subject, not the space around it, but for one reason or another it is intended to be seen small. The reason may be to introduce a delay in the

▲ SPACE AS SUBJECT

One of a sequence of photographs taken of a fishing boat in the Gulf of Thailand at sunrise, this image redirects the attention from the boat itself to the setting—and at this moment in the day, the interest is in the color gradient in the sky, well reflected in the exceptionally calm sea. With this in mind, the shot was composed with a 20mm lens, with the boat used for scale. In order to concentrate attention on the colors, the viewpoint was shifted so that the boat masked the sun, lowering the dynamic range. Finally, the horizon was placed low in the frame, focusing attention on the sky, with just enough sea to show that it carries the reflection.

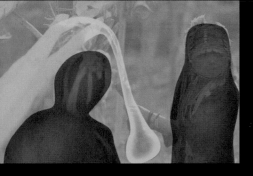

◢➤ CHOICE OF SUBJECT

As described in the text, there are two subjects intertwined in this photograph of Akha ethnic minority girls on the Thai-Burmese border: the girl in her specific attire, and the water from the bamboo aqueduct.

▼ LIGHT AS SUBJECT

A piece of contemporary furniture in wood and acrylic casts sharp shadows and refracted colors on the floor. These light effects are themselves the subject of the image, and its composition is designed for them.

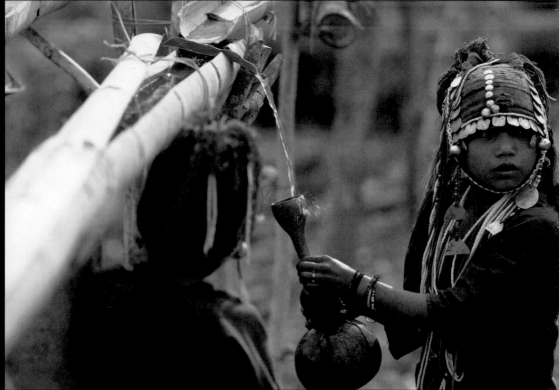

▲ COLOR AS SUBJECT

An as-found arrangement of glass pourings on a light table, in the studio of glass artist Danny Lane. The abstract shapes, the intensity of hue that comes from the backlighting, and the close cropping of the image focuses attention on the color alone.

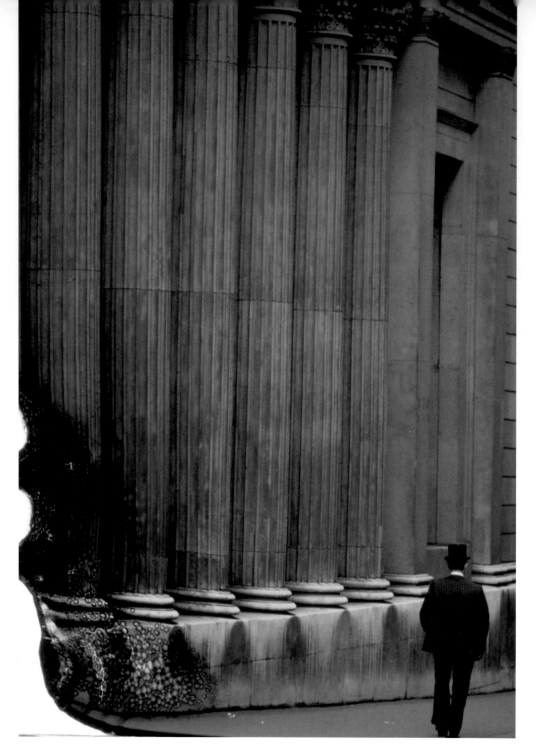

viewer spotting it, or to establish the importance of the setting, so the intent may not always be obvious from a first glance at the image.

But let's move even further away from the obvious and distinct—light, color, and spatial relationships. Abstract concepts can be subjects, and in some kinds of advertising photography and editorial cover photography the image may be called upon to deliver an abstract message. Just consider the following as subjects, and as real-life assignments for photographers or illustrators: a banking magazine cover on a looming threat to traditional ways (solution, shown here, an old-fashioned banker in front of the Bank of England, recorded on transparency with the film physically burnt at one side); promoting weight-loss through a fruit diet (solution, a slim-waisted apple wrapped with a tape measure); the cover of the book by author Graham Greene, *Ways of Escape*, (solution, a pair of empty shoes pointing away from the viewer). The list could go on forever; photography used to illustrate concepts, using metaphor, juxtaposition, suggestions, and allusions of one kind or another.

There is also the class of subject that is deliberately not what it appears to be. This is an interesting tradition that began as a reaction to one of the main problems for photography as an art, which is that by nature it is simply mundane. By this, I mean that the camera easily delivers flawless reproductions of real things (which for centuries painters and sculptors had strived for), so there is no surprise and no credit in just getting a decent likeness of something. Beginning in Germany in the 1920s, and particularly at the Bauhaus with László Moholy-Nagy and his photograms, photographers such as Otto Steinert, Andreas Feininger, and even, occasionally, Brett Weston searched for ways to make images that would puzzle and intrigue the viewer.

Moholy-Nagy, who taught at the Bauhaus

▲ **CONCEPT AS SUBJECT #1**
For the cover of a banking magazine, the brief was to illustrate the concept of threats to old ways from new ideas. The solution here was to shoot two icons of old-fashioned banking, the Bank of England and a broker in a top hat, and then simply burn the transparency.

THE PHOTOGRAPHER'S MIND

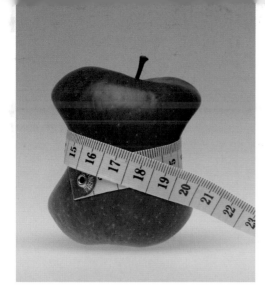

▲ CONCEPT AS SUBJECT #2
Not a deep idea, but simple and effective: the concept to be illustrated had to do with dieting and losing weight. Little more explanation is needed.

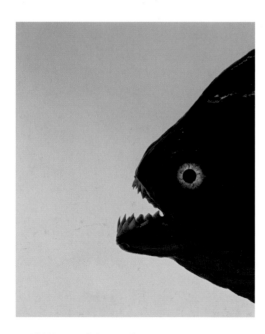

▲ CONCEPT AS SUBJECT #3
The concept here was aggression and attack, but in an abstract context of financial institutions, not social. A piranha with bared teeth was the solution.

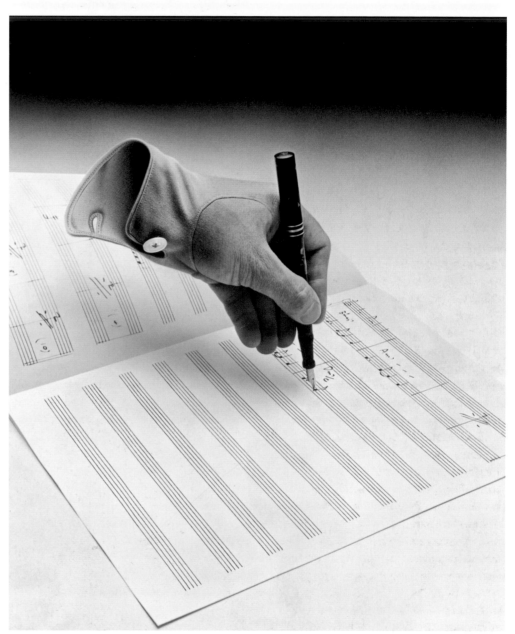

▲ CONCEPT AS SUBJECT #4
A slightly complicated concept, but one that came from the musician whose record cover this was. The album was called *Southpaw* because of his left-handedness—and he wrote his own music as well as performing it. The idea, from an art director, was a parody of Magritte, and done at a time, pre-digital, when such special effects were difficult and eye catching. The retouching was done pinstakingly on a dye transfer print, from two photographs: one with and one without the glove.

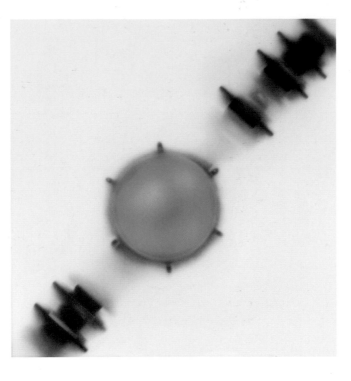

➤ PHOTOGRAM
An early idea of a direct representation of subject matter was to let the object cast its own shadow onto sensitized material. In this slightly different version, a watch with luminous dial is placed face down on an unexposed sheet of Polaroid SX-70 print film and left to make its own strange exposure.

WEB SEARCH
- Romano Cagnoni
- Abbas Attar
- László Moholy-Nagy photogram
- Otto Steinert
- Andreas Feininger
- Brett Weston
- Thomas Ruff *Blue Eyes*

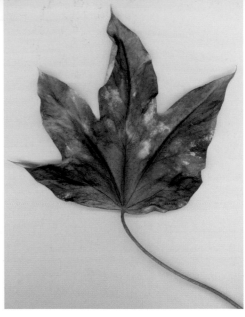

▲ SCANNER PHOTOGRAPHY
The photogram updated: Objects placed directly onto a flatbed scanner receive a unique kind of frontal lighting, with results that are not completely predictable.

until 1928, championed a radical approach to photography and its subject matter, listing "eight varieties of photographic vision," that began with the photogram—recording the silhouette and traces of objects placed directly onto photographic paper or film, without the use of camera or lens. He also anticipated how scientific imaging would add to this type of imagery with what he called "intensified seeing" and "penetrative seeing," which covered photomicrography and imaging beyond visible wavelengths.

After the Second World War Steinert founded Fotoform, a group devoted to abstraction, though this lasted only a few years as the once-radical idea fell prey to simply following formula. Indeed, abstract photography quickly descended into a camera-club cliché. The influential Swiss magazine, *Camera* (1922–1981), cautiously defended it in an introduction, saying that while "it concerns photographs which retain a resemblance to reality... the connection with the object or subject is so allusive as to be unrecognizable." Nevertheless, "this hardly

matters when the discovery of new facets in the object or subject results in a sort of bewilderment that seduces both the mind and the eye."

The genre of "looking-like-something-else" photography has persisted, and is even put to functional use. As Moholy-Nagy predicted, it was fueled by imagery coming from science. In the 1970s there was a fresh surge of interest in new imaging techniques as electron microscopy, ultrasound scanning, and deep-space astrophotography came online, with books such as *Worlds Within Worlds* (1977) celebrating the technology. Since then, the audience has become more blasé because of familiarity, not least because we now all know what can be done digitally. And where does contemporary fine-art photography fit into all this? The unhelpful answer is: scattered over what we've been talking about, with a trend toward not being obvious. Contemporary photography conceived as art is in roughly the same state of change and uncertainty as is the larger contemporary art market—in which it is now a full-fledged member. Quite apart from treatment, style, imagination,

originality, and so on, the question of subject matter for art is now completely open.

Art began rebelling in earnest with Marcel Duchamp, the Dadaists, and Surrealists in the 1920s, and has continued to do so. Now, challenging the audience's preconceptions of what art should be about is itself a major subject, making conceptual challenge a driving force in contemporary art photography, and this opens up the range of possible subject material infinitely. One example is the *Blue Eyes* series by Thomas Ruff of the Düsseldorf school. This is a succession of dispassionate, flatly-lit portraits, but the natural eyes have been replaced digitally with blue eyes, "thereby undermining the photographs' truthfulness as records," according to the Victoria & Albert museum notes. Photography about photography may not be to everyone's taste, but it now has an established place in the art world, meaning that if you decide to follow this route, then as long as you can justify the concept, practically any subject matter is valid.

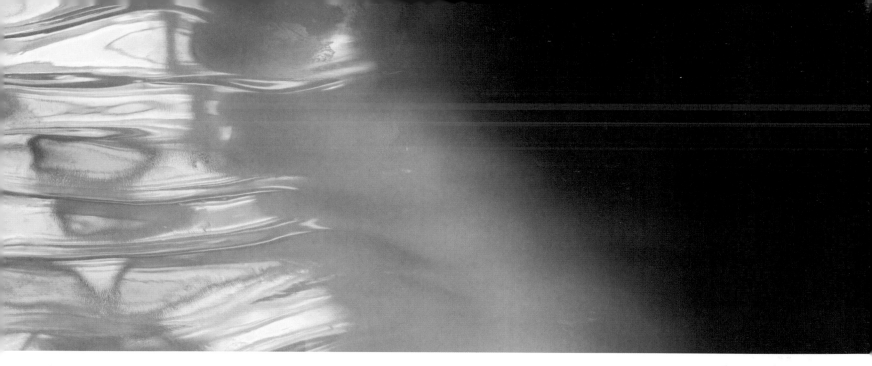

▲ REMOVING THE CLUES

A version of "what is it?" photography, this time using a macro view that deliberately cuts out recognizable features, here to make a shimmering and opalescent landscape out of the lip of a conch shell. Focus blending was used to introduce the depth of field associated with large views rather than close ups, to further obscure the real subject.

 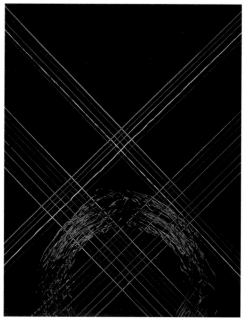 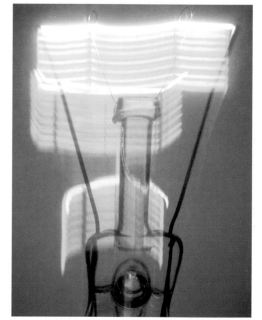

▲ IMAGERY FROM SCIENCE

Certain techniques and devices have a semi-scientific appeal, in these cases artificial fibers brought to glowing life in an abstract composition using crossed-polarized lighting—a polarizing sheet over the backlit surface and a circular polarizer over the lens turned for maximum darkness of the light source; and a portrait taken by thermal imaging equipment, which records the deep, heat-emitting infrared.

▲ WHAT IS IT?

Following the Bauhaus tradition already discussed in the text, the subject here (a lightbulb fillament) is deliberately made less obvious by means of extreme close-up camera movement during the exposure, and color manipulation.

LOOKING GOOD

Making things look "good" is such a fundamental aim that many photographers do not even question it and, by extension, they actively search for subject matter that in its own right looks good. And yet beauty in contemporary art and contemporary photography is not the simple proposition that it once was. Before even beginning to look at how to achieve it, we need first to decide whether we even want beauty in a photograph.

Depending on which kind of photography you subscribe to, this may seem a strange question to consider. Almost certainly, the majority of photographers see it as part of their job to reveal, enhance, or even manufacture attractiveness in their images. If you work commercially (and that includes fashion, portraiture, and weddings, as well as product photography), the degree to which you can create a beautiful image out of a subject that is not necessarily so will usually determine how successful you are. Yet for photojournalists, beauty may have a very low priority, and for those shooting subjects that are serious issues, such as conflict, poverty, and disaster, beauty is likely to be actively unwanted.

In photography conceived as art, the question is more complex still. Photography is now more fully absorbed in the mainstream contemporary art world, and beauty has largely faded from the agenda there. Until the early 20th century, the pursuit of beauty was central to art, and even subjects that were inherently repugnant, such as martyrdom and crucifixion, were generally treated in a refined and appealing way. With some exceptions, such as Albrecht Dürer, Hieronymus Bosch, and Francisco Goya, art generally set out to satisfy our love of beauty. As the art historian Ernst Gombrich wrote, "Most people like to see in pictures what they would also like to see in reality. This is quite a natural preference. We all like beauty in nature." Yes we do, and understanding why is crucial for anyone who sets out to create it or reveal it. As most photography around the world has beautification somewhere in its agenda,

this deserves some serious attention. This is what esthetics is all about, but as this is a practical rather than an academic book, I'd prefer to keep the terminology simple.

One single, difficult example (that also happens to have a special relevance to photography) is our feelings for sunsets. Why do we like sunsets? After all, they happen every day as long as the sky isn't overcast, but they seem to be a magnet for cameras. Right now, along the Earth's terminator, there are large numbers of people in position at convenient viewpoints, usually elevated, pointing cameras at the setting sun. In case you think I'm being cynical, I like sunsets too, especially if I'm somewhere picturesque: for some reason, I find them difficult to resist. Canvas opinion, and we find that people like sunsets because they find them beautiful. No surprise there, then. Sunsets are one particularly universal example of a sight that is generally agreed to embody beauty. Angelina Jolie is another (and Elizabeth Taylor and Ava Gardner if you want to retrace movie history). So is a full moon hanging low in the sky. And a swan coming in to land. And maybe Edward Weston's *Pepper*, 1930. Oh, and I almost forgot, a rose. What ties all these together is our general agreement about what is beautiful, something that has been debated since at least Plato. However, there has to be a consensus about what looks good, otherwise it is pointless. Nevertheless, mention beauty, and the phrase that springs to almost everyone's mind is "Beauty is in the eye of the beholder." This has achieved the status of cliché to the point where few of us even think about how obviously wrong it is. It would be meaningless if only one person—one "beholder"—found a piece of art beautiful, while everyone else dismissed it. Beauty needs a consensus, or at least the possibility.

Whenever we think that we're shooting something beautiful, or aiming for beauty, there's an inevitable sense in the back of the mind that other people should also like the result. If they do not, then for an image it means that the taste of the photographer is not meshing with the

taste of the audience. That happens often, and it may be to do with failure (the photographer is just not skillful enough) or it may be to do with matching the photography to the wrong audience. The last time I visited the annual Frieze Art Fair in London, the majority of the photographs on display would definitely not suit the audience for *Popular Photography & Imaging* magazine, but they fitted perfectly the context of the contemporary art market. Significantly, though, only a minority of contemporary fine-art photography claims beauty.

WHAT MOST PEOPLE TEND TO LIKE VISUALLY
This may not be an inspiring list, and leans, not surprisingly, towards the conservative, but it sets out the common denominators. To make something look good in a photograph does not mean checking each of these, but they all bear thinking about.

- The familiar
- Rich color
- Brightness
- Contrast
- Harmony
- Definition and clarity
- Beauty

➤ TOKYO TOWER

The busy time on the viewing platform of the Tokyo Tower is predictably just before sunset, where spectators gather to be surprised yet again by a daily event.

➤ GRACE AS WE SEE IT

Certain subjects are perceived as being by nature graceful, elegant, beautiful—swans are among these. However, this is just the swan's natural method of locomotion, just as much as a cockroach's rapid scuttle, but this sense comes from our ideas of nature and form, rather than from anything intrinsic.

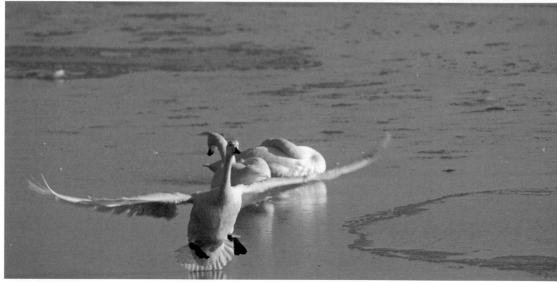

⌄ ➤ RICH SUNSETS, SUNRISES

Few people would deny that scenes like these, treated in this conventional, colorful way, appeal broadly. They are difficult to dislike, and tick all the visual and emotional boxes for most of us, even though creatively they do not have a lot to offer.

► THE PREFERENCE FOR BRIGHT AND COLORFUL

Several research studies in perceptual psychology confirm what the imaging industry has followed instinctively for years—that most people prefer rich colors to drab, bright images to dark, and higher contrast rather than flat. This can usually be summed up with the term Bright Colors. There are limits somewhere as to what is acceptable, but audiences tolerate extremes well. This image, shown in its Raw default form below, is given a 33% increase in the three values, and these are combined for the result far right—most viewers would instinctively prefer this version to the original.

▲ **+33% SATURATION**

▲ +33% brightness

▲ +33% contrast

▲ UNSOPHISTICATED COLOR

In markets that are relatively new to imagery and have had little time to judge and discriminate, extremes of color saturation, brightness, and contrast are normal in advertising and mass-market publishing. These Shanghai posters are typical—the digital image file here has not been exaggerated during the processing.

Whether or not it plays a rôle in your photography, we ought to know the basic facts about beauty and looking good. Plato considered it to be about proportion, harmony, and unity, while Aristotle believed it concerned order, symmetry, and definiteness. These are all ideas to which most people would still give a nod. But it was the 18th-century German philosopher, Immanuel Kant, who set the path for the study of beauty and art. In particular, beauty is a value, and it is always a positive value. It's something that we appreciate for its own sake rather than for what we might be able to do with it, or what it can do for us. In his *Critique of Judgment*, Kant called it "Disinterested" for this reason. The experience of beauty, in other words, is its own reward. We are prepared to set aside time from ordinary, daily life to experience beauty, because we take pleasure from it, in a mix of ways that can include the emotional, sensory, and intellectual.

Yet there's an important distinction between beauty of subject and beauty of treatment. Subjects and scenes that are generally agreed to look good are assumed to exist independently from how they are photographed, but of course it is through photographic skill that their inherent beauty is brought out. Ultimately, as we'll see, in any one photograph that sets out to look good, it is difficult to make a clean separation between the subject and the way it is composed, lit, and shot. This distinction, nevertheless, suggests some interesting creative possibilities, such as attempting to make beautiful things which are not, and we'll come to some examples later in this chapter.

Making scenes, people, and objects look as good as possible is a basic skill in much photography, particularly commercial. That is largely what clients pay for. In wedding and portrait photography it is even more definite; the bottom line is "Make me look as good as possible." Clearly, then, the answers lie in having a good knowledge of what is considered beautiful by most people—whether we're talking about a face, a figure, a landscape, or whatever. What then

sets certain photographers apart from others is not just the degree of skill, but also the level of inspiration to create imagery that transcends the average, while still being judged beautiful.

Beauty in nature, which includes our famous sunsets, as well as rolling and healthy landscapes, blue seascapes, white beaches, and more, is a category that most people agree on—at least within any one culture. Signposted beauty spots and scenic viewpoints are premised on this. Plato's ideals of proportion, harmony, and unity (that is, it all seems to fit together) are basic components for a beautiful landscape, and if you have already read *The Photographer's Eye*, which dealt largely with composition in photography, you'll recognize that these are qualities of the image as much as of the subject. That is because landscape is an idea that we have about terrain—it's how we experience the geography of a place.

One of the essential skills in photographing the landscape is finding the exact viewpoint and matching that to lens and frame, but the underlying assumption is that such a view exists, and that the landscape is somehow already well-proportioned, harmonious, and holds together. Well-proportioned means that the components—whether mountains, lakes, fields, woodland, or whatever—fit together in a size relationship that most people find satisfying. Harmonious means a coexistence between everything inside the landscape, without jarring notes such as a power station. Unified means that what we are looking at seems to have a completeness, as if it were meant to be a unit, fitting together seamlessly. Allied to this "unity" is a sense of economy of means—beauty in the way a photographer or artist treats a subject often involves the elegance of having used no more than was necessary to achieve the result. Over-elaboration and fussiness are common mistakes, but as these three qualities are mainly of composition, I'll deal with them in more detail in the following chapter.

But we should add other qualities. One is a peculiarly modern concern, that of natural correctness and an absence of pollution and

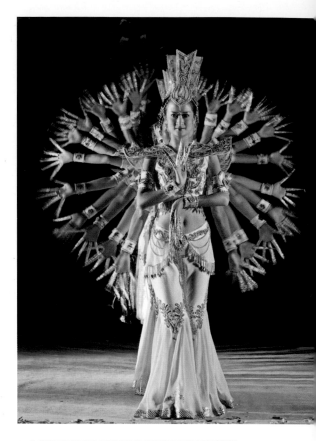

▲ **A COMBINED EFFORT TOWARDS BEAUTY**
A stage performance of the *Thousand-Hands Dance* involves beauty in the subject (the human form, female, chosen and dressed for appeal) and beauty of treatment, with carefully managed lighting that accentuates while leaving no shadows.

despoilment. Completely natural is good, and so is our idea of traditional land management, meaning fields with hedgerows, landscaped parks, small towns nestling in valleys, and so on, whatever social or ecological issues they might conceal. What is not good is diseased vegetation, aridity if it seems to be newly caused, signs of industry, garbage, and spoil heaps. That these last elements are increasingly common only raises the value of "unspoiled" views, while concern about this has helped create the bleak and unromantic school of campaigning landscape photography championed by Robert Adams—very much a rejection of beauty as an aim.

➤ BEAUTY IN ARCHITECTURE

A recent work by I. M. Pei, the Suzhou Museum, is treated here in a way that all architectural photographers will recognize as flattering and lush. The viewpoint is sensibly chosen, but the visual appeal, well calculated, comes from the precise balance of dusk and internal lighting, with reflections adding their own predictable attraction. Like a well-executed sunset landscape, this treatment is aimed precisely at mass appeal, to look inviting.

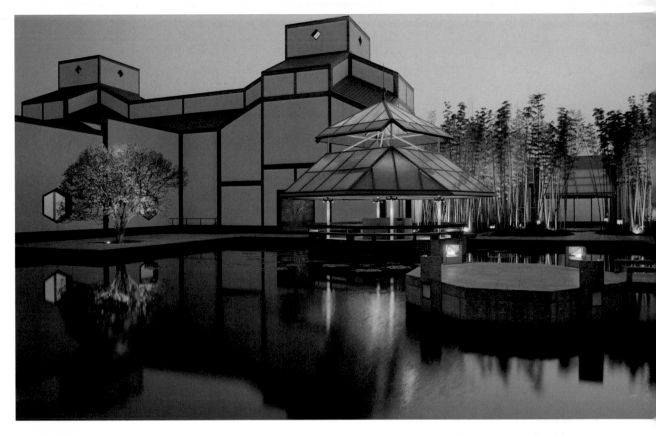

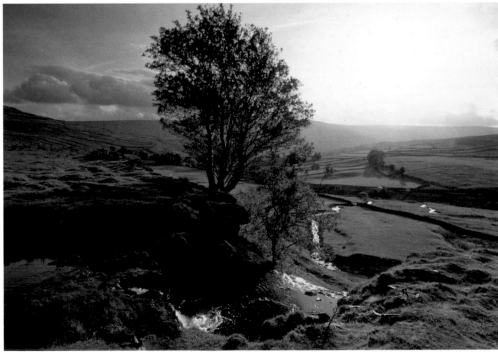

◄ TICKING THE BOXES FOR AN APPEALING LANDSCAPE

Although the precise view is not well known, the general location is—the renowned Yorkshire Dales. Photographing into the sun, at a time of day and weather with sensuous lighting, brings atmosphere and texture to the view, accentuated all the more attractively by the glistening reflections in the brook trickling through the scene. It is composed with a wide-angle lens (20mm) to accentuate the range of depth in the scene, from foreground to background, and this draws the viewer into the frame to give a palpable sense of being there (a telephoto treatment from further away would be less involving). Compare this with the painting by Turner on page 116, which is typical of much landscape painting in the 18th and 19th century in its deep view from silhouetted trees towards an expressive, uplifting sun that is close to the horizon.

This idea of correctness or rightness segues into the notion of the ideal, which plays a part in all kinds of beauty, including human beauty. The subject and its treatment in an image always benefit from being unblemished and perfect—no abandoned vehicle in that field over there, and no pimple on the model's complexion. No wonder that the temptation to retouch photographs proves too hard for some photographers and publishers to resist, whether it was *National Geographic* digitally shifting the Pyramids on its February 1982 cover, or the now universal post-production smoothing of skin in cosmetics ads and high-end fashion magazines.

Another quality that plays a part in our appreciation of beauty in nature is "pleasurable memory." This is more functional than the previous qualities and has to do with the image-evoking experience. We generally prefer sunshine to the lack of it, we like warm weather, mainly blue skies, and beaches of pure white sand (at least when we are on vacation), and landscape images that play to these memories generally score high on the "looks-good" scale. In a broader sense, this has to do with helping to project the viewer into the scene.

Finally, in the repertoire of beautification, there is also the power of good lighting. Lighting is arguably photography's most powerful weapon for manipulating its subjects. On a studio scale, enveloping light that softens shadow edges and displays a roundness of form is a predictable beauty workhorse, whether for an automobile, figure, face, or still life. This is a gross generalization, of course, but it is what umbrellas, softboxes, and lightbanks have in common. On occasion, axial lighting from a ringflash can also beautify, if the shape and surface texture of the subject allow the light to spread smoothly over it. Indeed, a large part of the success of broad-but-directional lighting comes from its treatment of surface, which is why the sheen on a nude figure (enhanced by oil) or the broad gloss on shiny or wet objects tends to make them attractive and/or desirable. It triggers a response in the viewer of being connected to the scene—being able to reach out and touch, if you like. This tactile, sensuous approach to lighting works particularly for anything that viewers might want to experience physically, whether an attractive nude body, a refreshing drink, or an appetizing food.

▼ THE SPOILED LANDSCAPE

Now more than ever, with our new ecological awareness, scenes of the Earth being demolished by man for commercial gain have the status of anti-landscapes. The ugliness of what is going on has become a new reason to enjoy images. One possible criticism of this view, of copper mines on the island of New Guinea, is that the compositional and lighting treatment is too attractive and undermines the bleakness of the subject, but in defence I would argue that the "prettifying" effect of widescreen format, foreground-background relationship and the dappled lighting simply points out the contrast.

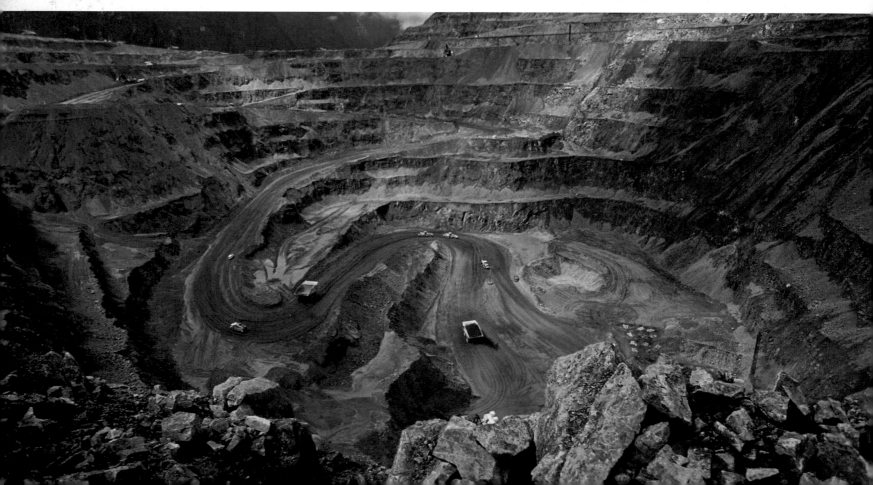

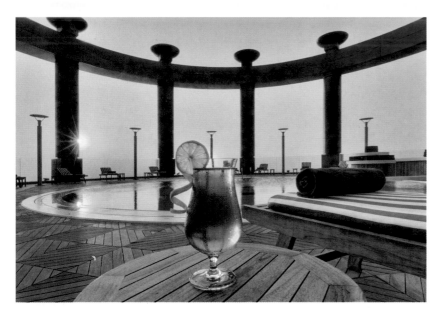

▲ WISH WE WERE HERE

Projecting the audience into a scene and turning on the beautification tap is essential in commercial work. Here the techniques include an in-your-face "you are sitting here" viewpoint, manicured and tidy poolside location, and perfect sunset timing. What is not obvious is complex high-dynamic range-exposure blending so that all tones are comfortably reproduced.

▼ PUTTING THE VIEWER IN FRONT OF THE PLATE

As with commercial destination photography, an important aim in food photography is to make the viewer feel as if the dish is really in front of them and ready to eat. This has resulted in one of the most widely used styles: low at-the-table viewpoint, very shallow depth of field to make the dish look close, and textural lighting.

▲ APPETISING LIGHTING

Most food photography not only aims to appeal, but to translate one sense, taste, into the completely different visual sense. Apart from the usual well-turned composition, lighting plays a massive role. Food lighting slowly follows fashion and there are tried-and-tested techniques for being attractive. Here, clarity, glow, and contrast of both color and tone are the goals. These are achieved by mixing a large area flash softlight, placed over and slightly back to heighten reflections in the silverware, with a low-raking warm tungsten spotlight.

Note that, at the end of all of this, beauty is about expectation, about conforming to what most people have learned to like. This doesn't make it sound very original and indeed it isn't. Beauty means not having too many surprises and this applies to beauty in a human face as well as in nature. But is human beauty a special case? Possibly so. Remember that beauty in nature is a "disinterested" quality, meaning that we enjoy it for its own sake and not because we get any profit from it. Enjoying beauty is not useful, just pleasurable. Beauty in people, however, certainly is useful. It helps in finding partners, and so evolution has had a large hand in it. Almost universally, people judged attractive to look at are also judged to be more intelligent, successful, interesting, and so on.

Because the beauty industry—from cosmetics to surgery—is huge, there is plenty of research on the subject, so for once the elements of beauty have been analyzed and quantified. If you were looking for a model to photograph and needed him or her to be attractive, just follow the accompanying lists. One project highly relevant to photography has been conducted by the universities of Regensburg and Rostock in Germany under the title *Beauty Check*, using morphing software to blend a large number of faces into composites. Different composites were made with varying proportions and these were presented to test subjects who then judged the pictures on attractiveness. The results showed that beauty tends toward averageness, that there are fewer differences between male and female beauty than you might expect, that skin texture is extremely important, and that large, well-spaced eyes lead the list of individual features.

A number of attempts have been made to model this by computer, and most of them, including that done by American surgeon Dr Stephen Marquardt, involve the Golden Section in the ratios between certain measurements (such as eyes to mouth compared to eyes to chin).

➤ MEASURABLE BEAUTY?

Digital manipulation has been used on this model's face in line with conventional beauticians' theory about ideal "beauty" proportions. These include enlarging the eyes, enlarging the mouth, and smoothing the skin. The model already matches basic Western ideals of facial beauty, and these three procedures push the portrait even further towards the stereotype ideal.

A RECIPE FOR LOOKING GOOD

• Satisfying proportions: certain proportions–of the subject, the frame, and the composition–are known from experience to be generally satisfying to most people. Follow these rather than challenge them. They include the Golden Section, other integrally related proportions, radial and bilateral symmetry. Choice of lens and viewpoint is often important; for example, using a longer lens to render proportions of the human face more pleasingly.
• Harmony: in color, tone, and texture, relationships between areas that balance each other in most people's perception.
• Unity: framing, lighting, and compositional devices that tie the scene together. One example would be a curve or combination of eye-lines that draw the viewer's eye inward.
• Fitness and economy: the maxim "less is more" may well be a cliché, but more often than not it works. Fussy and over-decorated scenes, subjects, and images tend to be judged less attractive. The Japanese word *shibui* is useful, meaning beautiful by being understated, not elaborated.
• Correctness: fits most people's ideas of how things ought to be and ought to look. In other words, fit for purpose. Beauty tends to be conventional and so needs a lot of skill, but not too many surprises.
• Ideal and unblemished: if the subject isn't, at least enhance the best and suppress the worst. This means being able to analyze any subject in terms of its beauty potential, whether a landscape, an object, or a face.
• Pleasurable memory: transmitting beauty means relating to the viewer's experience, especially with beauty in nature. The more the viewer has a sense of being there, usually the more effective.
• Sensual and tactile lighting: in situations where the lighting can be controlled or created, certain techniques, as described, are known from experience to deliver beautifying results on particular subjects.

THE INGREDIENTS OF FACIAL BEAUTY

This is a summary of the results published by *Beauty Check*:

• Strong stereotypes agreed on by most people.
• Smooth skin texture, free of blemishes and wrinkles.
• Tendency towards average.
• Symmetrical (but this only a weak influence).
• "Babyfacedness" in women, meaning eyes large and round, forehead relatively large, nose and chin relatively small.
• For both men and women, proportions as follows: eyes spaced further apart, higher cheekbones, browner skin (for Caucasian complexions), narrower face, fuller lips, narrower nose, darker eyebrows. For women in addition: longer and darker eyelashes. For men in addition: jaw more prominent.

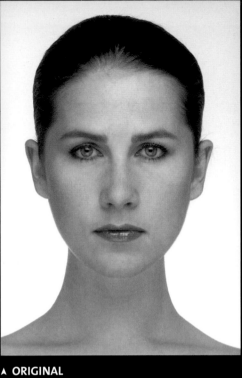

▲ ORIGINAL

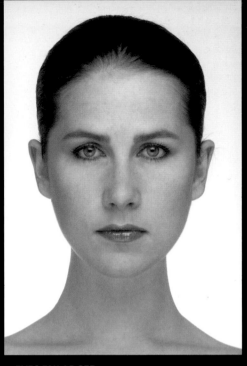

▲ EYES ENLARGED

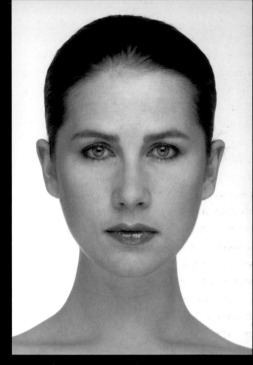

▲ EYES & MOUTH ENLARGED

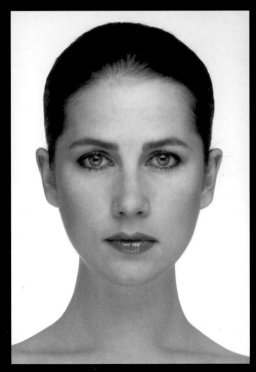

▲ SLIGHT SKIN SMOOTHING

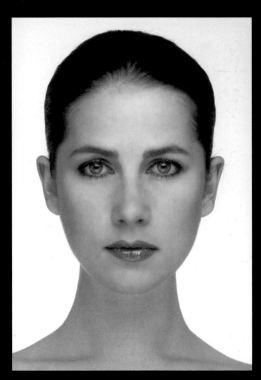

▲ STRONG SKIN SMOOTHING

Dr Stephen Marquardt has conducted extensive research on facial proportions and attractiveness, and takes this further. His *Facial Imaging Research* has quantified attractiveness geometrically and produced a computer model in the form of a mask or grid in ideal proportions. A key component in constructing this ideal grid is the Golden Section or Ratio—1:1.618. Numerical ratios also play a key part in judging an attractive figure. For women, the waist-to-hip ratio (WHR)—waist circumference divided by hip circumference—is one of the most important measurements. Psychology Professor, Devendra Singh, showed that the WHR across a wide range of women judged attractive (*Miss America* winners over 60 years and *Playboy* models), varied very little from 0.7. Nevertheless, more than for faces, the ideals for an attractive figure have changed over time. The modern ideal is slender (Rubens' nudes are usually quoted as evidence for different historical tastes), and breast size relatively large (whereas in the Middle Ages in Europe, smaller breasts were considered ideal). What appear to have remained constant, however, are the vertical proportions, and it probably won't come as much of a surprise that the Golden Section can be found here if you look for it.

➤ **VITRUVIAN MAN**
In Leonardo da Vinci's famous *Vitruvian Man*, the position of the navel is at this point vertically, meaning that the proportions of head-to-navel to navel-to-toes is 1:1.618.

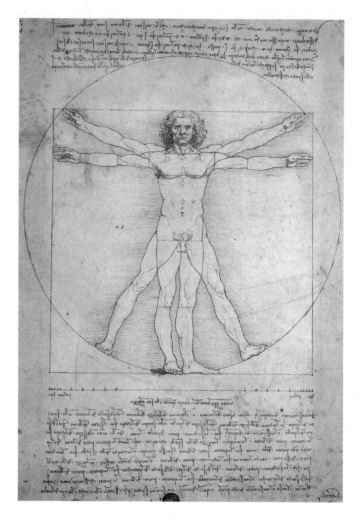

➤ **A MODEL OF IDEAL PROPORTIONS?**
Like many others, this grid derives from a mixture of harmonious proportion and actual measurements. The position of the eyes and their horizontal spacing, nose and mouth are particularly important for what most people would consider "ideal" proportions. Note, though, that this reflects Western tastes, where most of the research has been done. The three color bars show the golden section division for the following measurements: a) eyes to mouth/eyes to chin; b) outer eye to inner eye/outer eye to bridge of nose; c) eyes to chin/top of forehead to chin.

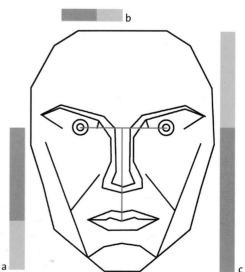

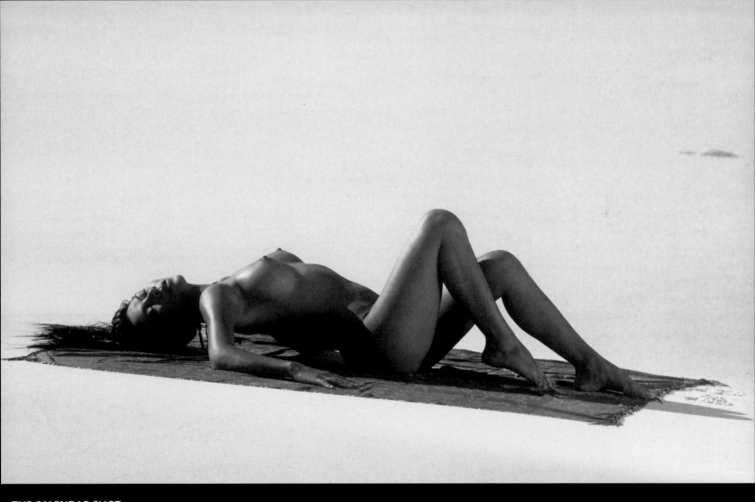

▲ THE CALENDAR SHOT
The naked female body in idealized proportions (prominent breasts, slender waist, long legs, for example) has always triggered predictable male response.

MODERN FIGURE IDEALS
· For women: slender (low body fat), WHR 0.7, larger but firm (high) breasts, relatively long legs.
· For men: low body fat, broad shoulders, narrow waist and hips, relatively long legs.

So, as with other kinds of beauty, if you want to achieve maximum agreement from the widest possible audience of viewers, these are the conventions to follow. But, to repeat yet again, aiming for conventional beauty (and beauty is always conventional) is not every photographer's aim. While photography for mass markets, in magazines and advertising, continues to follow the conventions and refine its techniques, elsewhere there are different ideas. At the edge of taste in beauty there are experiments in pushing the boundaries. This happens particularly in art, where contemporary ideas on the subject have been complicated by the need nowadays to be constantly challenging the audience's preconceptions. As long ago as the 1970s, Susan Sontag in *On Photography* could see that "In an apparent revulsion against the Beautiful, recent generations of photographers prefer to show disorder." The situation now has become even more polarized, between the large majority who continue to pursue the beautiful in life, and

a minority (some highly regarded within the critical world) who either want nothing to do with it, or would like to challenge it.

One way of being provocative is to say, in effect, "this is not beautiful, but you ought to look at it for other reasons," or "if you put your prejudices to one side, you could see this as beautiful." The trick, if there is one, is to somehow persuade the viewer to look for longer than usual and this usually means putting the image up in a place and manner normally reserved for the attractive: a gallery wall or a page in a high-fashion magazine, for example. Irving Penn's *Earthly Bodies* series of fleshy and unorthodox nudes shot in 1949–1950 are one well-known example, while more extreme were photographs of desiccated dead animals found in the desert by Frederick Sommer (1905–1999), and even more so his still life of a human foot amputated in an accident.

A variation on this is to apply beauty treatment to ugly or repugnant subjects. It's

no surprise that the main arena for doing this kind of thing has been the studio, where photographers can exercise the maximum control. Beauty techniques, as listed, are such a contradiction for a subject like the calves' foetuses shown below that they need to be applied rigorously in order to work.

WEB SEARCH
- Edward Weston *Pepper*, 1930
- Velvia saturation
- Robert Adams
- *National Geographic* Pyramids cover
- softbox lightbank
- ringflash
- *shibui*
- *Beauty Check* Regensburg
- Marquardt facial beauty
- *Vitruvian Man* Golden Ratio
- Devendra Singh WHR
- Irving Penn nudes
- Frederick Sommer dead animals

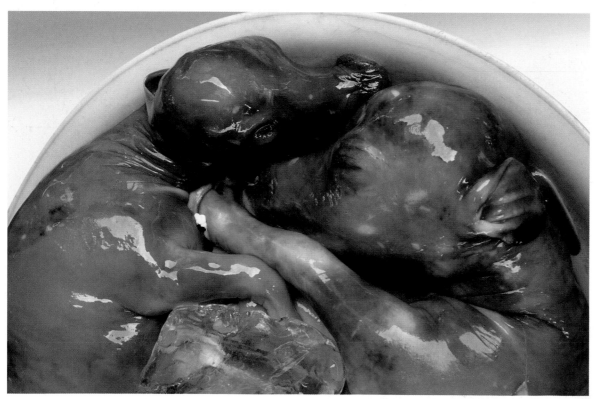

◄ NICE LIGHTING, PITY ABOUT THE SUBJECT
Calves' foetuses for sale in a northern Thai market. Just the idea of the subject matter is distasteful to most people, particularly when they learn that these are for cooking, but as objects they have a glistening appeal (maybe or maybe not added to by poignancy). Lighting is the unexpected element—a one-by-half-a-meter diffusing softbox attached to a studio flash to soften shadows and give broad highlights that convey every nuance of the texture.

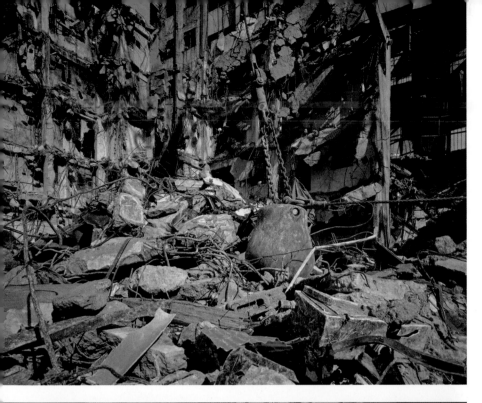

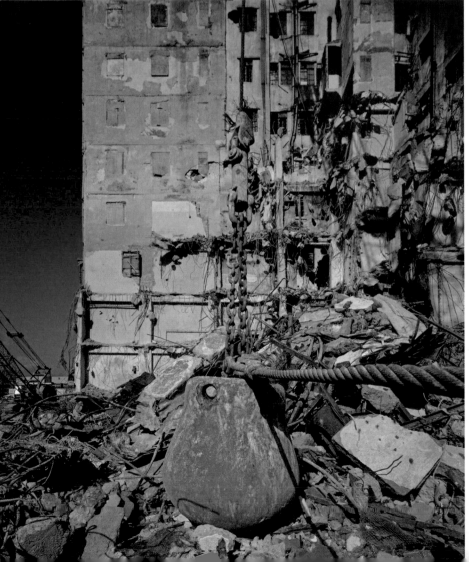

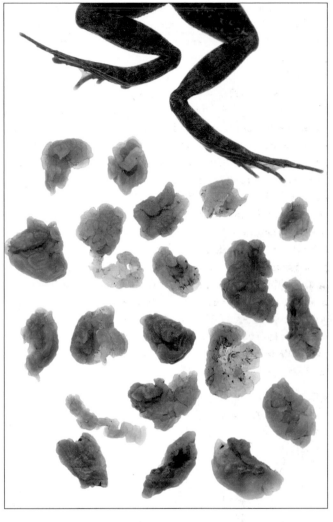

▲ PRETTY, UNTIL YOU KNOW

While the calf image opposite is immediately disgusting to most people, this seems just a well-lit and formally composed natural science image. In fact, it was for a feature on Asian food and medicine, and shows several dried frogs' uteruses, which makes the layout less innocent.

◄ ESTHETICS IN DISORDER

Large-scale demolition under way in Hong Kong is not by any stretch of the imagination a beautiful subject, but it can be made visually attractive by applying strictly formal composition, provided also that the viewer is prepared to look at it as a formal graphic experience.

DIFFERENT BEAUTY

As the photographs on the previous pages suggested, taste in the beautiful is not fixed. It changes over time and varies between cultures. Globalization applies to culture, art, and fashion as much as to the economy, and now that more people are exposed to photography, design, and styles of living from around the world, different esthetics are more easily accepted and absorbed. Human beauty is an obvious case in point. For example, models for fashion and advertising are no longer from one ethnic group—that of the audience—as they once used to be. Flick through any copy of *Vogue* and you will see a range of ethnicity and skin colors; something we now take for granted, but which has in fact evolved over many years.

But, as we already saw, human beauty is a special case, because it involves a large amount of self-interest, with viewers typically making quite personal judgments about the people in the photographs—attraction, possibly, or as a substitute for themselves or as an ideal. When it comes to more general beauty, as in nature or objects, one of the biggest shifts has been toward the idea of beauty not being necessarily perfect. This is by no means entirely new as an idea, and in western art a number of the Romantic painters of the late 18th and early 19th centuries exalted ruins as a subject—notably Piranesi's fantastic etchings and Caspar David Friedrich's paintings. What started as an appreciation by the educated elite soon became popular and remains so to this day. When the poet Shelley wrote his sonnet *Ozymandias* in 1817 (in which he was describing the fallen statue of Rameses II in Luxor), he was evoking precisely this romance and mystery. "Round the decay / of that colossal wreck, boundless and bare / The lone and level sands stretch far away." The actual site, somewhat restored and with the head less romantically upright, is shown above.

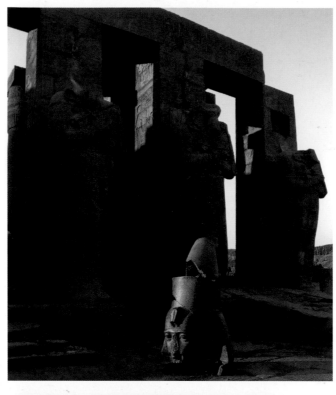

◄ **THE ROMANCE OF RUIN**
The temple of Rameses II at Luxor, Egypt, the inspiration for the poem *Ozymandias*, by Percy Bysshe Shelley: "Half sunk, a shattered visage lies..." now the right way up.

▼ **MORE OZYMANDIAS**
A less elegant head, in concrete and a Vietnamese military one, shares a similar fate in Cambodia in the period immediately following the Vietnamese occupation.

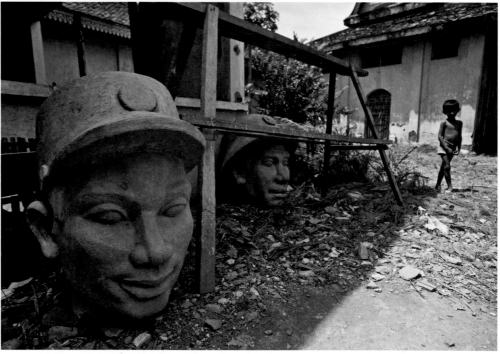

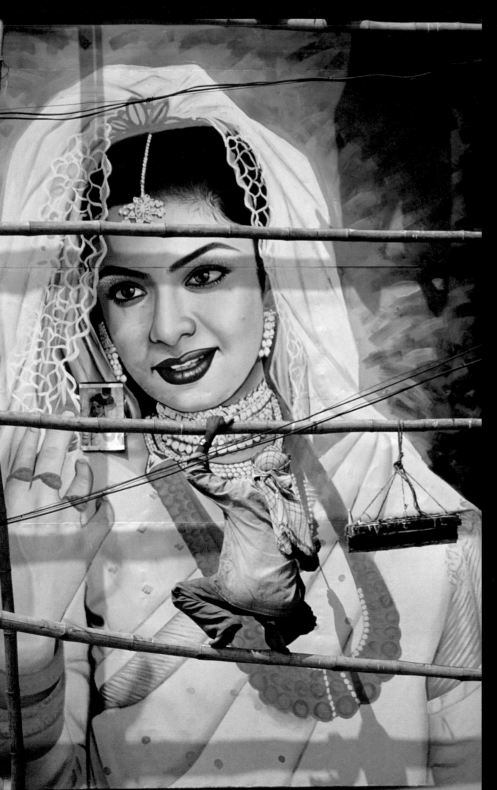

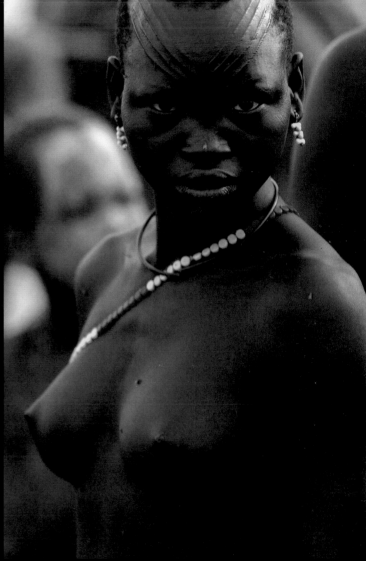

◄ **BEAUTY BY CULTURE**
Standards of beauty that were once confined to specific cultures, as in this Indian cosmetics poster, are now becoming more widely understood and enjoyed by other cultures.

▲ **BEAUTIFICATION BY CULTURE**
Scarification in many African groups is regarded as enhancing beauty, and while this cultural taste does not usually export very well to other societies like those in the West, this style, on a young Mandari woman in southern Sudan seems to be an attractive exception.

Photography played its part in the evocation of mysterious lost empires, as ambitious 19th-century travelers such as Maxime du Camp and John Thomson brought back hard-won images of shattered and worn temples, and monuments from the Near and Far East. Judging ruins as beautiful became an automatic reaction for the public, and the rôle of imagery has been crucial, because photographers and painters can control the presentation. As in any display of the beautiful, ruins have to conform to expectations, which makes viewpoint, lighting, composition, and timing critical.

Angkor in Cambodia is one of the great ruin destinations for tourists. When the French conservators set about restoring the collapsed temples, they chose one, Ta Prohm, as an exercise in romantic restoration. Genuinely untouched and overgrown ruins are actually unintelligible, and often cannot even be seen from more than a few feet away, let alone appear romantic. André Malraux, on his way in 1923 to rob one such temple at Angkor, described it as "a chaos of fallen stones... it looked like a mason's yard invaded by the jungle." So what the French did was to clear the untidy secondary growth, but leave the huge trees that had entwined themselves around the stone temple, and make it structurally sound by inserting concrete beams and pillars (but none of them obvious). The result is a manicured state of abandon, weeded regularly, which matches what most people want from a ruin. False, nevertheless.

This appreciation of the decrepit now extends to some modern industrial archaeology. As Susan Sontag wrote in 1973, "Bleak factory buildings and billboard-cluttered avenues look as beautiful to the camera's eye, as churches and pastoral landscapes. More beautiful by modern taste." This might be a slight exaggeration, but it's true that we are now conditioned to see certain kinds of decay as charming. In order to qualify, modern ruins have to fulfill some conditions, in the same way that the French conservators at Angkor maintained a few temples in an acceptably ruinous condition rather than a real state of decay. You can even use this as a guide to making attractive images of modern urban wreckage: they should be relatively clean and dry (dust is acceptable, wet garbage that probably smells to high heaven is not), the dirty bits should be at a distance and not thrust in the viewer's face, they should appear to be collapsing because of being abandoned instead of being actively vandalized, and they should be empty of life rather than harboring some possibly dangerous citizens—or, if a figure is needed for scale, one or two only and looking as if they are working. Atmospheric lighting always helps.

RUINS AT THEIR BEST

- Ideally, partly buried, partly clear.
- Important parts unobscured by secondary growth.
- Partly collapsed, with at least some key part recognizable.
- One or two hand-crafted elements visible, with extra points for sculpture and maximum points for a sculpted face or head.
- Either no people or, for scale, just one or two very small. If so, looking as if they belong there—local inhabitants, soberly or traditionally dressed, no T-shirts, definitely not tourists.
- Lighting atmospheric, with mist and aerial perspective a bonus. If not, flat lighting may be acceptably melancholic. But not bright-blue-sky postcard weather, and if this is unavoidable, the image should be converted to black and white.

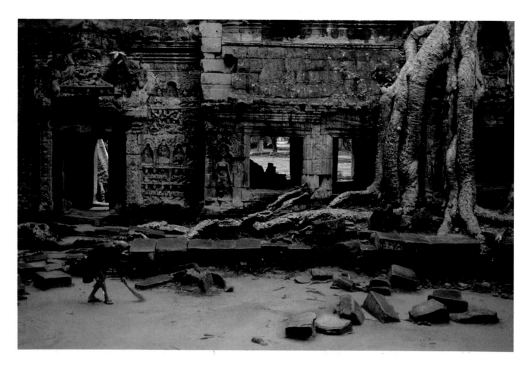

> **LOST WORLDS**
A Cambodian caretaker sweeps leaves from the floor of one of Angkor's most evocative ruins, Ta Prohm. This is simply a continuation of a policy invented by French conservators to maintain an idealized romantic state for the enjoyment of visitors.

◄ MODERN RUINS

Abandoned factories are the modern equivalent of ruined temples, and the more distemper and decay, the better they look, as this one at Ashland, near Barcelona. Note that the limited range of colours helps the ruined feeling.

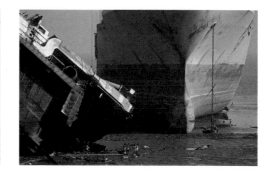

▲ URBAN ARCHAEOLOGY

A street on London's Isle of Dogs, sold up and abandoned prior to redevelopment. The limited color palette, ranged around rust, and the flat lighting are both appropriate for the subject.

▾ GRANDEUR IN WRECKAGE

Ship breaking on the Gujarat coast, India is an impressive scale of decay— and even more impressive is that it is done manually. The ships are beached by special pilots, then slowly cannibalised for steel and parts. Three versions from the same viewpoint show some of the choices in trying to maximize the sense of scale. A medium telephoto establishes the further ship clearly, but a long telephoto makes the wreckage loom larger because of perspective compression. Between the two long telephoto shots, the choice is around how obvious the small figures should be to establish the scale.

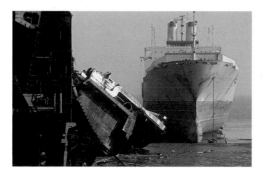

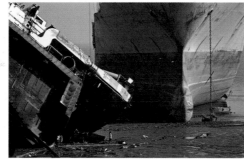

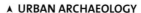

The exceptions have been cataloged differently by photographers such as Robert Adams and Edward Burtynsky. These are the truly unlovable views of despoiled landscapes that suggest we ought to do something about the environment. We looked at this earlier, under *Looking Good*. Beautification techniques get replaced by deadpan objectivity, meaning that flat lighting rather than golden and raking light tends to be preferred, and dynamic or clever angles and composition are rejected in favor of flat, head-on views. We'll look in more detail at what goes into this seemingly objective graphic style in the following chapter.

Going back to the European and American Romantic view, this was not quite the same as the imperfections enjoyed in China, Korea, and Japan. While the origins lay in Chinese culture, it was principally the Japanese who articulated them and spread the word, as it were. One of the great esthetic inventions of the Japanese, which has made inroads into western imagery and design, is *wabi-sabi*. Famously resistant to any straightforward definition, it combines *wabi* from the verb *wabu*, meaning "dejection, bitterness, being reduced to poverty," and *sabi* from *sabu*, meaning "to get old, to be discolored."

These essentially negative emotions were converted into terms expressing a very particular kind of beauty. *Wabi* has come to mean humble and simple, while *sabi* means rusted and weathered, and the two combined in the expression *wabi-sabi* suggests what the Zen scholar Daisetz T. Suzuki, called "an active esthetical appreciation of poverty." The Chinese origins of this reflect Daoist ideas, as in the sayings "The beauty of simplicity is incomparable," and "infinite indifference is the most beautiful." When photographers suffer bouts of "peeling-paint syndrome" (as in the *Nostalgia in Decay* images on the facing page), this is approximately what we're responding to.

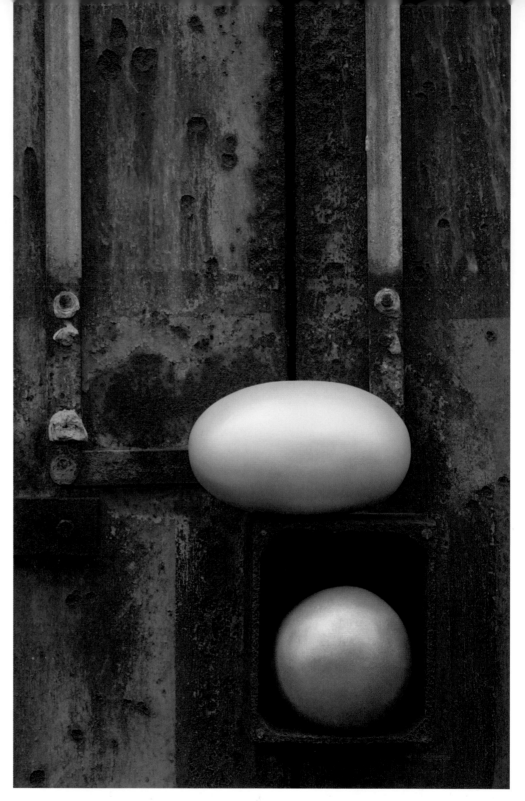

▲ DECAY FOR CONTRAST
The objects being photographed were painted sculptures by a friend, Yukako Shibata, and our idea for settings was contrast: rough and rusted industrial textures against the smooth and almost ethereal glow of the artworks.

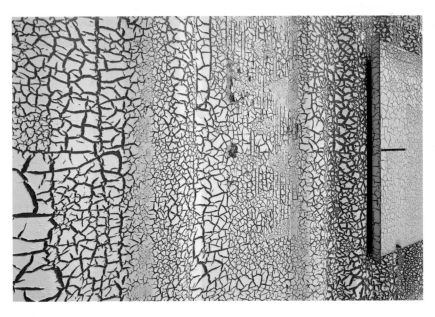

▲ NOSTALGIA IN DECAY #1
Rather than dismiss decay as a by-product of neglect, to be cleaned up as soon as possible, focusing on detail, as in this cracked paintwork, instead celebrates the time that went into creating the effect. From a rarity point of view, a wall like this could be considered valuable.

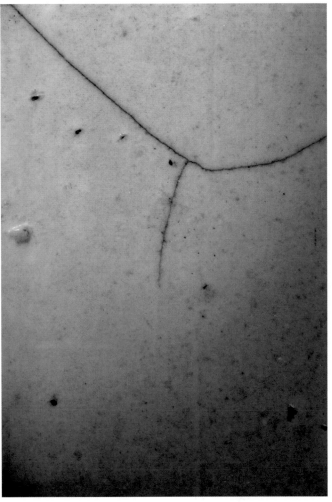

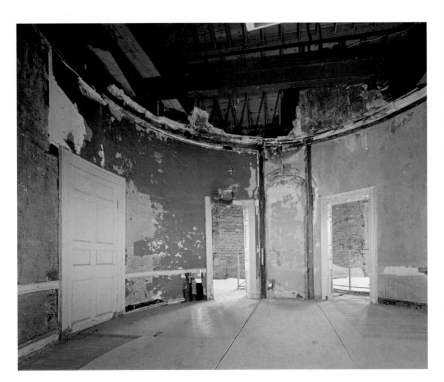

◄ NOSTALGIA IN DECAY #2
The interior of a cupola in an old Southern US mansion. Note the plasterboard flooring that suggests a halfway stage in some kind of restoration, adding a second layer of abandonment.

▲ AGE THROUGH DETAIL
An old Song dynasty bowl in the collection of a friend. What he valued most was its sense of age rather than form, so I concentrated on the crack. The soft shadow edge suggests moving sunlight, adding a second layer of time to the image.

There is a well-known anecdote of Sen no Rikyu, (1522–1591), who perfected the tea ceremony, teaching his son how to sweep the garden path leading to a tea-house. His son meticulously cleaned everything, down to the last leaf and twig. Rikyu chided him, saying, "that is not the way a garden path should be swept," and shook a tree to scatter some leaves. This principle is still followed in temples, and indeed, when I photographed a garden in Japan, I found exactly this, as in the pictures below. But the photographs also neatly illustrate one photographic problem with the idea. On reflection they look as if the fallen flower was artfully placed rather than artlessly left, as actually happened. This is a compositional problem faced by photographers daily, especially in genuine still-life sets—achieving a naturalness, even carelessness, without insulting the viewer who knows already that the set is contrived and will see through the pretence that it was just thrown together.

My own introduction to this sense of imperfection came many years ago when I was photographing for a book on Japanese food. The kitchen was in Hong Kong and we had a temporary studio set up there. Most of the dishes, naturally, were the height of elegant perfection; pristine and spotless. However, we were shooting one casserole dish that had been simmered quite strongly, and by the time it was ready, some of the stock had bubbled over the side and dried. As it was placed under the lights, I reached out with a cloth to wipe this off. The chef quickly said "No, no." I hesitated. He continued, "Leave it, please. It gives it character."

Irving Penn, one of the greatest studio photographers, over a period of seven years from 1967 to 1973 shot a series on flowers for *American Vogue*. Freely admitting ignorance of the subject, he felt that this allowed him to follow his own sense of beauty, without being "tied to the convention that a flower must be photographed at its moment of unblemished, nubile perfection." He went on, "In fact, the reader will probably note my preference for flowers considerably after they have passed that point of perfection, when they have already begun spotting and browning and twisting on their way back to the earth."

This hints at another aspect of imperfect beauty, as do ruins, and that is the passage of time. This is imperfection as impermanence, the idea that beauty cannot last and so has to be caught and enjoyed while it can. Poetry again often does the neatest job, and it is no surprise that some of the best comes from East Asia. The Tang Dynasty poet Li Shang Yin (813–858) wrote, "Sunset is so beautiful, but it is close to dusk," and in *Lo-yu Heights* (Poem 80) hints at coming to the end of one's life in "The setting sun has infinite beauty / Only, the time is approaching nightfall." Photographing the last moment's of the day, or the edge of decay, can also be a way of catching the beauty of loss.

▼ HOW TO SWEEP A GARDEN
As the text describes, the imperfection of leaving something behind, in this case a flower, has a more intense and nostalgic beauty than spotless perfection, as the monk who swept this Buddhist temple in Japan understood full well.

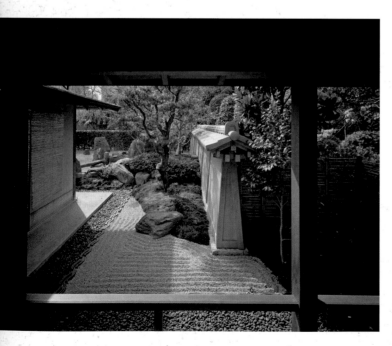

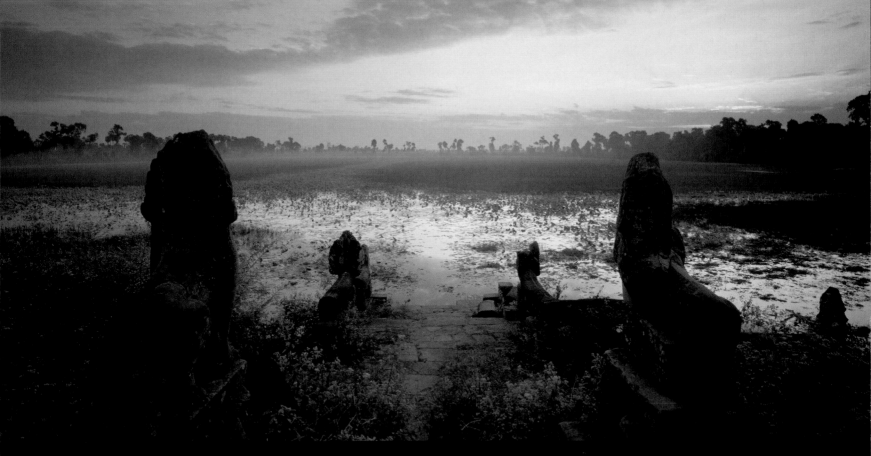

▲ THE REMAINS OF THE DAY
Revisiting Angkor, a rich source of ruins, these ancient bathing steps took on an even stronger sense of history and poignancy when seen in silhouette as the sun touches the horizon—the point in the day when change is most obvious.

WEB SEARCH
• Condé Nast *Vogue* covers
• Piranesi
• Caspar David Friedrich ruin
• Robert Adams
• Edward Burtynsky
• Irving Penn flowers

DEAD MONSTERS

The flip side of beauty is the sublime, a special case in which we experience a sort of fascinated delight at scenes and situations that are overwhelming, vast, or even terrifying. These are not hard to find, as anyone would agree who has stood on the edge of a volcano's crater as the Earth starts to shake, or been caught out in the open with lightning strikes getting closer. In fact, it was these kinds of natural forces that inspired many Romantic artists and poets of the late 18th century to create an art of the sublime—and it was explained and analyzed by philosophers such as Edmund Burke and Immanuel Kant. More up to date, when the American military used the term "Shock and Awe" during the bombardment of Baghdad, they unintentionally pointed out the essence of the sublime: shock for those on the receiving end, and awe for those watching comfortably from a distance on television. At its very simplest in photography, it involves the kind of scene, sky, or lighting typically referred to as "dramatic," but it is far more interesting than that.

Photography is well equipped to depict the sublime because many of the occasions that are sublime, such as storms, change rapidly and need some speed to be captured. At the same time, photography is poorly equipped because of its tendency to reduce all things and experiences to a similar format and presentation with which we are all too familiar. There is a danger of trivialization. In addition, the sublime as we experience it often involves senses other than just the visual (noise and wind, for example), so photography has to face this extra challenge also.

Overall it has been in writing, particularly poetry, that the sublime has received most attention—perhaps not surprisingly given that it was writers and philosophers who defined it. Dante's *Inferno* ("And now there came, upon the turbid waves, a crash of fearful sound at which the shores both trembled...") is one renowned example. But poetry, with its ability to create word-pictures, is not completely alien to photography. Wordsworth's *The Prelude*, perhaps the most famous sublime poem, is about a traverse of the Alps (in 1805 seen more as we would think of a remote region of the Himalayas), and contains some highly visual passages that you could easily imagine translating into a photograph: "Black drizzling crags... the sick sight and giddy prospect of the raving stream, the unfettered clouds and regions of the heavens, tumult and peace, the darkness and the light..."

> **DANTE REVISITED**
An opencast mining pit, treated in an ominous way. The timing, near sunset and framing, with the top edge of the widescreen frame just below the horizon, has sufficient flare with a reddish glow that suffuses the already dust-filled atmosphere. The effect, given the scale evident from the machinery, hints at the *Inferno*.

▼ **THE EFFECT OF PROCESSING**
In this photograph of a crater lake on the Indonesian island of Flores, the basic traditional elements of the sublime are already there— stormy sky, swirling clouds, dark foreground and pool of light, as in the schematic opposite. Processing, however, can enhance the sublimity by working on the sky, darkening, adding contrast, and particularly important, reducing saturation to make it more threatening.

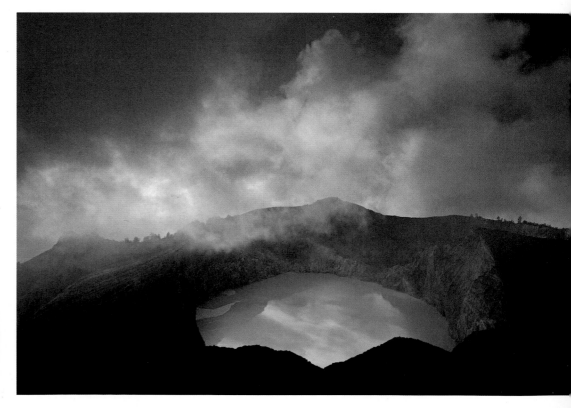

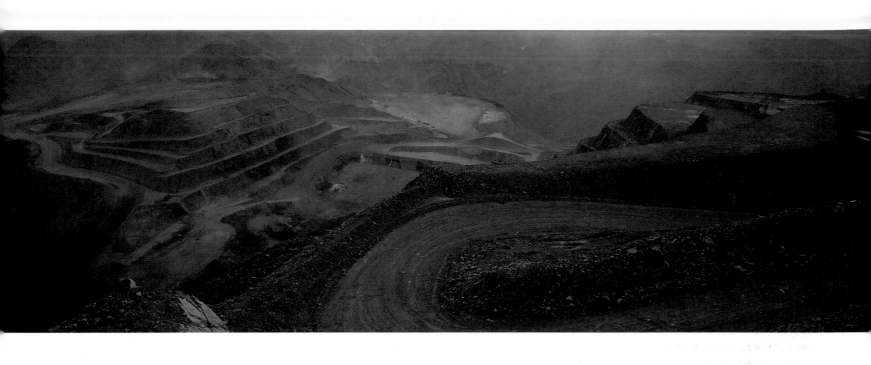

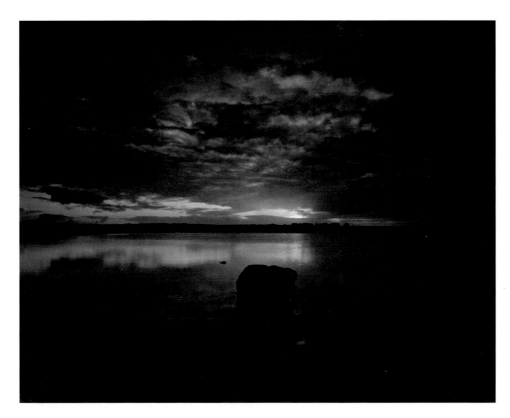

◄▲ LIMITING THE COLOR
Dozmary Pool, Cornwall, which featured in the legend of King Arthur. A brief break in a storm at sunrise provides the elements, but care was taken in the processing to increase color saturation in the highlights and decrease it in the shadows, to further heighten the contrast between storm and light.

Beginning with Kant, there have been traditionally two kinds of sublime. One has to do with size—things too large to comprehend, such as mountains and infinity—the other is dynamic, to do with overwhelming force and danger, such as a violent storm or a volcano erupting. With both, and particularly the second, there is an odd appeal, and it was put best by one of the first writers on the sublime, Joseph Addison, who said, in *The Pleasures of the Imagination* (in *The Spectator*, 1712): "When we look upon such hideous Objects, we are not a little pleased to think we are in no Danger of them. We consider them at the same time, as Dreadful and Harmless; so that the more frightful Appearance they make, the greater is the Pleasure we receive from the Sense of our own Safety. In short, we look upon the Terrors…with the same Curiosity and Satisfaction that we survey a dead Monster." Vicarious pleasure, then.

A brief look at how the 18th century Romantics dealt with it is not out of place. These include the painters J. M. W. Turner, Caspar David Friedrich, and Claude-Joseph Vernet, among others. Without suggesting that these are in any way elements of a formula, certain techniques run through the genre. Making frequent appearances, although not all at the same time, are large scale (of the pictures themselves), low horizons to give pride of place to towering skies, small figures used for contrast of scale, large areas in low key (dark, brooding stormclouds), a preference for backlighting whenever the sun does occasionally appear, attempts to convey dynamic movement in the sky (Turner was a master at this), and distances dissolving into mist and formlessness (particularly in the work of Friedrich).

But there was—as there is now in photography—a fuzzy boundary to the sublime where it slid off into sentimental fantasy, as with some painters of the Hudson River School, such as Thomas Moran. Lush and attractive though many of the sunsets were, their appeal is not to the sublime, which ought to inspire at least some awe. The same applies to photography, and there are often no clear divisions between tapping into the sublime and simply basking in a landscape spectacle.

WAYS OF OVERWHELMING SIZE AND NATURAL FORCE

SIZE:
- Large scale of reproduction (and large prints are, in any case, the fashion in fine-art photography).
- Low horizon, large sky area.
- Using small figures for scale.

FORCE:
- Low key for brooding, lowering effect.
- Low chromatic range.
- Great attention to complex forms of clouds, and cloud modeling.
- Lines and vectors that swirl and have dynamic movement.

▾ FORMLESS MIST
Another, quite different approach to the sublime landscape is to have the elements dissolve into mist, fog or cloud. These isolated Chinese mountains only just emerge from the clouds (for which particular care was taken in the processing to keep it subtle), and this conveys the sense of mystery and vastness for which Chinese mountain paintings were famous (and these were also, incidentally, the inspiration for the landscape in the film *Avatar*).

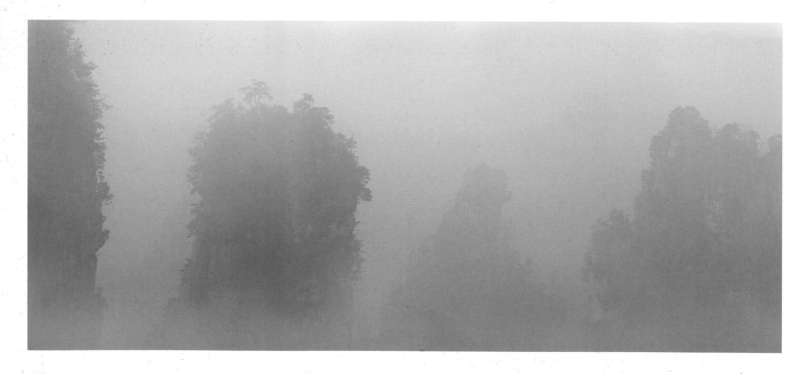

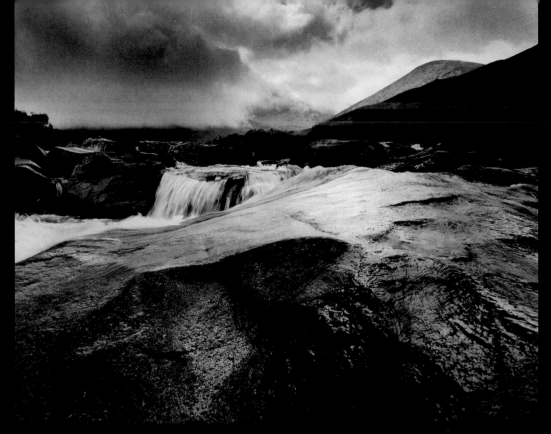

This landscape, photographed on 4x5 black-and-white film, has here been processed digitally for full effect, with the stages shown. The first row of diagrams below show, from left to right, an analysis of the tonal gradients, the masses, the vectors, and the correspondence of the two main highlights. The processing decision steps go as follows: 1) the original printed full range with little contrast, 2) contrast increased overall and the black-and-white points set, 3) the sky equalized for maximum contrast and detail, 4) the lower two-thirds darkened, 5) contrast increased in the lower right area, 6) contrast increased in the extreme right foreground and lightened to help the vector shown in the diagram below, 7) the highlight on the rock brightened for more contrast and better correspondence with the sky highlight, 8) contrast and detail brought out in the band just below the clouds.

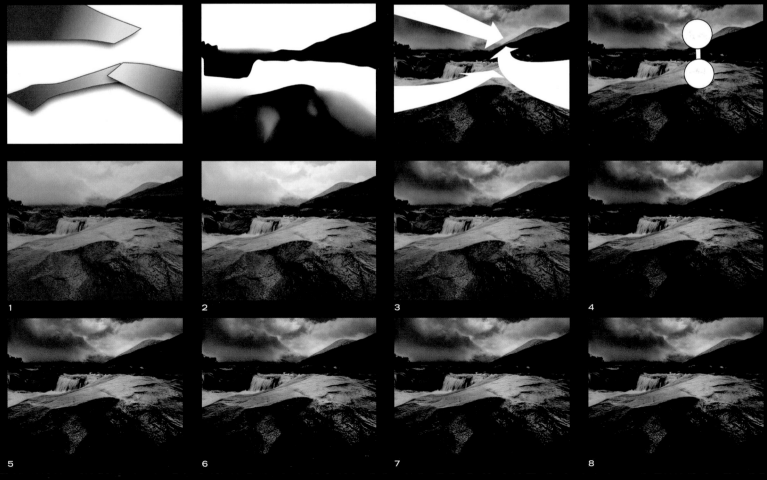

1

2

3

4

5

6

7

8

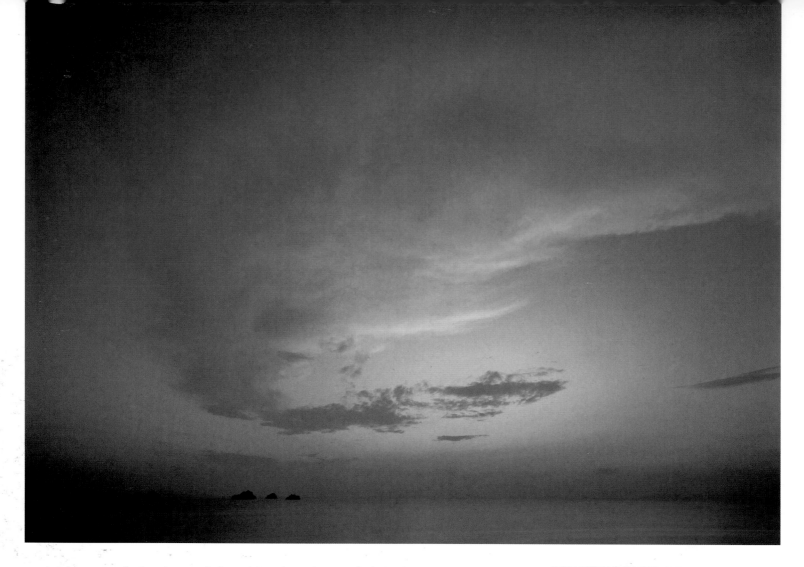

Are there ways of using photography's special image and optical qualities to give substance to the idea of the "formless" sublime? Well, it has certainly been tried. One instance was Ernst Haas' book *The Creation*. This was an attempt to evoke the Biblical meaning of the Creation (though not from a religious standpoint) through unmanipulated photographs. I say unmanipulated because this, in the late 1960s, was before the days of easy digital fantasy, and in any case, Haas was a "straight" photographer; the most he allowed himself was the occasional double exposure. The project began with an industrial assignment that required Haas to find ways of photographing elemental power. As Haas tells it, on his return from one long assignment, his assistant had assembled a selection of slides in the projector, and ran them to a soundtrack by Haydn, saying, "Do you realize what you

have photographed? You have photographed the creation of the world." Haas continued to work on this idea, and for the early part of the story, in addition to images of volcanoes erupting, thunderstorms, high-altitude skyscapes, waterfalls, and waves—all traditional subjects for the sublime—he photographed in close-up an abalone shell. The light and tight framing turned it from the prosaic into "a vista of immense proportions," as he put it. In one sense, this was continuing the tradition of abstract photography, in another it was an escape from reality into the imagination.

It also illustrates how well-equipped photography is to create this kind of fantasy, by using framing, optics, and lighting to make illusion. The possibilities are vastly extended by using techniques such as multiple exposures and photomontage, and now, of course, through the

▲ NOT QUITE SUBLIME, BUT...
A skyscape that is neither in the style of lush travelog sunsets (the colors are muted and a darkness suffuses the edges), nor exactly sublime, being calm and quiet.

endless opportunities of digital manipulation. Photography's stellar advantage in this is that it simply looks real. Even when we know that an image is a complete fantasy, it has no brushstrokes and so still gives the viewer the impression that the image is of something rather than laid down on a surface. This premise of being just about believable has made possible a huge genre of science-fiction movies, from the wires and string of Stanley Kubrick's *2001: A Space Odyssey* to the sophisticated CGI of James Cameron's *Avatar*.

▾ VISIONARY EFFECTS

More straightforward in execution than the image next to it, this is a composite with a simple, though abstract concept, and has been used many times, including a GEO cover because it gets straight to the point. The three elements are a silhouetted landscape, a separate silhouette of two figures, and a collection of astronomical imagery.

▾ HINTING AT THE SUBLIME

By creating a deliberate confusion of scale and content, this image suggests an almost cosmic scale—possibly some scene from science fiction—by combining four photographs. Or rather, two photographs that make only a secondary contribution and two, for want of a better word, photograms. The red circular shape is a direct exposure on a sheet of film of the spark generated between the two spheres of an electrostatic charge generator, while the surface lit by raking light with a star-like object is an unintended light leak through a gap in a sheet-film holder. The clouds and the landscape below simply help to give depth. The value of using imagery that is impossible to identify is that it frees the imagination to see it in whatever way it has been composed, which in this case, with a black background, perspective and careful layering, means as a vast skyscape.

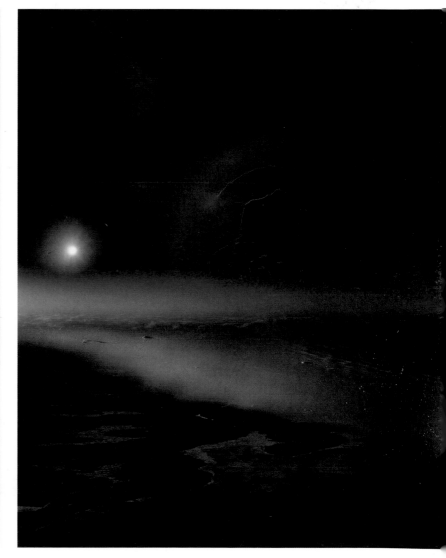

Although the sublime has traditionally been associated with awe in the face of nature, and this extends smoothly into modern visions of the cosmos, more recent writing on the subject gives it an even more fundamental place in human experience—embracing the horror and dread of war, holocaust, and fears of mass destruction. Bringing the sublime up to date involves subject matter that we are *really* uncomfortable with. But can it effectively be dealt with in the same way as the natural sublime? Through the use of dramatic visual techniques and scale?

The problem is that the aim of photojournalism is to communicate news, immediacy, sometimes emotion and violence, rather than the sublime, which benefits from some reflection on the part of the viewer. Naturally, there is no formula here, and it's very much a matter of opinion, but there is an argument that a slower and more formal presentation might serve the terrible side of human nature better, and that pumping up the visual rhetoric would be over the top. Two photographers who have taken this approach are Simon Norfolk, who makes formal compositions of what are often the landscapes of war to convey what he calls the "military sublime," and Romano Cagnoni, who for one project used a large-format view camera to photograph the ruins of towns in the former Yugoslavia destroyed in the Balkans conflict. As he put it, "The aim was to have technically perfect architectural photographs of

war-damaged sites, intending a disconcerting effect."

The pictures here, from the Cambodian Killing Fields, show the difference between photojournalism of emotional moments and the quieter record of aftermath. And presentation, yet again, can be pressed into service: The German artist Gustav Metzger, in his *Historic Photographs* series, had great enlargements made of historic photographs from the Nazi era and the Vietnam

war, and then covered them so that they could be seen only by close, uncomfortable confrontation. *Anschluss, Vienna, March 1938*, for example, is a large photograph of Jews in Vienna being forced to scrub the street with toothbrushes, but it is laid flat on the floor and covered completely with a cloth. To see it, the viewer has to crawl under the cloth, which not only mirrors the humiliation of the people in the photograph, but makes it too big to see all at once.

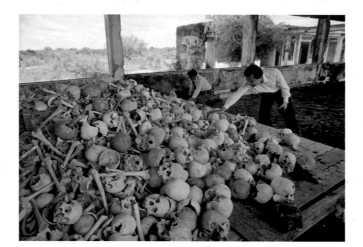

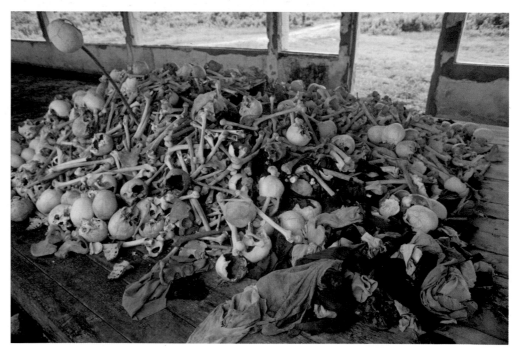

WEB SEARCH
- J. M. W. Turner
- Claude-Joseph Vernet
- Thomas Moran
- Ernst Haas *The Creation*
- Kubrick *2001* Star Gate
- Gustav Metzger *Anschluss*
- Romano Cagnoni ex-Yugoslavia
- Simon Norfolk military sublime

▲ ➤ **CONTEMPORARY SUBLIME**
Horror, such as the Cambodian genocide, can be treated obviously or quietly. This journalistic approach recorded the encounter between Haing Ngor and Dith Pran of the movie *The Killing Fields*, and the recently exhumed remains of people executed (Dith Pran's family among them).

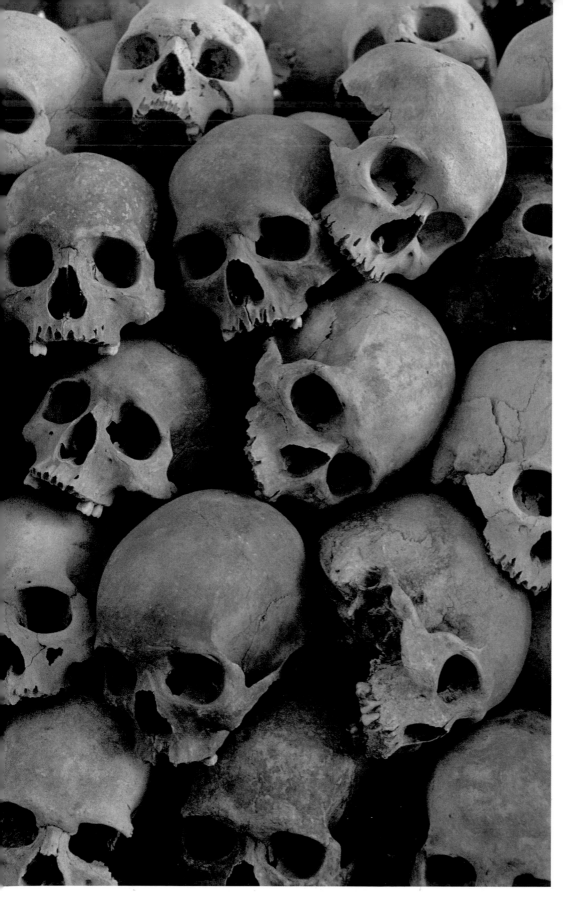

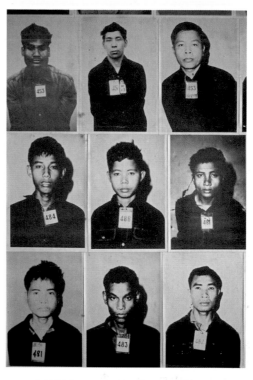

▲ ◄ ▼ A MORE REFLECTIVE TREATMENT
The same subject, but here more objectively recorded. A pitiless still life of the skulls of victims as arranged by monks, and a wall of Khmer Rouge records photographs of prisoners prior to torture and execution.

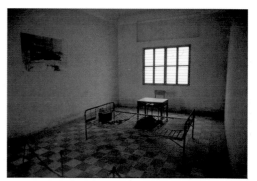

CLICHÉ AND IRONY

Clichés may be a little less common in photography than in, say, writing, but I would argue that they are more of a problem. The reason is that they are more difficult to avoid. A clichéd phrase can easily be replaced—you only have to use a thesaurus—but in photography there are some scenes that simply do not have very good alternative viewpoints. And while viewpoint does not rule every photograph, it very much applies to those large, fixed scenes and subjects that everyone has an opportunity to visit. Whether the Grand Canyon, Eiffel Tower, or any popular magnet, the problem is that it's all been done before.

Cliché has come to mean generally a trite or over-used idea, or in our case a photograph. It is almost universally condemned as a sign that whoever is using it is unimaginative, lacking in creativity, or lazy, or all of these. That sounds reasonable, but how did clichés get to be in the first place? Almost none of them started as trite and commonplace. When the English photographer Francis Frith photographed the Sphinx and Pyramids in 1857, he brought back to the untraveled viewing public an amazing sight, all the better for not being shot with a tricky angle and parts obscured. Since then, it has become a postcard view, which in its own way goes to

show that it was a popular view. Here, admittedly, we're looking at ways to take our photography forward and work hard at it, but it might not be completely fair to dismiss tried and tested images out of hand. The American conceptual artist Jenny Holzer, best known for her text installations in public spaces, plays devil's advocate: "Clichés are truth-telling, time tested, and short. These are all fine things in words. People attend to clichés, so important subject matter can be disseminated. Clichés are highly refined through time."

It's a provocative idea and perhaps there is something to learn from it for photography. Instead of a knee-jerk dismissal of a view as too

◄ A BASIC DILEMMA
By almost any standards, this is a striking view and a dramatic landform. There are many angles for this sandstone pillar, known as Thor's Hammer in Bryce Canyon National Park in the western United States, but this is particularly tempting—sunrise with the tip just occluding the sun's disk. The bowl that rises up to the left, right, and behind the camera position acts as a reflector to give the best of both worlds of lighting—a silhouette, but with a high level of fill. The problem is that the very precision of the viewpoint means that anyone who has the idea for this will inevitably take a near-identical shot.

obvious, it might be worth re-appraising it if there is a way to persuade an audience to look at it freshly. This is exactly what Holzer does with her installations. Maybe not so easy with a photograph, but if you think about presentation, there are some possibilities. One is scale. In fine-art photography in recent years, very large prints have been in vogue. By large, I mean measured in feet or meters rather than inches or centimeters. In the West, Andreas Gursky is probably the best known of photographers working to scales that exceed 15 feet/4 meters. The Chinese photographer Wang Qingsong does similarly large-scale prints, including one that is

31 feet (9½ meters) long. Debate continues as to how much of the strength of these photographers' work lies in sheer size, but it certainly does command attention in a gallery or show. I'm not, incidentally, implying that either of these artists' images are in any way a cliché, but rather that unexpected presentation compels viewers to look at photographs more carefully. Another possibility might be in the form of an animated slideshow or movie; dissolves and tracking shots applied to still images can certainly enliven them, while well-chosen music adds another dimension to the viewing experience.

However, back to the problem of the obvious,

acknowledged, "perfect" viewpoint. Does it even exist? Or rather, according to what taste does it exist? First, let me mention a special case, which is when the intention of the creator of a scene or subject is to control the view. This is less common in large views, for obvious practical reasons, but quite usual with architecture and design. In fact, designed spaces share a great deal with works of art. Photographing them involves considering how they were intended to be seen. Strong examples are English landscape architecture of the 18th century and Japanese formal garden design, particularly stroll gardens developed from earlier Chinese principles.

➤ PERFECT FRAMING?

A view and a garden, which has been designed deliberately to look like a painting or photograph. Any other camera angle is simply less good.

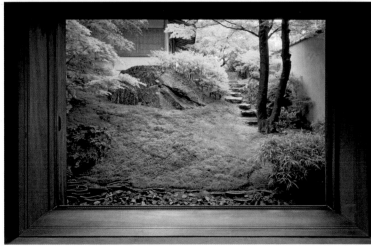

◄ THE FINEST VIEW

A famous view of Blenheim Palace that Randolph Churchill called with some justification "the finest view in England." The 4th Duke of Marlborough employed Lancelot "Capability" Brown in 1765 to redesign the gardens. He created the lake and this highly engineered view, which greets the visitor arriving through the Woodstock Gate by carriage. I was shooting a story on Blenheim for the Smithsonian and so had access at any time, and was able to explore this viewpoint minutely. It soon became obvious that the view—which takes in the house, lake, and bridge—is extremely precise, to within a few paces. To shoot in any other way, it seemed to me, would be perverse. Lighting is the only variable.

Unlike the constructed, or designed landscape, natural views rely on consensus, and one practical consideration is simple efficiency. As long as the subject is agreed on, and is something concrete and straightforward, such as a rock formation or a building, then only a limited number of viewpoints will show it recognizably. There would be little point, for example, in photographing the rock arch shown here side-on, unless, of course, you were being extremely ironic and doing this to challenge the viewer's assumptions. A second consideration is what people expect to see in terms of a satisfying angle and pleasing proportions. This is where we get into the issue of normal versus cutting edge, and the essential conservatism of what most people like.

Interestingly, there is a measure of the common denominator of public taste, and that is the sales of stock photography. This is really where the marketplace for photography now resides, with many millions of images licensed for sale and accessible online. In whatever commercial area—travel destinations, fashion, and lifestyle—the really big earners are images that sell over and over. Simply because of being sold and reproduced so many times they have become, in effect, clichés. Creatively that might not be a good thing, but financially it could hardly be better. The founder of one of the most successful stock agencies of the 1980s and 1990s remarked that 90 percent of the sales came from 10 percent of the images.

Strategies employed by professional stock photographers are instructive, because they are dealing with cliché-prone material (as I write this, a check on a major online stock site shows more than 12,000 hits for a search on "Eiffel Tower," for example). I'm indebted to my friend Steve Vidler, a travel stock photographer, for explaining how this works. Rule one is to concentrate on what you know will sell, which demands the discipline of not getting side-tracked into the unusual. This is probably the opposite of what many photographers would do. Instead of adopting a "dare to be different" approach, successful stock photography means identifying with both the mass of final viewers and the picture editors who are catering to them.

This research would lead Vidler, for example, to shoot a well-known site with a tourist couple prominently in view—a couple that a reader could identify with. "Tourists in front of the Eiffel Tower: how boring, you might think. But bear in mind that this type of image is one of the most sought-after in the travel industry." While acknowledging that it has "certainly become increasingly difficult to get a different slant on the iconic subjects because of the sheer volume of imagery and choice available to image buyers," Vidler sees it as a challenge rather than a cause for despair. He makes sure that he is on-site before dawn, in good weather, and will work hard to compose the shot with some extra element, such as a reflection or, in the case in question, a street and attractive café with the Eiffel Tower in the background.

For photographers who want to separate themselves creatively from others, and carve out their own distinctive niche, the limited-viewpoint scene is more difficult to solve. Not least, there is the underlying irritation that you are not the first. Yet if you had been, or if you didn't already know what had been done, would you naturally go to the same spot as others? The same problem in reverse is if you are fortunate enough, or persevering enough, to be more-or-less first (as happened to me at Angkor). Then, you should really anticipate what everyone else will do later, because what you find obviously satisfactory, they will too. But in any case, if you did manage to find a very specific and less-obvious view, as most of us try to, you can be sure that when it has been published it will be copied. I once had the doubtful pleasure of being at a temple in Angkor and seeing a photographer, and assistant exploring with camera and tripod in one hand and my book in the other, looking for the same views.

▲ A NECESSARY VIEWPOINT
As described in the text, a rock arch, in this case Delicate Arch in eastern Utah, is visually only an arch from a limited angle.

▲ TAOS CHURCH

San Francisco de Asis church in Ranchos de Taos, New Mexico, is locally claimed to be the most photographed and painted church in the United States, and with good reason. Both Paul Strand and Ansel Adams photographed it, while Georgia O'Keefe painted it. The interesting thing is that almost everyone photographs the back of the church, not the front. This is because the heavy buttressing at the back is massive and sculptural—a set-piece in the study of form—while the front of the church is ordinary, and less interesting.

The problem is that there are few variations you could make, apart from the light, as the sensible viewpoints are all close together. So the dilemma is how far can you go with any technique to be original? Put another way, why ruin a good shot just to make it different? My two solutions were a different crop and format (a 6x17cm camera), and a wide-angle

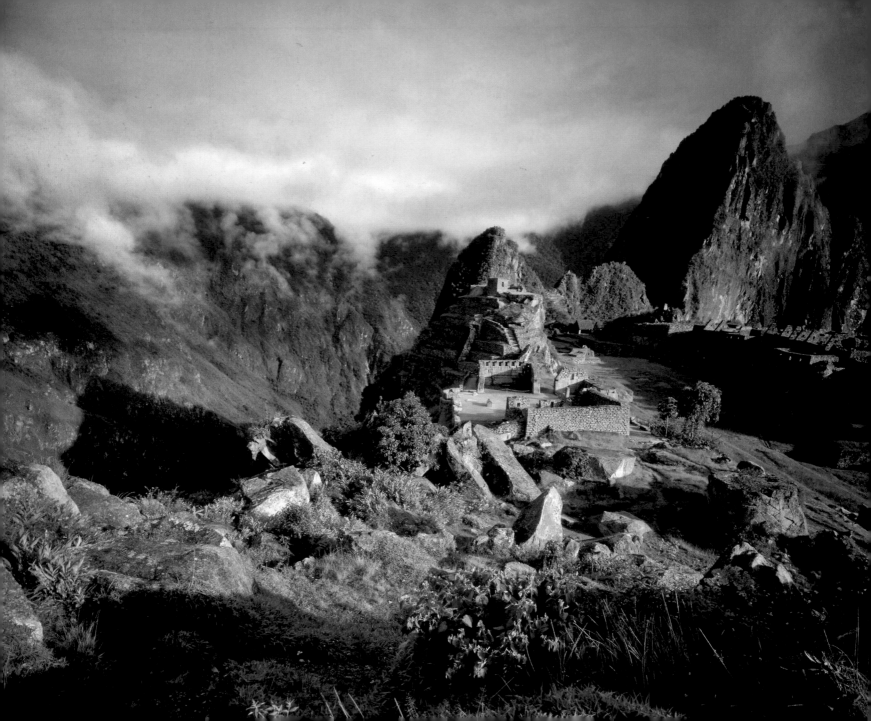

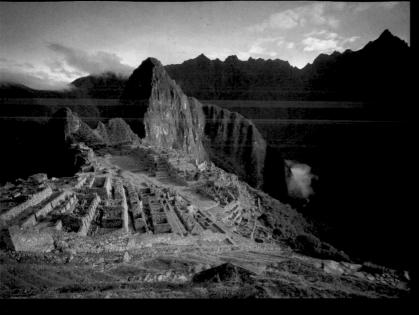

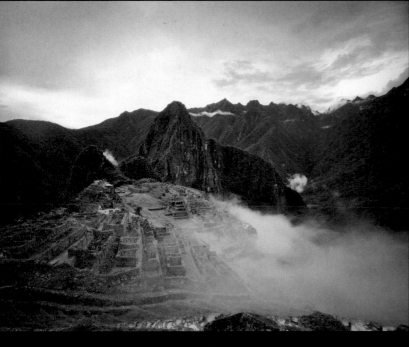

◄◄ MACHU PICCHU

If you have seen any photograph of this ancient Inca site in Peru , you have seen most, because the terrain means there is very little choice of view that takes in the entire site. Before I went, I had expected more freedom of viewpoint, but if you want a clear, overall view that takes in the ruins of the ancient city and the distinctive peak of Huayna Picchu that dominates the site, it is from this location alone (and please also do a stock library or general web search). You may also notice an overall similarity of lighting, because not only does the aspect of the site favor morning light, but also, because the surrounding mountains are high, by the time the sun strikes Machu Picchu it is already well past sunrise. This removes any possibility of interesting dawn light (I noted the time of shooting, and my sun position calculator for that date shows that sunlight struck the entire site exactly one hour after sunrise). At first glance, the prominent peak in the shot, Huayna Picchu, looks as if it has a commanding view, but while it's climbable, a recce later in the day revealed that it was hardly worth the effort.

The options, therefore, are very limited. Weather certainly is one, as the smaller images show, but that depends on how many days you would be prepared to stay. The other thing that happens at a location like this is that you are rarely alone. There will typically be a group of people in the same place, which in itself is not a problem, but very soon after this standard photograph has been taken, people start moving off, down toward the ruins and so into view.

Fortunately in this case, I spotted what I thought might be a viewpoint with foreground several minutes down the slope, and went there quickly before anyone else came into view. One of the things I was trying to do, apart from avoiding imitating every other shot, was to make the lighting work. From the smaller "standard" view, you can see that the distance to the subject shows an efficient but not particularly interesting play of light over the ruins, even though the lighting angle is good for texture and form, and more of the ruins are shown.

However, I felt that if there were a foreground, the relief and local contrast would be stronger and, while less of the ruins are revealed, the photograph would be more interesting visually. The result worked for me and, although not a ground-breaking discovery, it did sell. Another possibility, as you can see on any large stock agency site, is posing a llama in front of the view, but that has quickly become even more of a cliché.

◄ MACHU PICCHU

The caption above describes this situation, an extremely well-known site and the reasons for the standard view (this page, top) being so common. The second picture above shows a weather variation, underlining how important sunlight is. The bottom image shows the two viewpoints seen from the peak in the distance: the upper is the standard view, the lower the one found for the main shot opposite.

As the previous examples have shown, with a given subject there is a limit to the number of ways in which you can treat it photographically, and still come up with a sensible, acceptable image. The further you stray into weird angles and effects, the greater the risk of the image simply looking silly. One thing that can help is fashion. Treatments and techniques that at one time would have been completely rejected by most people can gradually become tolerated by a general audience, and then even liked. For instance, when ultra-wide lenses (meaning a shorter focal length than 28mm) began to be used by professionals in mass publications in the early 1960s, they were controversial for their distortion (even though Bill Brandt, for one, had made extreme wide-angle nude photographs in the 1950s with a specialized Kodak police crime-scene camera). Art Kane, for instance, made 21mm close-and-distorted fashion photography his hallmark, and the style soon became almost normal in the United States and Europe. But what is "fashionable" can just as quickly be thrown out, becoming yet one more cliché, as indeed happened with the wide distorted look.

The most decisive way of dealing with photographic clichés is to redefine the subject, and we have already looked at how much broader the definition of a subject is than most people would think. A clichéd beauty spot may well be susceptible to being treated in a different context, and an effective route into this is a journalistic approach. Researching the subject thoroughly may throw up a very different kind of opportunity, such as restoration work or an event. This would prevent any attempt at "improving" on the classic treatments, but it also offers something different.

◄ ˄ AN UNTRIED VIEWPOINT
A view of Stonehenge, which receives 800,000 visitors a year, at the time of an unlikely-to-be-repeated excavation. This was the point of the assignment—the first archaeological dig that had been permitted in almost half a century—and while the results are likely to be useless for a travel brochure, they are priceless as a unique view.

WAYS OF DEALING WITH CLICHÉD SCENES
- Make a technically superior version, such as higher resolution or a fuller dynamic range.
- Make a stylistically superior version (admittedly a matter of taste), such as refining the composition.
- Search for a different viewpoint or framing, if one exists. With a very over-photographed subject, this is unlikely, but still possible.
- Different lighting or weather to that which has already been shot. With luck and perseverance this can succeed even with heavily shot locations.
- Make a stylistically different treatment (not the same as "superior"). This could involve a different color look, a monochrome version with special treatment of the key and/or contrast, or even using a style that exploits new technology, as happened with ultra-wide lenses in the 1960s.
- Redefine the subject. In fine-art photography this is the most rewarding solution. Redefining is open-ended, but one example might be to step back and show other photographers shooting the scene, altering the subject of the image.

WHAT MAKES A PHOTOGRAPHIC CLICHÉ?
- An inherently attractive subject with a conventionally attractive viewpoint.
- Established points on the tourist trail that fit the above.
- A strong stylistic technique that is past its sell-by date–in other words, identifiable and over-used. Example: racking the zoom during the exposure for a radially blurred treatment, fashionable in the 1970s, but quickly done to death. Another, more recent example: simulating a miniature scene by shooting a normal landscape with a tilt lens that limits the focus to a narrow plane.
- Any subject or style that becomes so popular and so reproducible that it is taken up by many other photographers. A victim of its own success, in other words. Example: running straight lines as diagonals, which was considered "edgy" for a few years in the 1990s. As was overexposing for a washed-out look. As was cross-processing film.

While the previous example of Stonehenge reveals a uniquely positive view of the subject, a less positive example is the case of the mountain in the image shown right. This is Meili Xue Shan ("Beautiful Snow Mountain") in Yunnan, China. Rising above the Mekong gorge to nearly 23,000 feet (7,000 meters), it lives up to its name as a very attractive peak, and is actively promoted by the province's fledgling tourist industry. So, what to do with an admittedly pretty sight at sunrise that is endlessly reproduced on posters and in brochures? The classic viewpoint is from a small town on the east bank, and every tourist dutifully rises at dawn to take a picture. However, when we visited, a high wall was in the process of being built by the road to make sure that only paying tourists could see the mountain. Outrageous, of course, but at the same time a photograph with a story.

This is the more ironic, or even cynical approach to a subject, and as a general attitude can be applied not just to the obvious targets, but to subjects in general. It appeals to a different kind of audience, and suits some photographers' personalities better than others. It also runs its own special risks, such as misfiring (no-one gets the point) or seeming simply willful. The safest way of doing this is to make sure that the story you are telling is a solid one, not frivolous.

Certain subjects themselves have either become clichés or are teetering on the brink. To quote Sontag again, this time on Paul Strand and Edward Weston: "Their rigorous close-up studies of plants, shells, leaves, time-withered trees, kelp, driftwood, eroded rocks, pelicans' wings, gnarled cypress roots, and gnarled workers' hands have become clichés of a merely photographic way of seeing." This recalls the art director of *American Vogue* in the 1930s, M. F. Agha, rounding on such clichés of modernist photography as "Eggs (any style). Twenty shoes, standing in a row… Ten teacups standing in a row… More eggs …" But Sontag added that such subjects had become clichéd because "what it once took a very intelligent eye to see, anyone can see now." In

▲ **FINDING AN ISSUE**
Retaking for the many-thousandth time the admittedly beautiful sunrise shot for which this mountain is famous seemed pointless. Instead, as described in the text, I chose to focus on the dubious exploitation of it.

both of these cases—natural found objects and commercial/retail ones—the subject material was destined for cliché by being first innovative and then fashionable. As with other kinds of cliché, they started with hard work and imagination, and became victims of their own success. Finally, subjects with a potential for cliché may simply not catch your eye. Many photographers pay attention to other aspects of life and scenery than the picturesque. It's admittedly difficult to ignore the sights that most people are drawn to, but not always impossible.

WEB SEARCH
• Francis Frith Pyramids
• Jenny Holzer
• Andreas Gursky
• Wang Gingsong
• Francisco Asis Taos image
• Macchu Picchu image
• Bill Brandt nude
• Art Kane wide angle
• zoom effect photography
• Edward Weston driftwood
• Paul Strand abstract

▲ BEHIND THE SCENES
A fashion show, but to explore a bit further, the camera here goes behind the scenes to capture a moment, pose and expression that are less ordinary.

▲ THE "WEATHERED HAND" SHOT
There are endless variations of this, which by no means invalidates it, but does raise the standard, and demands that any new shot has to be very well executed.

▲ A LITTLE STRANGE
It's just a cheap restaurant in Phnom Penh, Cambodia, but the welcoming sign at the door displays rather odd taste on the part of the owners.

LIFTING THE MUNDANE

Considering clichés leads us naturally to questioning what makes a fit and proper subject for photography. This has been argued for as long as cameras have been used. Even the expression "fit and proper" has undertones of correctness, but things have changed. With photography now much less influenced by corporate media and by photography "stars," the question has become a more personal one that has less to do with meeting approval than with satisfying the photographer's own sense of what is worthwhile. Most photographers begin by searching for a type of subject that will satisfy their ambitions, and the two most obvious places to look are the established categories and whatever is close to hand. These couldn't be further apart: what *Time-Life* used to call "the great themes" with history and tradition behind them, and the easy-to-reach bits and pieces lying around the home and the neighborhood. One is what people think they ought to be doing, the other is just something to point the camera at without thinking too hard, but I suspect that most of us have gone for both.

When photography was taken more respectfully than it now is, the acknowledged genres were either lofty or at least purposeful. *Time-Life*'s great themes in the *Life Library of Photography* were "portraits, still life, the nude, nature, war, and the human condition," and commercial photography followed some of these at a less exalted level (weddings were

a mixture of the first and last, and pack-shots a form of still life). There were other ways of dividing photography, but they were always directed at content, and worthy content at that. Most photographers pursuing a career still define themselves as belonging to one chapter or another, joining other members. It helps answer the inevitable question "what kind of photography do you do?" and adds a little structure to an activity that is often loose and anarchic. But there is also the counter-view that following one of these themes or genres is unnecessarily limiting. Photographer Romano Cagnoni, when asked about the genre of his work (mainly reportage), replied, "Is there a creative photojournalist? Or a fine art photographer? Wedding photographer? Advertising? Fashion? Is it not enough just to be a photographer?"

Taking a less disciplined, or at least less restrictive view of what to shoot may be healthier for one's creativity, and one of the significant changes in photography has been opening up acceptable subject matter to include the ordinary and unspecial: both ordinary objects

and ordinary lives. The news event that affects millions, never-before-seen wonders of wildlife, and expressions of great emotion will always, of course, be important and fascinating, but the mundane can be intensely rewarding for photography if the photographer treats it as something special. After all, Edward Weston probably didn't think he was being trivial when he photographed a toilet. He was trying to look at it with a fresh and concentrated eye.

In fact, it was the Surrealist movement of the 1920s and 1930s that first prompted the photography of the ordinary. This may come as a surprise to the many people who think of Surrealism in terms of fantastic, dream-like imagery, epitomized by Salvador Dali and Magritte and followed in photography by Man Ray and Angus McBean. Certainly, fantasy is the visual legacy best remembered and still exploited, but the success of manipulated and staged Surrealist imagery put more basic Surrealist ideas in the shade: fundamental ideas that everyday subject matter had meaning and that we can find the extraordinary in the ordinary.

➤ ORDINARY URBAN
The muted tones and thick atmosphere tie the urban elements of this scene together. There is no grand architecture here, just the margins of railway running through London, and an ordinary passer-by, but it communicates the atmosphere of the usually ignored parts of a city.

➤ TRAMPLED UNDERFOOT

A beer can left on the pavement and trodden on by many passing feet, becomes an *in situ* still life, made more interesting by the surrounding snow. Images like this rely on persuading the viewer that the close inspection of the ordinary will be worthwhile.

A photographic hero for the Surrealists was Eugène Atget, whose obsessive and meticulous scenes of Paris were largely absent of people, but full of detail. Rather than great buildings and grand boulevards, he preferred quiet corners, shop windows, and nostalgia, and his images—shot with a large-format camera—invite deep examination. This is a kind of *Inventory* photography, and it intrigued the Surrealists with its wealth of subject matter captured more or less instantaneously and "automatically." Three Surrealist obsessions were automatism (creative works produced innocently), appropriation, and the found object (*objet trouvé*) that was given new meaning simply by being chosen. Straight photography of the everyday, like Atget's, had all of this.

One of the most influential art critics of the time was Walter Benjamin. In *A Small History of*

Photography, published in 1931, he wrote, "Atget's Paris photos are the forerunners of surrealistic photography." He also wrote that Surrealist "writings are concerned literally with experiences, not with theories and still less with phantasms." More recently, teacher and critic Ian Walker's books, *City Gorged with Dreams* and *So Exotic, So Homemade*, revive the argument that the meaning of Surrealism in imagery has been hijacked by the dream-like, Freudian, and manipulated, whereas it is really more about "photography that largely takes place in and around the city, where the banal and the marvellous coexist on a daily basis."

In the 1920s, a considered photograph of a Paris shop window had a certain surprise value (*Avenue des Gobelins*, 1927) for its very banality, and when I say an *Inventory* photograph I mean an image that is more than just a record, but one that holds within the frame a wealth of

undiscovered detail to examine. This is still a rich vein to explore, which favors high-resolution images and large reproduction. Interestingly, while this was once the preserve of large-format photographers with bulky equipment, digital photography has made this style of image more accessible to many more people. Not only are sensors improving in resolution, but the high megapixel count is becoming available in less expensive cameras. There may well be an element of pixel addiction in this, but it certainly makes detailed *Inventory* images more possible. In any case, very smartly designed stitching software is widely available and virtually automatic, so by shooting an overlapping series of frames of a scene—up and down, as well as from side to side—any camera can produce a very large final image.

◄ SHAKER BOX
Flat-on, the contents of this Shaker box, in neat compartments, are interestingly lit, but the composition is deliberately uninflected—just a record. This matches the plainness of the subject. This is one kind of "inventory" subject, in which we are invited to study the contents rather than admire the photography.

▲ FOUND LIGHTING, FOUND SUBJECT
This pair of shoes was untouched for the photograph; they looked like this, taken off the night before, at exactly this moment of morning sunlight entering the room. The only arrangement needed was to position the camera and crop for this framing.

▲ SHOP WINDOW
The crisp afternoon lighting gives graphic interest, but the appeal of this photograph of a shop window in Kyoto lies in what we can tell about the culture—total focus on a perfect product.

▲ UNEXPECTED ELEGANCE
A package of Japanese udon noodles, when unwrapped, revealed a surprising perfection of form. Lighting completed it: placed on a lightbox, they glowed.

Three old Chinese courtyard houses, still lived in though not in the original wealthy fashion. These are as found, unlit, with nothing moved or tidied up, and shot very plainly with a view camera, rising front and on 4x5 film. The purpose is pure record, and their appeal as images is enhanced greatly by being part of a series; they need to be seen together so that the eye can move from one to the other, making inevitable comparisons.

The elevation of the mundane has gone much further, though. Milestones on the journey toward "anything at all" in still life were Frederick Sommer's photographs of assembled chicken parts and similar, Irving Penn's series of scavenged cigarette butts in the 1970s, and Jan Groover's very domestic arrangements of kitchen utensils. So for anyone who felt a little shame in photographing very ordinary things from around the house, there is now no need. What there is need for, however, is a high degree of imagination, style, and technique to compensate for the lack of, well, meaningful content.

This still leaves the puzzle of why so many photographs of, say, fire hydrants still look like, snapshots of fire hydrants. A trawl through some of the images of these you will find online is anything but inspiring, and would encourage many people to go back to finding special subjects as a way of guaranteeing a good final result. But it doesn't have to be like that. Street furniture is still a worthwhile subject, given some pre-conditions. They are, first, originality, and second, that one way or another the audience is compelled to look at it seriously, and these apply, naturally, to all mundane subjects. It may not be possible to be completely original, but either in choice, composition, lighting, or something else, the

image has to compel. This is even more important with an ordinary subject than with one that is already special. As for presentation, it needs to be put in front of viewers in such a way that they do not pass over it because they know what it is and are not interested. An exquisitely interesting treatment may or may not be sufficient for this. It may need extra help.

Let's put this to the test: What made Irving Penn's studio photographs of street detritus compelling and memorable? To start with, they were original, in that no-one (that anyone remembers) had chosen used cigarette butts swept up from the street before. In addition, he brought his considerable skills as a photographer fully to bear on them in the studio, as if they had been an expensive item of jewelry. They were also presented to an audience who paid full attention to them, partly because of his name and reputation, and partly because they were printed in a special way—platinum prints and very large.

So what lessons can we learn from this? First, Penn was truly beyond his time, but that was a long time ago and simply choosing the equivalent of cigarette butts isn't going to cut anything anymore, as the barriers of acceptability have been breached already. Treatment is the key, made all the more important by the banality of

the subject matter. Here, we are in the land of style, which is the theme for the second part of this book. Any of the approaches and methods featured there are potentially applicable here, and I mentioned one already—the full studio beauty treatment. Another might be a reprise of the abstraction approach of the Fotoform movement. There are many stylistic possibilities, and while much of this falls under the heading of "still life," that does not mean that it has to be studio-based and under tight control. For example, the work of British photographer Martin Parr, best known for his (usually) close-up images of the trashy British vacation experience, is most often lit unflatteringly by flash and points the way to more of a reportage approach.

Finally, presentation is important, and this is a theme I will keep returning to. If you photograph for an audience—and almost all photographers do—how the work gets seen makes a great difference to its effect on a viewer. The possibilities here have been expanded greatly with the development of relatively inexpensive large-format printing, and web-based shows.

◄ McDRINK
Read what you like into it—untidiness, littering, unintended humor or McCulture—this urban detail of graffiti and an abandoned fast-food drink had an obvious unintended humor.

WEB SEARCH
- Edward Weston toilet
- Objet Trouvé Surrealist photograph
- Atget *Avenue des Gobelins*
- Frederick Sommer chicken
- Jan Groover
- Irving Penn cigarette butts
- Fotoform Otto Steinert
- Martin Parr

▼ FOUND ART
The Icelandic farmers who bale their hay in plastic awaiting collection by tractor certainly have no esthetic intentions, but the result is striking and appealing, particularly when treated as a panorama.

THE REVEAL

There's a time and a place for being clear, which is something that photography does brilliantly. It may even be what is wanted most of the time, as in spot news and in any situation where the priority is making a record. Almost all one-line advice on photography, including "move in close," "use a plain background," and "use flash outdoors" (these are from Kodak's Top Ten Tips on their consumer website), is premised on the need to show as much as possible—the characteristic view, in other words. Looking back at our investigations of cliché, you can see that in many scenes and subjects, the idea of an optimal viewpoint and optimal lighting includes getting as much visual information as possible.

However, being obvious has a serious drawback: It's often not very interesting. The reason for this is the clearer the image reads, the less there is for the viewer to do, and as the influential art historian, Ernst Gombrich, described it, this component is the "Beholder's Share." Reading the photograph, or decoding the image, is part of the pleasure for the viewer, so surfeit of crisp, clean, perfectly lit and focused pictures can just cause the audience to lose interest. Sometimes, therefore, it pays to give the viewer something to look for, to encourage them to stay involved.

In cinematography, the reveal is the sequence during which the audience is made aware of something just by the camera movement. It pans slowly to one side or tilts up or down, to reveal an actor or something that the audience had not expected, so changing the meaning of the shot. There is always some element of surprise, of the unexpected, and it is the director who takes charge of how this is presented to the audience. It works because of control: the audience is captive and has nowhere else to look but through the camera. The reveal is a powerful and frequently used dramatic device in cinema, and it relies simply on being able to manage exactly where and for how long the audience will look. The only choice we have is *not* to look (as some people do when the suspense is too great), not *where* to look.

◄▼ **LOOKING BEHIND**
A modern Japanese office in metal and sandblasted glass. Choosing this viewpoint was deliberate in wanting to show, architecturally and prominently, the materials being used. By partly obscuring the table and chairs behind the glass, the viewer is made to want to look behind at the rest, and as the foreground is obviously glass, to pull the two sliding doors apart.

This is all possible because a movie is linear, but what if we could make a still photograph work like this? So the viewer approaches it, looks for a while, then starts to notice there is more to the image than first thought, finally noticing something that was not obvious at first glance. Wouldn't a photograph constructed that way be more interesting and more memorable? One of the most famous sequences that combine cinematography and still photography to reveal a surprise is in Antonioni's *Blow-Up*, the moment when the photographer, played by David Hemmings, makes successive enlargements of a negative that he shot in a park to discover, hidden among the bushes, evidence of a murder, something he and we (the audience) hadn't seen at the time.

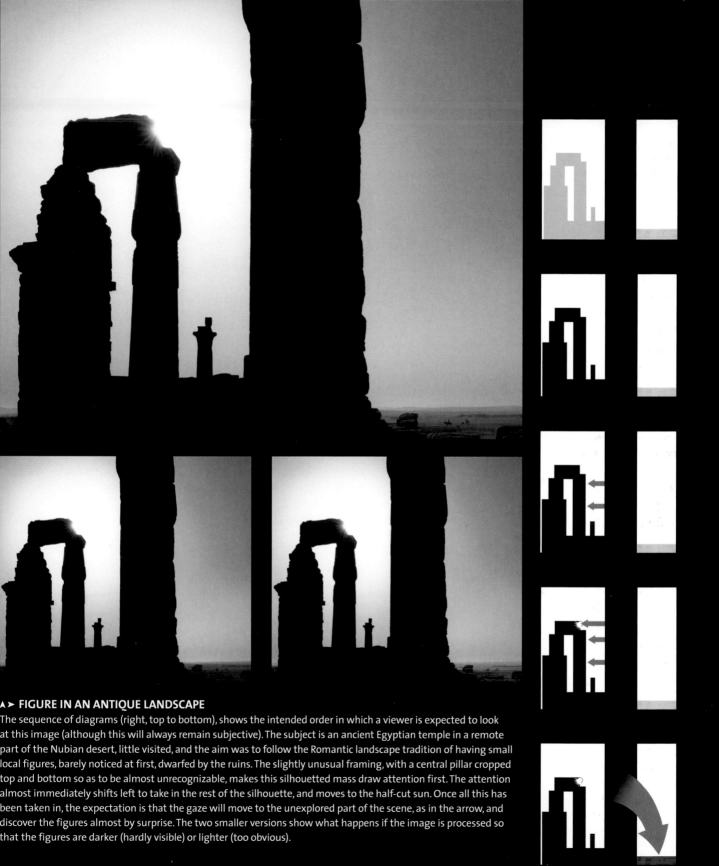

◤➤ FIGURE IN AN ANTIQUE LANDSCAPE

The sequence of diagrams (right, top to bottom), shows the intended order in which a viewer is expected to look at this image (although this will always remain subjective). The subject is an ancient Egyptian temple in a remote part of the Nubian desert, little visited, and the aim was to follow the Romantic landscape tradition of having small local figures, barely noticed at first, dwarfed by the ruins. The slightly unusual framing, with a central pillar cropped top and bottom so as to be almost unrecognizable, makes this silhouetted mass draw attention first. The attention almost immediately shifts left to take in the rest of the silhouette, and moves to the half-cut sun. Once all this has been taken in, the expectation is that the gaze will move to the unexplored part of the scene, as in the arrow, and discover the figures almost by surprise. The two smaller versions show what happens if the image is processed so that the figures are darker (hardly visible) or lighter (too obvious).

The practical issues of the reveal were brought home to me on a shoot in Burma, during the making of the film *Samsara*. We were in Mandalay, and driving through the city on our way to one location, when the director, Ron Fricke, spotted a huge marble Buddha being worked on in a side street. We stopped and Ron decided to delay the planned shoot and concentrate on this instead.

The point of the shot was the surprise of coming across a very large statue being carved and polished in the middle of that kind of rustic-urban chaos that used to be so common all over tropical Asia — hot, dusty open-air life. The way to handle it, as Ron explained, was some kind of reveal, so that the audience become aware of what the statue is only at the end of the shot. Some Burmese women were polishing it, and the shot would start close up on one of them, slowly revealing what she was doing. As all this was going on, I wondered if the sense of a reveal was possible under these circumstances in a still photograph. The answer: not really, but I played around with the options nevertheless. The problem in this particular case is that the subject is visually commanding, not least because of its brightness. Varied processing makes some subtle changes to its prominence, but weakening qualities like contrast and clarity does the head of the Buddha no favors. I include it here as a starting point for our investigation, and not as a successful example.

⌄ ➤ BUDDHA IN THE STREET

This situation is fully described above. Although not entirely successful as a reveal, the camera was angled deliberately for two reasons: to be able to place the Buddha's head right in the corner without also having uninteresting sky elsewhere and to introduce dynamics that would take the eye away from the Buddha to the street. Inevitably, the eye will come back to the head, but other means of temporary distraction were timing the shot for passing interest in the street, and adjusting the processing to vary the contrast in the head (less contrast gives less definition to the white marble features, and so attracts a little less immediate attention).

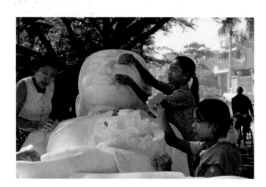

▲ SCENE SETTING

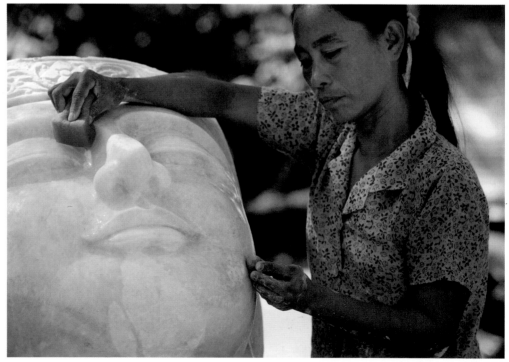

▲ BEGINNING

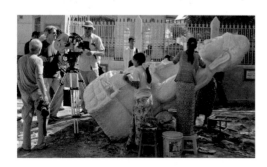

▲ FILMING

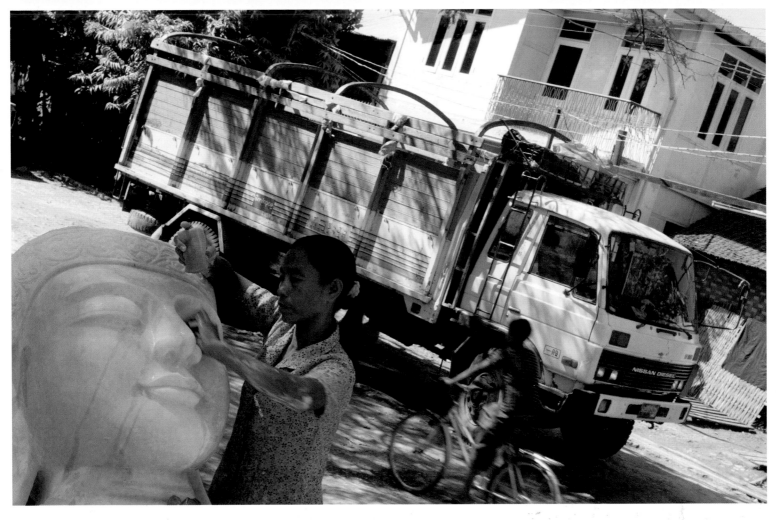

▲ FINAL FRAMING

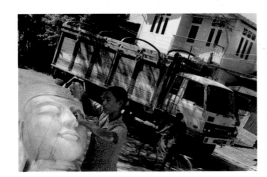

▲ BEFORE MANIPULATION

▲ ALTERNATIVE COMPOSITION #1

▲ ALTERNATIVE COMPOSITION #2

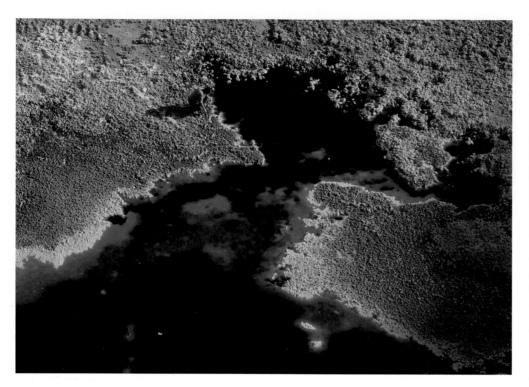

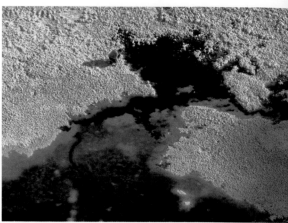

◄ ▲ A QUESTION OF SCALE
A geologist inspects toxic scalings in an abandoned open-pit gold mine. The colors are clearly of interest and this overhead view gives strong abstract graphic possibilities. In fact, a figure is needed to give scale if the shot is to be documentary, as intended; otherwise it becomes a scale-less exercise in abstraction, which in this instance was not wanted. Some slight surprise at the scale was wanted, and this meant inducing a slight delay in recognizing the figure. For this reason, the man was positioned close to the upper edge rather than more isolated; the eye would naturally be drawn to the strong color contrast lower in the frame. For comparison, see how the reveal works in black and white: on the one hand there is no color to draw the eye to the lower middle, on the other, the figure is less immediately recognizable as a person in monochrome.

The problem with a photographic reveal is two-fold. First, to delay the viewers' reading of the photograph, while not losing them entirely, and second, to direct their attention to the right point in the image. Common to both is that the subject being revealed nearly always has to be small within the frame. Painting has some useful examples, particularly because so much subtle control is possible in a constructed image. Both *The Sermon on the Mount* by Claude Lorrain (c. 1656) and *The Martyrdom of Saint Catherine*, probably by the Antwerp painter Matthys Cock (c. 1540) are essentially landscapes, but embedded in each is the action of the title and the subject.

In Lorrain's painting, held at The Frick Collection, New York, the striking features are its size; a large, dark mass dominating the scene; that the subject of the title is nowhere to be obviously seen; and the foreground is taken up with spectators of something. The diminishing perspective of the spectators on the grass, the distribution of brightness (brightest in the corner), and their gaze, all lead the eye to where it

would not immediately go—the top of the dark hill under the trees. And there is Christ giving his sermon.

Similar techniques are at work in *The Martyrdom of Saint Catherine* held by the NGA, Washington, though it is not as large a work and the subject of Saint Catherine being tortured is even smaller in the scene. The brighter foreground and darker distance encourage the eye to start in the foreground, with the additional distraction of a seaside town, ships, and prominent rocky crags off to one side. Ultimately, though, the diagonals, the horizon line, and a violent storm lead the eye to where the action is. Important in both pictures is that the titles give us a clue to keep looking.

So how can we translate this into photography? Well, both use tonal range to try and start the viewer in a particular place (brighter) that is away from the final subject. Both use familiar compositional devices to lead the eye—eye-lines, diminishing perspective, and converging diagonals. One places the subject very

eccentrically, the other keeps its contrast low. And they both have "captions" (titles) that tell us what to look for. All this is possible in a photograph, but without the opportunity to construct things so carefully. Photography has to be more opportunistic and simply take advantage of the situation when it looks promising. On the plus side, if you are aware of the techniques that work, you can take advantage of these instantly with a photograph. Processing, particularly of a Raw file, allows a huge range of additional interpretation, including opportunities to adjust the range of brightness, saturation, contrast, and more. Within the realities of the scene captured, you can shade any of these image qualities to direct attention.

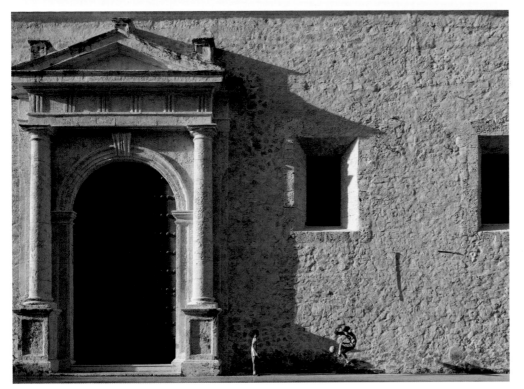

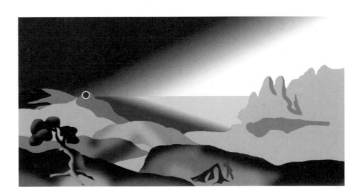

⋏➤ CONFLICT OF SUBJECT

Two boys play football against the façade of a colonial cathedral in Cartagena, Colombia. This was an organized shot for a Sony promotion, so I could choose the location and direct. The image, intended to be run large, deliberately uses a dominant setting to catch the eye first, then hope that the attention will move to the boys. It is a variation on the "figure in a landscape" shot. The three diagrams show the intended sequence of viewing and attention: first the massive doorway, then the eye shifts right to the two dark rectangles of windows, then finally down to the small figures. High-contrast raking lighting was important.

⋎ THE SERMON ON THE MOUNT

This diagramatic representation of the original painting by Claude Lorrain described in the text is an archetype of the slow reveal in classical painting.

➤ THE MARTYDOM OF SAINT CATHERINE

This diagramatic representation of the original painting shows the figures in the lower center of the frame as very small in proportion to the larger view, with the red dot indicating the point where the viewer's eyes would naturally be drawn at first glance, before exploring the whole frame.

WAYS TO DELAY AND REVEAL

- **Picture within a picture:** Possible, for example, as a small frame within the larger frame of the photograph, as in the view through a window when that window is part of a larger composition.
- Small subject within a larger but already coherent setting, as with "distant figure" kinds of image. Large presentation can help, as can a panorama. See the references to the painters Claude Lorrain and Matthys Cock on pages 70-71.
- **Eccentric placement:** Off-center positions tend to be noticed later, and this is even more exaggerated with a long panorama.
- "Point" to the subject using such known compositional devices as an implied line, shaft of light or eye-line that acts as a vector.
- Processing that favors one part of the image over another, to direct the viewer's attention: altering brightness, contrast, saturation, and so on.
- **Add a caption:** If this contradicts the viewer's first impression it might encourage a closer look.
- **A sequence:** This is less predictably successful than you might think, and the problem is the widespread feeling in photography in general that using a series of images to make a point is something of a cop-out, that a single image ought to be able to do the job. Audiences were introduced to the idea of sequences by picture magazines. One of the earliest was the British *Weekly Illustrated* in the 1930s under the editorship of the Hungarian Stefan Lorant, who went on to found the influential *Picture Post*. Perhaps the most famous example was the picture spread on Mussolini, photographed by Felix Man and run in 1934, in which an establishing shot of the Italian dictator's huge office in the Palazzo Venetia is followed by a time-sequence of close-ups of him at his desk. But design and layout play such a crucial part that few photographers have been able to make it work consistently. One of the best known who has is Duane Michals.
- **Time-based presentation:** With this, you can order a sequence of images that builds in the way you choose. Or with a single image, a slow zoom or a slow pan can be almost exactly the equivalent of a reveal in the movies. But you could argue that at this point the still image has become a moving one.

◀▲ CONTROL BY LIGHTING

A Spitfire cockpit containing the pilot's goggles and logbook. This is a historical documentary shot, but to give graphic interest I decided to make everything less obvious at first glance by breaking up the components with light and shadow. The diagrams (left) show the design process. Reflections in the goggles of the single softbox studio light, and their fairly central position, make them the focus of the composition. Next, light on the cracked cockpit glass and on a page of the logbook create balancing elements with the goggles in a triangular arrangement. But also, their corner positions pull the attention outwards, top left and bottom left. Finally, the shadows themselves have a dividing effect. The aim of all this is to slow down the view.

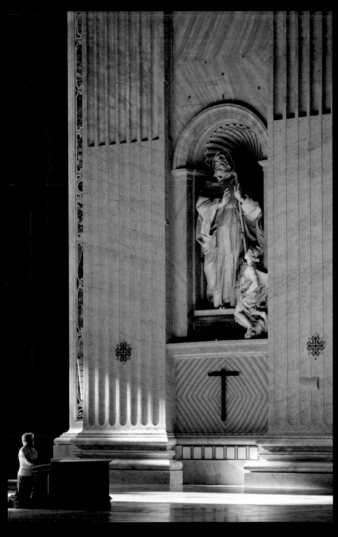

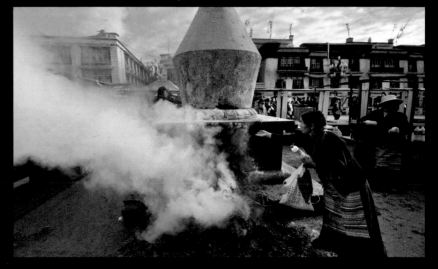

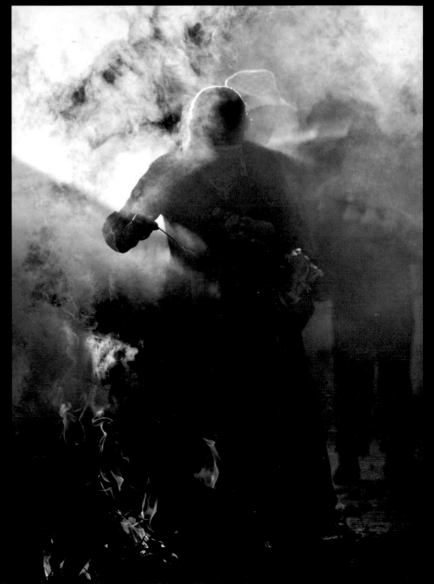

▲ THE EFFECT OF LIGHT ON ATTENTION

The way that the light falls in this view of the interior of the Basilica of St Peter's, Rome clearly draws the attention downwards. That the kneeling figure is both sunlit and outlined against the darkness behind increases its visual prominence, and makes it possible to place it in the extreme corner—and still have it register. In any normal viewing, the statue draws attention first, the kneeling woman second.

➤▲ MORE ATMOSPHERE, LESS OBVIOUS

The chosen shot from a sequence of Tibetan pilgrims making burnt offerings is deliberately obscure in detail, preferring atmosphere and some mystery about what is going on. The smaller wide-angle image (above right) explains all, but is less interesting.

Practically, the relatively subtle techniques for delaying and shifting attention belong under the heading of composition, and we'll be looking at these in more detail in the next chapter. Initially, though, they belong to the motivation behind the picture in the first place. In addition, the image has to be large enough when seen to be able to read the detail, so the more of the field of view it fills, generally the better. Judging how "hidden" the small subject is on first view is critical: too subtle or too small and the danger is that the viewer won't "get it" and will just move on. If there had been more research done on eye-tracking we might have a more precise idea of how attention moves across an image, but commonsense says that the eye notices large-scale shapes and contrast first, and then looks around for detail, assuming, of course, it seems interesting and worthwhile. Finally, when it comes to presentation, web-based displays also offer opportunities for showing an image, or several, in a linear way, such as panning and zooming over a still image, or dissolving from one to another.

Attempting to lead the viewer's eye and attention is just one strategy for making the experience of a photograph more interesting and less immediately obvious. Others involve aiming away from the obvious and focusing on clues—a shadow, perhaps, or a part of the larger subject so that the viewer can work out what the rest might be. Anything or any condition that partially obscures the subject can also, if it has just the right balance of information and visual interest, do the job of giving the viewer more to do, and therefore more to engage in with the image. The smoke-filled image shown here is one example, while the whole subject of treating things stylistically through a veil appears in the following chapter.

Yet others rely on shooting slightly off-target, or at some aspect that in a way "reflects" the main topic. This might even be literally off-target in some cases, such as shooting the reactions of spectators rather than the spectacle or, more

likely, in addition to the spectacle, and then deciding which makes the more effective image. Less literally, it includes looking for "traces" of the real subject that intrigue by not explaining themselves immediately. The cancer ward masks shown opposite are a working example of this.

The need for further explanation, like the hiding of a small, important subject in a reveal, involves some practical decisions. One of them is that, in pulling back from direct and obvious "bull's-eye" shooting toward something more ambiguous, at some point we hit the caption barrier. Captions divide photographers; some appreciate them as companions for their pictures, others think they distract. Some even despise them as crutches for what they believe are failings in the image itself. Harold Evans, former editor of *The Sunday Times* and *The Times*, in his classic book *Pictures on a Page* (1978), wrote, "Photographers and art editors tend to be snooty about headlines and captions" and called for "a necessary antidote to the idea that words pollute pictures. This is a piece of intellectual debris from the early idea that photography was art or it was nothing." Evans was adamant that the necessity of a caption did not mean that a photograph was inferior. "The wordless picture story may have an esthetic rigor, but words can enhance both emotional and cognitive values." With some photographs it is simply unreasonable to expect a viewer to get the entire point that the photographer is making, and a caption can nudge their attention in the right direction.

▲ PARING DOWN TO THE DETAIL
Stones and yak skulls all carved with a Tibetan sacred mantra at a stop on a pilgrimage circuit. In fact, each of the three images works perfectly well, but the reason for closing in (they are shown in sequence) was the shape of the shadow. Seen in extreme close-up, it is difficult, though not impossible, to work out what is casting it. This again is an attempt to attract attention through ambiguity.

THE PHOTOGRAPHER'S MIND

◄ ▲ CANCER WARD

This was an assignment situation, meaning a shot was needed whatever the circumstances. The location was a cancer ward in Hong Kong, and the reportage way to go was to concentrate on the people and their families, and their expressions and actions. There are two images here using this approach.

But I found this unsatisfying somehow, and uncomfortable: what do these occasions tell us that we don't already know? Probably some more telling moment would come from spending longer.

Then I saw an arcane little tableau—the acrylic positioning masks with targets used for precisely applying radiotherapy. This was how they were kept, no artful arrangement, and the openings for the mouth area look like—pain? I don't know, maybe that's too obvious and cheap, but being oblique served the cancer ward assignment better for me.

▲ UNSAVORY DETAIL DELAYED

The subject is the aftermath of a fatal car crash, with the body of the driver being removed from the vehicle. A lot of images were shot, from varying angles, because it was obvious that any fully recognizable view of the body would be unacceptable. Most images, including this one, used rear-curtain flash, which mixed motion streaking with sharp detail. In the end, this shot was chosen for publication because all the action is there, yet the victim becomes obvious only slowly. First, the attention is drawn to the raised hand (why is it closed and being held at the wrist?), and the oddness of this draws attention in the direction of the arrow, making it clear at last. Some dodging and burning was done.

CHAPTER 2
STYLE

More now than ever before, many photographers feel the need to put their own personal stamp on their imagery. Naturally, this depends on character (some people prize individuality while others just want to satisfy themselves by becoming more skilled), but photography has gone beyond a simple surge in popularity to become a near-universal activity. For many, understanding imagery is the new literacy and, if you already know the vocabulary and grammar of putting images together, the next step is to develop a style.

The trouble is that basic education hasn't yet caught up with the fact that most people use a camera throughout their lives, and making images is hardly taught, let alone what I'm trying to do here, which is to look at different styles and show what goes into creating them.

This has very little to do with how a camera or software works, but a great deal to do with how we see things in front of us and how we frame and compose them.

This book, and this section in particular, takes up where *The Photographer's Eye* left off, to look at the different ways of using the many techniques of composition. At this point, I include in composition the effects of lens, timing, and lighting, because they all combine to create a particular style of image. Ultimately, a style is personal and identifiable, but nevertheless tends to fit into one or another grouping. This gets much less attention in photography than it does in painting and other visual arts, and I'm doing my bit to redress that here by laying out the main range of styles in contemporary photography. Some of them are more self-conscious than others

and have more of a manifesto behind them, particularly those that follow post-modernism, which I've grouped together under *Low Graphic Style*. In the arts there is some antagonism between modernism and post-modernism, and one result that to me seems less than useful is the tendency to identify with one camp and reject everything from the other. Unless you have strong feelings about the philosophy behind a style, why not take from all of them as and when it suits you? None of them has been appropriated and fenced off, and we can all, if we want, join in. Nor is there any law that says one photographer can commit to only one style. Why not experiment? Why not follow different strands? Many well-known names from photography's history did.

THE RANGE OF EXPRESSION

Style in photography moves faster than in most other fields, which is one of the themes running through this book, but it is also notoriously difficult to pin down, though temptingly easy to make vague comments about. The most usual way of defining "style" is by listing photographers who seem to have something in common, and letting the viewer work it out. This may be fine for a casual visit to a gallery show, but for people who want to practice photography and put the lessons to use, we really need to dissect styles in detail. What are the actual devices, strategies, and techniques that go together to create a way of composing or a method of lighting? We ought to delve into the nitty-gritty of putting images together and I remain surprised that this is rarely done. The hardware and the software of photography is treated endlessly on the web and in books, but for some reason there seems a strange reluctance to look at the actual imagery in the same way.

First, let's be clear about what style is. Style is an identifiable, personalized way of doing things, and as we're dealing with photography, it results from the many specific choices a photographer makes in composition, focal length, timing, and lighting. These are what we have to work with, and the reasons why we may divide the frame in such a way, place a main subject just there, or wait for a certain quality of light. These, in turn, come directly from our personal tastes and interests. This is why it sometimes takes a while for a style to develop, because at the start you might simply want to explore all the possibilities in photography, and not yet have any fixed ideas about how images ought to look.

It's also important to remember that style in photography differs from other visual arts in that it depends on opportunity. As almost all photography (except for some kinds of constructed and manipulated imagery) has to take from real life, it does not always offer room to maneuver. If the nature of the subject or the way you can approach it is restricted in some way, then there just will not be much opportunity to shoot it in your own, worked-out way. The photograph here, of a rhinoceros, is just such an example. As is usual in wildlife sanctuaries, access is by vehicle only, so the camera position is restricted, and as the vehicle follows a circuit, the photographic opportunities are limited. What's left in a situation like this is the choice of focal length and framing, and timing. Of course, some photographers who have a determined and very strong style just wouldn't be interested in taking the tour in the first place, and choosing not to bother with a subject or scene is just as important in maintaining a style as is searching out preferred subjects.

Style can be conscious and deliberately formed, for example the low graphic style of New Topographics, New Color, and the Düsseldorf school, but it can also be the result of innate tendency, where photographers simply follow effects that they like as they come across them, such as a drift towards intense colors and contrasts. Depending on how wide you want to cast the net, there are probably a few dozen identifiable styles in regular use today, but the way I've chosen to present the range of style here is to make basic groupings.

The baseline, as it were, is classical composition, and contemporary tendencies fan out from this. They push outward from the predictable in three general trends: toward extreme arrangements; toward a deliberately plain, deadpan style; and toward what looks like chaos, but which is in fact cleverly managed. In painting, specialist and teacher in the psychology of art, Rudolf Arnheim, believed that Classicism tends toward simplicity, symmetry, normality, and reduction of tension, while Expressionism heightens the irregular, the asymmetric, the unusual, and the complex, and strives for the increase of tension. We wouldn't use the term "expressionism" now in photography, but the two directions are still valid. From classical, style can go in one direction toward reduction and more simplicity, and in another toward asymmetry and even, as we'll see, managed chaos.

Classical composition is the style that uses widely accepted conventions of framing, placement, balance, division, and so on, and it has proved remarkably resilient over decades of photography. In turn, many of its features are inherited directly from painting, giving it a legacy of centuries. Ideas that crop up constantly are harmony, rightness, satisfying balance, and order. These are all fairly conservative notions, and what ties them together is that they have a wide acceptance with most people. There has to be a reason for this, and also for the long success of classical methods, and it lies in the way we perceive—in the hard-wiring of our visual system, if you like.

⋏ ➤ LIMITED OPPORTUNITY
With the viewpoint and occasion fixed, and the subject very distinct, this Indian one-horned rhinoceros in a national park in Assam gave very few options for stylistic choice. The framing could be wider to show the setting, or vertical, but the main variable was the exact timing of the photograph. Even this depended on what the animal chose to do in the 12 minutes that it was in view. The smaller sequence shows some of these possibilities.

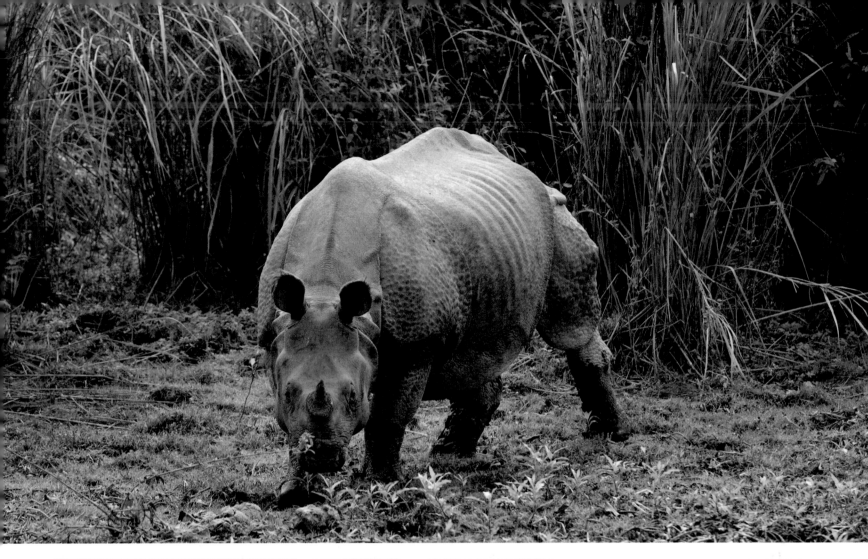

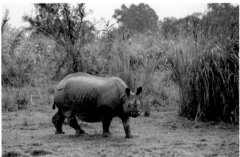

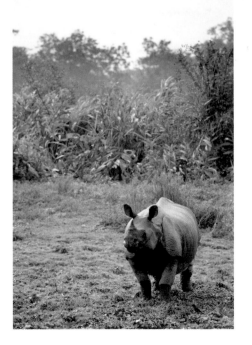

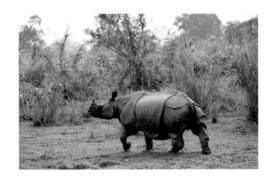

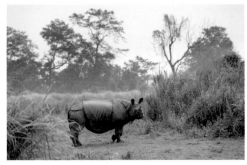

◄ **EXTENDED OPPORTUNITY**

Even from the limited amount of information in this image, which makes its subject out of light, mist, and a forest path, we can imagine that there are countless other ways of treating the early morning scene, some more descriptive, others less so. Here, the fact there is no obvious object to draw the attention frees the photographer to play with other image qualities, in this case flare and tone.

WAYS OF SEEING—AN EARLY VIEW

The photographer and teacher László Moholy-Nagy, writing in the 1920s, predicted eight ways of approaching a subject photographically. While not styles, these ways of seeing set the stage, and were the first serious attempt to clarify what was special and what was possible photographically, as opposed to in other visual arts. They were:

Abstract seeing: Direct recording without a camera or lens (such as a photogram).
Exact seeing: Reportage.
Rapid seeing: Freezing fast movement.
Slow seeing: Slow-motion blur and time exposures.
Intensified seeing: Photomicrography, filters, infrared.
Penetrative seeing: X-rays.
Simultaneous seeing: Montage and multiple exposure.
Distorted seeing: Optical distortion and post-processing manipulation.

Research in neurobiology is now providing answers as to why we have particular likes and dislikes to do with images, and much of this relates to our hard-wired visual system. For instance, it is now known that images from the optic nerve are processed by two systems in the brain, called by Harvard neurobiologist, Margaret Livingstone, the What and the Where systems. The differences in the visual information that each extracts (color only in the What system, for example, and more sensitivity to brightness differences in the Where system) accounts for such effects as vibration when we look at contrasting colors that have the same luminance. They are also responsible for certain image attributes—such as large-scale differences in brightness—being more obvious when we look slightly away from them.

Another hard-wired effect is that at the first level of processing signals from the retina, we are especially sensitive to differences of brightness across an edge. This is due to so-called center/surround cells, which respond more to sharp edges in hard lighting than to the soft edges from diffuse lighting. Yet another effect is color opponency, in which we perceive colors as pairs that tend to cancel each other out—the foundation of what we think of as color harmony. The following series if images is all rooted in the way the human visual system works, and is the most obvious example of what, without thinking, we expect to see in an image. And expectation, of course, often becomes preference.

An element with a clear continuous edge sitting within the frame is a subject; all else is background.

Brighter areas at the top of the picture.

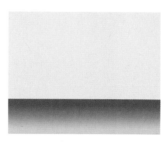

Light comes from above.

In outdoor scenes, foregrounds are darker and backgrounds are brighter.

A sense of gravity operates in a frame, pulling elements slightly downwards.

A low horizontal line or edge is a base.

Edges and lines that are nearly horizontal or vertical are seen to be horizontal or vertical.

Main subject of interest is sharply focused.

Main subject of interest is near the center of the frame.

Pairs of colors go well together when they are complementary.

Bright colors proportionately smaller than dark colors.

Elements that are similar in color go well together and seem unified.

► HARD-WIRED HARMONY

Red and blue-green are perceived as a harmonious pair because of the way the human vision system works. Stare at an area of just one of these for several seconds, then shift your gaze to a blank white area, and you will see an after-image in the complementary hue. This is known as successive contrast, and was discovered in the 1820s by a French chemist, Chevreul.

Not only this, but together in the same image, they are seen to reinforce each other in strength, as do the red and green hue. This is known as simultaneous contrast.

▼ ► HARMONIOUS COLOR PAIRS

Complementary hues such as red and green sit opposite each other on the color wheel. Each hue reinforces the strength of the other, creating harmony and balance within an image.

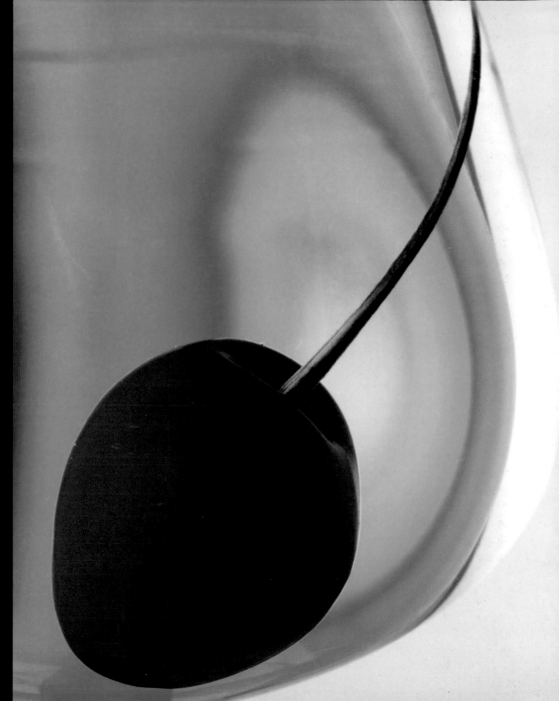

Unconsciously, therefore, we look for harmony and balance, and find this comfortable to look at. By now, most of the ways of creating comfortable visual experience are known, and include techniques such as assigning the proportion between figure and ground based on their relative contrast, or setting one color against its complementary, or dividing the frame according to some harmonic relationship. But here is the danger point.

Doing all of these things may well satisfy our perception, but comfortable is not usually interesting. Art, whether in photography or some other medium, does not aim simply to satisfy our sense of harmony and proportion: The eye and mind need stimulation. We like to be surprised, to be shown new things, to be given something to think about. Neurobiology can explain quite a bit about preferences for certain kinds of framing, placement, and the other elements that go into composition, but what attracts our attention and keeps us on the edge is actually the opposite.

This crystallizes when we look at balance. Our sense of balance, and our liking for it, is deep-rooted and capable of provoking physiological and psychological reactions. As such, it has become commonplace to say that images need to be balanced, and if they are not well-organized there remains some sense of dissatisfaction. The ideal should be to balance elements in the frame. Most simple advice on balance in composition leaves the impression that this solves the problem, yet most of us know intuitively that while perfect balance might be calm and soothing, it can also be boring. A brief look at any good photograph, or at any great work of art, shows that the balance is not formulaic, but that it contains surprises and nuances that are simply not in the instructions for "composing by numbers." We therefore need to stay aware of two competing tendencies in composition—balancing for equilibrium, and disruption to jolt the awareness. They can, some would argue should, coexist perfectly well in the hands of an artist or photographer who can... well, balance the two.

▲ THE UNEXPECTED

What attracts in this image is the unexpected presence, and alignment, of blocks of color—in other words, the unusually precise graphic geometry in an everyday scene. Women whitewashing a house in northern Sudan make a slightly exotic subject for most people, but it is that arrangement of the elements that catches the eye. A less design-conscious treatment would have been closer with a wider angle of lens, concentrating on the actions rather than the formal arrangement.

◄▲ BALANCE AND SURPRISE
The balance in this street shot comes from a classic division of the frame that fits the Golden Section, while the element of surprise is the disconnect caused by shooting partly into the glass at left, which refracts and reflects to show an apparently different slice of the scene. The activity across the frame also serves to energize the attention so the eye does not easily settle in any one place.

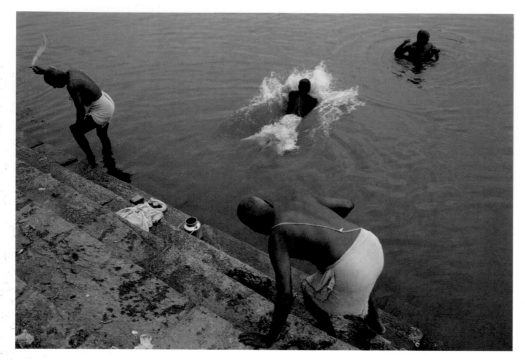

Just as Gombrich in 1959 came up with the idea of "the beholder's share"—that the viewer gets most enjoyment from a work of art when he or she has to complete it by becoming involved in it—so modern information theory (Jürgen Schmidhuber, 2007) shows that the eye and mind like to solve visual problems such as discovering the elements of a particular composition, or seeing the way a photographer has created a tonal structure for an image. When these turn out, in the viewer's eye, to be concise or "neat" solutions, there is an internal reward, sometimes called a curiosity reward. In the jargon of this kind of analysis, neatness means "compactly encodable." In other words, it's the appreciation of economy in an image that contributes to our feeling that it looks good.

That there are, or should be, two conflicting tendencies at work together in composition is an essential point that often gets missed. The tendency toward stability and resolving tensions is the craft element; the one more easily taught and learned. The other tendency to create interest through originality, surprise, and nuance is much less easy to pin down, but often provides the edge or the spark in an image. Both can work very happily together, and have done throughout the history of art, although this calls for skill and judgment. In order to move on, keep things fresh, and surprise, all progressive photographers push outward from the established and the limits of this are now set by the audience the photographer is trying to please. If that means a wide audience, as in mainstream editorial or advertising, it can't be pushed very far, but with a niche audience, such as a sophisticated fashion readership, it can be pushed further. Photographers who care to shoot for no-one but themselves have the freedom to catch it perfectly, or be ahead of their time, or just be completely out of step, but that's a chance they take.

▲ NEAT SOLUTIONS

Organizing several units into some sort of order is a common task in composition, and well understood by anyone looking at the result with more than a passing interest. While there are few credit points for doing this in a studio where objects can and must be deliberately arranged, out on the street (or in this case on the river bank), it takes some effort, patience, and luck.

Here, the man diving into the water creates an obvious triangle that is easy to grasp as a tidy graphic solution. Nevertheless, it took anticipation and fast reaction to capture (see what it would look like in the digitally-manipulated version without the diver). The brief internal reward for the viewer of the photograph comes from recognizing the triangle as deliberate.

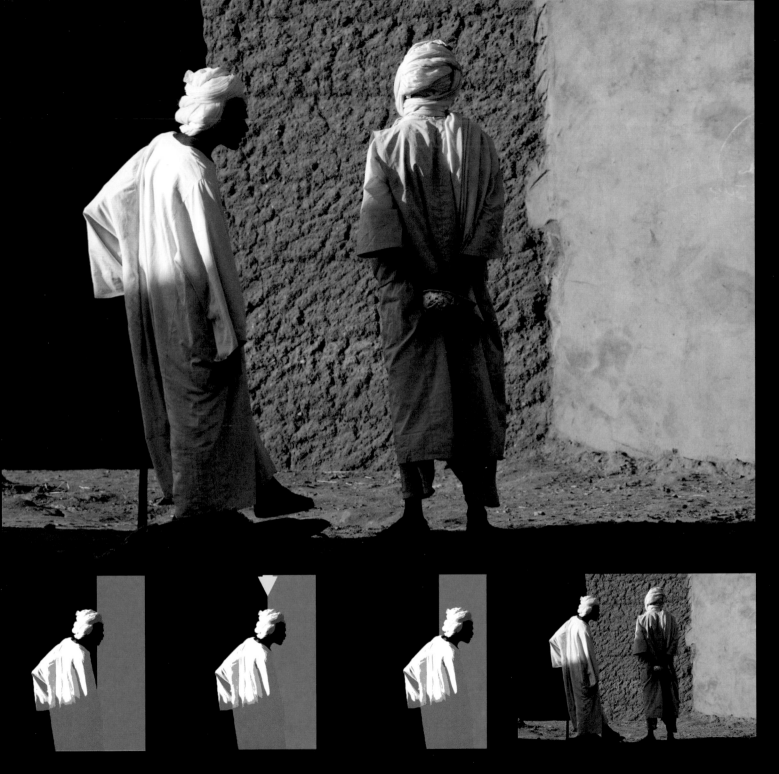

▲ NUANCE IN THE DETAIL

Within the overall composition or idea behind an image, there is usually room to polish the result by taking care over the details. These vary wildly according to the picture circumstances. Here, the composition is basically about two white-clad figures set against cleanly demarcated blocks of wall and a doorway. The two fine points were making sure that the vertical axis of the figure at the left aligns with the vertical edge of the dark doorway (a matter of stepping a little to one side), and catching the moment of the foot just hovering above its shadow. Another version (computer-manipulated just for this demonstration) shows what the result

There is an argument that photography needs to keep jolting viewers out of complacency more than other visual arts, not only because of the sheer volume and pace of delivery of photography in our lives, but also because most people take photographs themselves and so are more aware of it. But each time it does, it renews the need for more jolts. We are now so used to being surprised by inventive imagery that we expect more and more of it, and the answer is to consciously push the limits, and to experiment. Style in composition builds on experience—not so much the photographer's experience, but general acceptance. Good photographers are highly adept at experimenting successfully with composition, even if they don't put it into so many words. This is nothing new in art. In *Art and Illusion*, Gombrich describes how the painter Constable "thought, and rightly, that only experimentation can show the artist a way out of the prison of style."

Then there is the cycle of taste and fashion. There's fashion in everything, not to be lightly dismissed because it affects whether new productions are accepted or rejected. The ephemeral world of clothes, hair, and makeup (serious enough if you're making your living from it) is the most affected because the industry manufactures change deliberately, and does it regularly. Photography is not quite so febrile, yet neither is it all that far behind. The fashion in imagery changes steadily, chipped away at by individual curators, art directors, picture editors, and rising photographers who want to do something different and push aside the old. This isn't anything new—it's always been like this. Man Ray and Moholy-Nagy, for example, wanted to break out in the 1920s every bit as much as the latest crop of graduates from photography colleges want to break out from modern convention. The difference these days is that the opinion makers who accept or reject new trends in style have become less of an elite.

Until recently, there was a filter that determined what got published and what, by

extension, was considered worthy of being published, and praised. This filter was traditional publishing in traditional print media. It was taken for granted that in order to climb the ladder of acceptance as a photographer, you had to persuade someone at a print publisher, such as a magazine, to take your work. If not, you didn't really exist, at least not outside your local neighborhood. In addition, there was a hierarchy of media, with local newspapers near the bottom, rising to international publications such as *Life*, that truly had the power to create stars out of cameramen.

This power, control, and influence has never been more sharply highlighted than now, as these old-fashioned organizations decay in front of our eyes, replaced, at least in the world of photography, because of the Internet. What inhabits the Internet is democracy, or rather, disruptive democracy. Internet publishing is to all intents free, so anyone can put up a website, and they can do anything they like to attract people to it. If they do it well—through word of mouth or inventive promotion—and deliver the goods on-site, the screen-based real estate can be as successful as the website of the largest, wealthiest company. This is democratic. At the same time, it is also highly disruptive, because it changes the established order of things. Photography forums have now become a major player in judging style, and just one example is opinion about HDR.

➤ HDR STYLE CONTROVERSY
The invention of HDR (High Dynamic Range) tone-mapping techniques has made this particular way of processing images a style issue debated hotly in online forums. Originally developed as a way of solving the less-than-adequate dynamic range of digital sensors, it was taken up by many people as a way of making unusual, hyperactive imagery from otherwise ordinary material.

Here is one high-contrast landscape that was shot for HDR, but processed in three competing ways. The scene, at high altitude in Tibet, is well beyond the contrast range of the camera sensor, which has a range of a little over 12 f-stops, so it was shot as a rapid sequence of 5 frames, spaced 2 f-stops apart.

The first version is processed from just one frame and has the expected clipped highlights and deep shadows, which is quite similar to what you would expect from film.

The second version (my intended and preferred one) captures the rich modeling of the clouds and holds the landscape below, while still keeping a natural photographic look. It does this by using exposure blending (called Exposure Fusion in Photomatix).

The third version uses HDR tone mapping, deliberately exaggerating such effects as haloing, high local contrast, and over-recovery. The unrealistic effect is actively preferred by a large number of photographers, while loathed by others in equal measure.

WEB SEARCH
- László Moholy-Nagy
- New Color
- New Topograhics
- Rudolf Arnheim
- HDR
- Photomatix
- Neurobiology/Livingstone's What/Where systems
- Jürgen Schmidhuber
- Gombrich's "the beholder's share"
- Chevreul's Successive Contrast

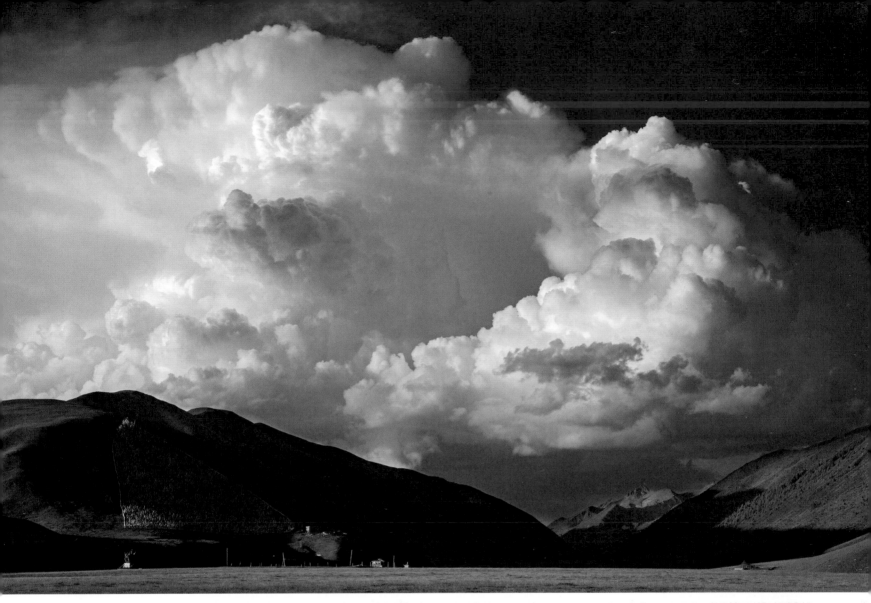

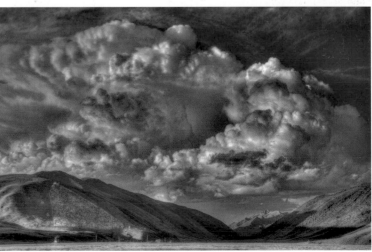

CLASSICAL BALANCE

There have always been photographers who flouted the polite recommendations of framing and composing, but in general there was a vague consensus about what worked and what didn't, what was acceptable and what was not, until around the 1960s. This was the decade in the West in which mass culture was presented with confrontation, challenge, and excitement,

and photography played its part. This was the decade of experimentation in composition, with unexpected cropping (David Bailey), extreme placement and balance (Guy Bourdin), ultra-wide angle lenses used close and from strange angles (Art Kane), rich and contrasting colors (Pete Turner), and more. We'll come to all of these in a while, but what the 1960s did in fashion, editorial,

and advertising photography was to define what had been the standards. What I'm calling classical composition (with some misuse of the word classical) became easier to understand when it was contrasted with new ideas. And because the 1960s were not really as revolutionary as they seemed to some at the time, the standards didn't go away. They are still alive and well, and being

PROPORTION DEPENDS ON CONTRAST

The most basic arrangement in photography is figure and ground: one object set against a background or setting that appears to extend beyond the frame. These are the two components here, and whether it is through tone or color (or both), the generally satisfying balance between the two is strongly affected by their contrast. As the accompanying illustrations show, the stronger the contrast between the two elements, the smaller the figure can be and still feel balanced. It doesn't matter whether the arrangement is light against dark or dark against light; if the setting is fairly consistent and extends right up to the frame edges, it is always perceived as the ground. Anything sitting within it is perceived as a figure.

➤ STRONG AND BRIGHT COLOR = SMALL
The combination of quite high tonal contrast (4:1) and very high color contrast (the lacquered box is neutral black) allows these extreme proportions to work. The area occupied by the gold clasp and orange cord is less than 6% of the picture area.

➤ HIGH TONAL CONTRAST = QUITE SMALL
Color, which reinforces the contrast in the picture of the black Japanese lacquered box, plays almost no part in this image, but the high contrast from the strong afternoon sunlight and the pale clothes (8:1) makes these the "natural" proportions—the bright areas take up 14% of the frame.

➤ MODERATE CONTRAST = NEARLY EQUAL
A porcelain skull by artist Lia Jianhua. The background tone varies, there is no color, and the brightness of the skull against its base works out to an average 4:3. The proportions work well with the skull occupying one-third of the frame.

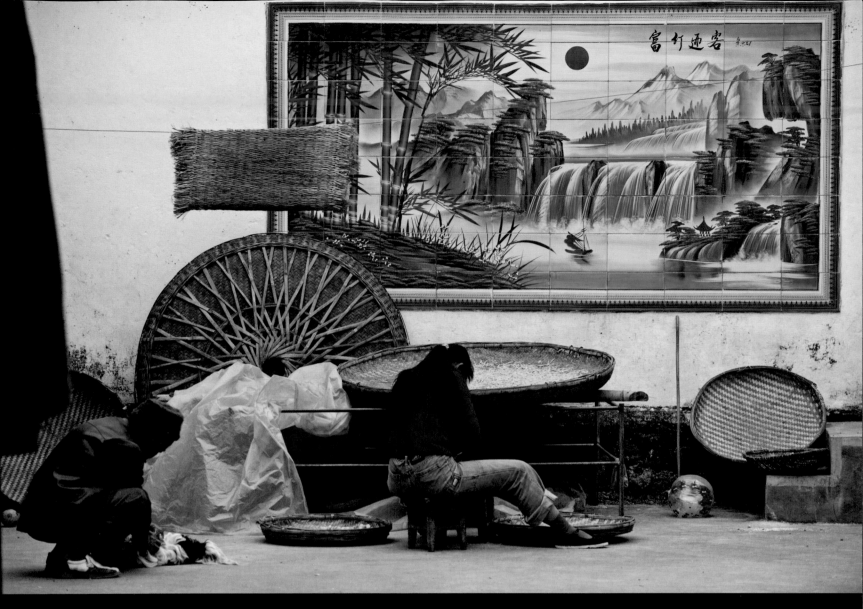

▲ ➤ SPATIAL BALANCE

In this scene, distinct areas or segments are arranged, within the limits of the few seconds available and the viewpoint, so that they are linked in some form of order. There are three groups identifiable mainly by shape, but also by subject: the rectangular picture (1), the circular trays (2), and the two people (3). The starting point is the mural, with the idea that it would be an anchor to the frame, and so aligned exactly and closely to the upper right corner. This is balanced on the left with the silhouette of some hanging material (4); the two together provide "stops" on either side, and framing like this was a matter of adjusting the zoom on the lens. The group of circular trays was as it was, and its arrangement against the mural was part of what first suggested the shot. Handling the two figures meant a combination of timing and a small adjustment of camera position so that the left figure is just within the edge created by the hanging cloth. All this had to be done within a few seconds before someone turned and looked at the camera. The underlying aim was an ordered arrangement, with everything "fitting" as much as possible—in other words, stylistically conventional.

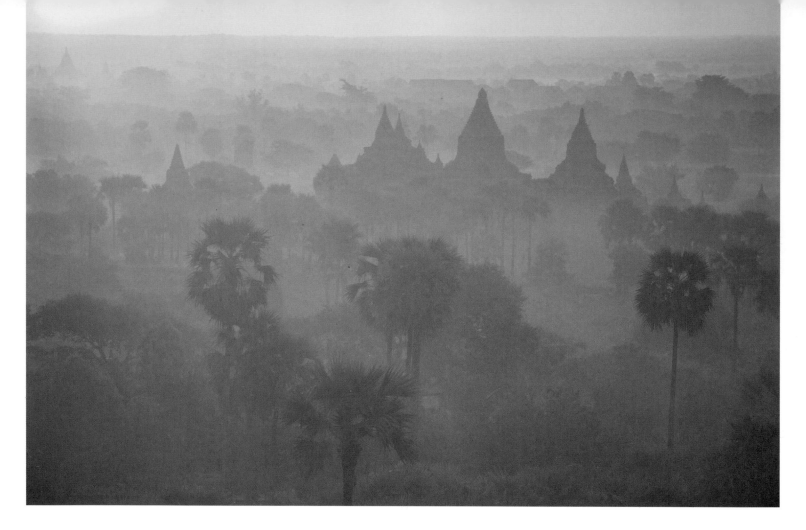

used by the majority of photographers. The main quality that they have is simply that they satisfy. They do this by triggering known reactions in most people's visual awareness.

A large part of *The Photographer's Eye* was taken up with the principles and techniques for achieving this, but here I want to explore the underpinnings. Not in a rarefied way, because composition in photography is always a practical matter, but looking at what all kinds of effective, successful composition have in common. In no way am I suggesting that there exists a sort of ideal way of composing an image; the ideas, the strategies, and the individual techniques vary as much as photography itself. But in classical composition, the common thread is organizing the image in a way that most people would think is balanced.

That sounds sensible, but balancing what exactly? The ground against the sky? A small figure against a larger setting? Foreground

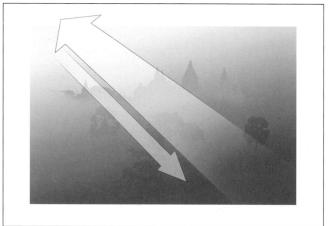

▲ BALANCE ACROSS A GRADIENT

Even when there are no sharp breaks between components, the sense of balance—or lack of it—remains. In this aerial photograph of old temples in Bagan, Myanmar, the silhouetted outlines provide the interest, but the main structure in the image is a tonal gradient. It goes upward from dark to light, which fits in with the eye's expectations of darker foreground to lighter background, and so the initial eye movement is from lower right to upper left. We assume that the scene continues this gradient beyond the picture frame. Naturally the eye returns back down the scene, and this diagonal tends to channel the interest, but the major vector is bottom right to top left.

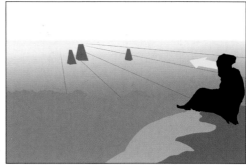

◄▲ BALANCE OF FOREGROUND AND BACKGROUND

Depth in a scene creates a natural opposition between the foreground and background, but as long as there is a clear sense of depth or different planes, we automatically sense the potential for contrast. This affects framing, placement, and relative size. Here the figure of the sadhu on a rock obviously relates to the towers of the temple in the distance. This sense of depth gives more visual weight to the two elements than if they were objects in the same plane, and the composition is organized to suit, placing the man at extreme right. That he faces into the frame also adds the extra dynamic of a vector.

colors against background colors? These and many others are the specifics of composition, and while it's necessary to look at the particular in order to do any kind of analysis, most picture situations are not that simple. Just as there are often different layers of subject in a photograph, there are usually layers of elements to be balanced. Very rarely, for example, can you find a situation in which there is just one isolated object against a uniform background, so the issue for the composition is purely one of placement. Typically, there are many things going on in an image, and different components will all influence each other. We'll see more of this in detail in *Interactive Composition* (pages 156–159), because they need to be dealt with on the spot and instantly. For now, it's enough to say that there are six kinds of component affecting balance: spatial, tonal, depth, sharpness, color, and content, and more than one of these can be at work at the same time.

▼ SHARP-UNSHARP BALANCE

Because we expect vision to be sharply focused, the eye is always drawn strongly from anything blurred toward sharp detail, and this affects the balance. Here, even though the weight of color is in the unsharp red banner, and despite the prominence of the Chinese character in white, the pull of the in-focus figures remains strong. Strong enough that they balance well, even taking up just 6% of the picture area.

◄ BALANCE OF COMPLEMENTARY COLORS

The principle of complementary colors, perceived as balancing each other, is well-researched and known to be an effect of color-opponent cells in the retinal ganglion. From what Arnheim calls the fundamental primaries (red, blue, and yellow), the complementaries are green, orange, and violet, and the pairs are seen by most people as harmonious.

The German poet J. W. von Goethe was the first to refine this balance by taking into account relative brightness, allowing more area for the darker color, as shown here. As a principle this works, but it assumes particular pure colors. Red and green, for example, are certainly not always equal in brightness. Saturation also varies, and above all, the simple description red or blue can cover a range of wavelengths.

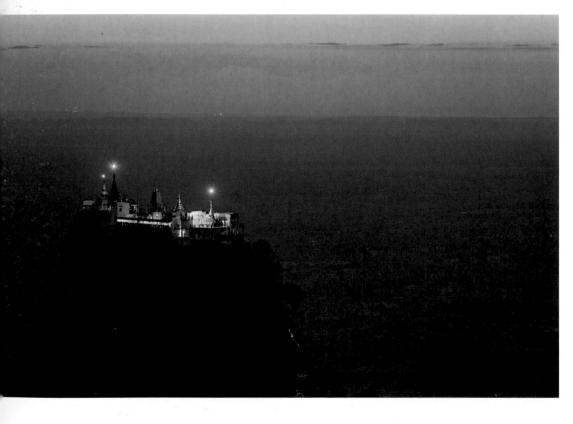

◄▲ PHOTOGRAPHY'S MOST COMMON COMPLEMENTARY PAIR

The color temperature (or white balance) scale provides a blue/orange contrast that occurs whenever the sun is low in a clear sky, and also at dusk between tungsten-lit interiors and the ambient blue outside. When the sun is at one end of the sky, so to speak, scattering in the atmosphere affects the shorter wavelengths (bluish) more than others. So, as here in a view over Mount Popa in Myanmar, the color of light that remains from this scattering is reddish, while the much weaker reflected light from the sky, which bathes the shadows, is bluish. Interestingly, the much more efficient processing now possible digitally can recover so much of the dynamic range that it preserves the richness of colors in scenes like this better than film ever could.

➤ A UNIFYING COLOR THEME

Less to do with balance of opposites than with unity, a single color that suffuses the image helps to create a different kind of harmony. In some situations, the single hue may appear as a color cast that ought to have been corrected, and this has to do with the viewer's expectations. Strictly speaking, our visual system's color constancy, which adapts for changes in the color of light and lets us see scenes as if they were neutrally lit, wants no color cast, but photographs of it are a different matter. We are now accustomed to seeing images with color themes (such as bluish scenes at dusk and orange scenes in tungsten-lit interiors), and accept them as such. Here, logic plays a part: this interior is designed to have a green theme, which makes it acceptable that the shadows on the white furnishings have a greenish tint.

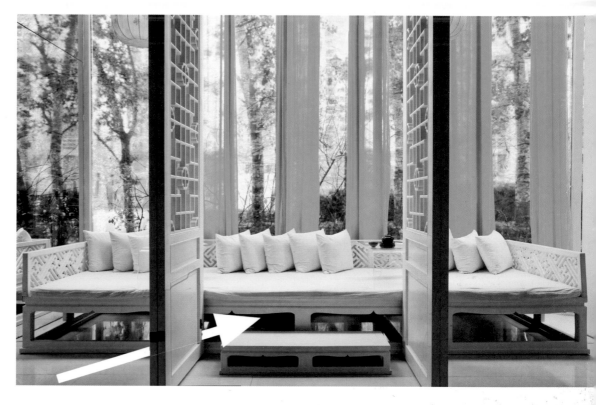

COLOR HARMONY

Color in art and photography is worth a study in itself. How we perceive it and how we prefer it involves subjective feeling as well as the neuroscience, and the psychological elements are difficult to extract from the mix. Classical theory has evolved through many different interpretations, but the concept of certain colors balancing others is well accepted. These are known as complementaries—opposed colors that, if mixed completely, would produce a neutral gray or white.

Van Gogh, who thought deeply about color, wrote about painting the four seasons in four pairs of complementary colors: red/green for spring, blue/orange for summer, yellow/violet for fall, and black/white for winter. However, as Arnheim points out, van Gogh also wrote that the red and green he used in his painting *Night Café*, 1888, expressed the "terrible passions of humanity... everywhere there is a clash and contrast of the most disparate reds and greens." Color is therefore very much open to interpretation, and also depends on the many different ways of juxtaposing hues. Prominent, intense areas set against each other have a different effect to smaller, muted patches of the same colors. And the greenish yellow that van Gogh used in *Night Café* is different to the warmer yellow of his cornfields.

Image courtesy of Yale University Art Gallery/Art Resource, NY/Scala, Florence.

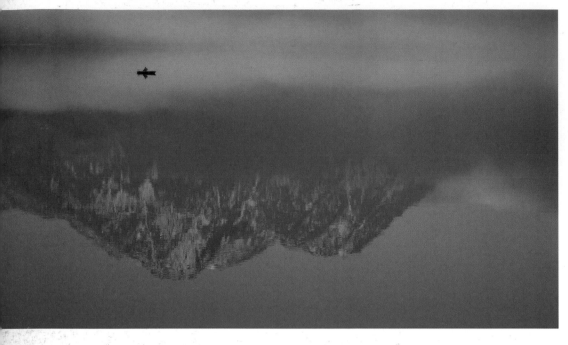

◄▲ DIVISION INTO FIGURE AND GROUND
The boat is tiny against the reflections of mountains in the still lake, but tonal contrast draws the viewer's attention to it immediately. Placing it eccentrically helps the eye to separate it from the background, which becomes an element in its own right.

Balance invokes the ideas of harmony, equilibrium, and weight, and by definition it plays to a wide audience. Later on we'll look at styles of composition that appeal to minority tastes, but the generally understood aim of classical composition is a balance that most people will appreciate. It allows for all kinds of experimentation, but if the sense of balance in a picture goes way beyond the expected—which means beyond even a pleasant surprise—then the composition has entered new territory. "New territory" does not mean wrong in any sense, just that most viewers will not accept it. Non-classical composition, as we'll soon see, is meant to be challenging, not easy, or conventional. There are reasons why a sense of balance and a need for it is widely felt, and these largely have to do with the psychology and physiology of perception. This is perhaps easiest to measure and grasp in color relationships, but the idea of a satisfying equilibrium applies to all types of balance.

In case all of this gives the impression that visual balance is simply a matter of doing the math, there is no such thing as perfect balance,

simply interpretations. Opinion counts strongly, and one photographer is likely to disagree with another on the fine points of balance in an image. An even stronger influence comes from the psychology of seeing: the eye and brain want to resolve any imbalances and actually manage to do so to a degree.

An example of this is the small single object on an empty background—basic, but relatively rare. Viewed as a single focus of attention and an empty field, composing so that the object is off-center would seem to throw the image off-balance. It doesn't, of course, as the example here shows. One explanation is that placing the subject moderately off-center brings into play harmonies of frame division, such as the Golden Section. But viewed purely in terms of balance of masses and tones, what happens is that the "empty" background is perceived as being an object in its own right. With a small object in the center of the frame, the background simply surrounds it. If the object is distinctly to one side, however, the background acquires presence. This is our visual system at work, making its own compensation.

TYPES OF BALANCE

Spatial: Discrete areas within the frame—that is, distinct segments.

Tonal: Dark and light, and gradations from one to the other.

Depth: Most photographs depict recognizable scenes from life and nature, so there is always the potential for balance along the depth axis (the z axis).

Sharpness: An entirely photographic feature from either focus blur or motion blur. The eye is drawn strongly toward sharpness, so a conventional balance needs a considerably larger area of blur to offset the sharp element.

Color: Differences in hue and saturation.

Content: What we know about events, people, and other objects in the frame influences our attention, sometimes to the exclusion of almost everything else. Recognizable things in the frame have varying visual weight. A face, for example, has a "heavier" visual weight than its area or tonal contrast would suggest.

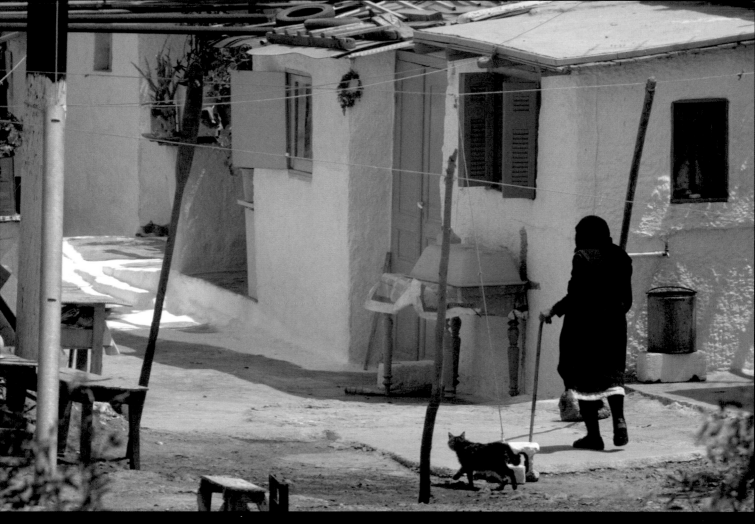

◄▲ THE INFLUENCE OF CONTENT

What we know about the subject, and how interested we are in it, affects placement and balance. A single face or a single person pulls more weight in a scene than its size would merit. In this situation, an old woman and her cat walking have a stronger pull on the attention than would anonymous black objects in the same position, and so for balance can be placed well to the right. Also, their movement introduces a strong leftward vector and we anticipate them being closer to the center of the frame; this pushes their natural place for balance

Balance in an image is typically created through opposing tensions. Total symmetry, such as a simple object dead-center in a square frame, is undeniably balanced, but in a static way that normally lacks interest. Anything asymmetrical contains a directional tension, so that, for example, an off-center placement "pulls" away from the center and wants to be resolved by an opposing tension. This is the basis of most compositional strategies, and it is the process of resolving tensions that satisfies the viewer's search for balance. In other words, effective traditional composition uses a dynamic balance rather than a static one, and removing all tensions when taking a picture—by placing subjects in the frame's center or even dispensing with obvious subjects, for example—makes for less visual interest.

As I mentioned in *The Range of Expression* (pages 78–79), there are two conflicting tendencies that we can put to good use: striving for balance, and injecting interest by provoking the sense of balance. By nature, we like to see that the components of an image are going to be resolved rather than are actually resolved. Denying this and going for static balance would, therefore, seem to be a basic error, but while that might have held some truth in the past, art in photography has caught up with even this fundamental of composition. As we'll see when we look at the low graphic style that evolved in the 1970s, dynamic balance can be rejected on formal grounds, even to the annoyance of more mainstream photographers.

▲ THE STATIC BALANCE OF PERFECT SYMMETRY
Here, the bilateral symmetry is in the subject itself—a vaulted ceiling in Westminster Abbey—and the photograph simply follows the lead. This very formal symmetry focuses on the center and does anything but encourage the eye to wander. Static does not necessarily mean dull and lifeless. It suits this subject, but is probably best used sparingly.

WEB SEARCH
• David Bailey
• Guy Bourdin
• Art Kane
• Pete Turner
• Complementary colors
• Van Gogh's *Night Café*
• J W von Goethe

▲▼ OFFSETTING FOR VECTORS

These two exposed Bronze Age burial tombs in Wales follow the usual pattern, and the triangular capstone always looks as if it points to somewhere. This is not a case of wanting to lead the eye, but a vector that has to be taken into account for the composition. It adds a dynamic sense to the image, particularly when, as here, the camera position is low and the lens wide-angle, so that the capstone points down. Despite the difference in frame shapes, both situations here call for the tomb to be offset to one side, to counter-balance the energy of the vector in the opposite direction. In the first image, the offsetting is less than it would normally be because of the counter-influence of the trees, which push back towards the center. In the second image, the distant and not very prominent clump of trees are the only stop.

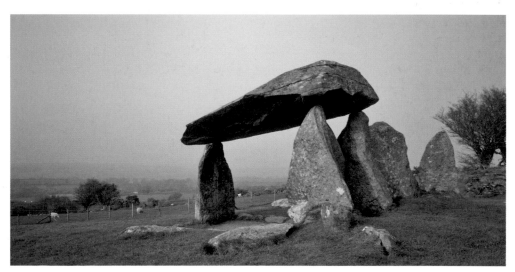

HARMONICS

The question of balance has an essential effect on both the shape of the frame and on the way it gets divided. Everything starts with the camera's image frame, whether you see it through a viewfinder or on an LCD screen on the camera's back. This is so deceptively simple—a plain rectangle—that it's easy to skip over and ignore the subtle pressures that the frame places on how we compose any image. First, there is the shape and orientation of the frame, and then there is the way we divide it, as is inevitable with almost every scene. Both summon up proportions and ratios that together offer endless possibilities for shifting and adjusting the framing, if you're prepared for that. In the way most photographs are taken, and I'll get to this at the end, there's rarely time to think deeply about proportions, balance, and so on. Nevertheless, it's a mistake to think that because of this no-one does it or it's impossible. Photographers skilled at composition simply do it very quickly, sometimes without thinking about it consciously. What follows now is a much more leisurely analysis.

The frame dimensions are obviously important in composition, but in photography they are decided in quite a different way from any other graphic art. They have always needed to be standardized for manufacturing reasons—film and sensors—and camera manufacturers who went their own independent way invariably failed. Sheet film settled down to a handful of formats, as did rollfilm, while the small dimensions of 35mm film restricted most camera manufacturers to 3:2. Printing is an entirely different matter, with complete flexibility, but photographs are usually composed in the camera, not on a printing easel or monitor, so the viewfinder frame still rules for most people. In other words, while painters have always chosen their canvas dimensions and proportions according to the painting at hand and their personal taste, photographers have generally bowed to the frame that the camera offers them.

When we look into how the popular image formats were decided on, it may or may not

come as a surprise to discover that it was usually for expediency rather than for creative reasons. The 3:2 proportions of the 35mm format, for example, come not from determining an idealized ratio, but from the sprocket holes of the film. That began when Oskar Barnack at Leitz seized on the sprocketed 35mm film made in rolls for motion picture cameras as a means of loading sufficient film into a still camera to shoot many images without having to reload. The result was the Leica, and the issue in those days was that this was a miniature film, so image quality in the enlargements was a potential problem. The original standard for motion picture was a frame that was four sprocket-holes high (film moves vertically through the gate; running it horizontally is more difficult, and confined to expensive formats like Imax), which gave a 4:3 proportion that was well accepted from the painting tradition. Barnack simply doubled this to eight sprocket holes and ran the film horizontally, giving 3:2 proportions to realize as large an image area as possible.

The 4:3 ratio now adopted by most non-SLR digital cameras needs little comment, fitting as it does into a long tradition of images on canvas and then the original universal standard for cinema. Is it fanciful to relate it to the musical fourth, the harmonic interval of 4:3, which was definitely used by many painters because it was pleasing to the ear? But then cinema, which continues to influence photography in all kinds of ways, moved in the 1950s to distinctly wider, more expansive aspect ratios, partly as a way of combating the threat of television, with its still-fat 4:3 format. Directors generally preferred wide, because it was more interesting and dynamic for composition. Perhaps surprisingly, it took television a long time to catch up with this preference, but now 16:9 has become the standard broadcast format, and is making inroads into still photography. As we'll see in a moment, 16:9 is, like 4:3, conveniently related to harmony in music. This may well have something to do with it being an attractive format to compose in.

▼ **35MM FILM**
The possible frame shapes for a 35mm frame depend on the spacing of the sprocket holes. The first motion picture format (1) was a predictable 4:3, with the film running vertically. At Leitz, the film was turned on its side for a larger frame—a major concern for image quality—and given 3:2 proportions for the same reason, size (2). The third illustration (3) shows how it would have worked if the length were across seven sprocket holes, giving an image of almost 4:3 proportions, but with a loss of picture area.

1

2

3

DIGITAL PROPORTIONS

The old film-based range of camera formats was more varied than the new digital range, including 5:4 for large-format (the mainstay of studio shooting), square (the original rollfilm format and maintained by Hasselblad), 7:6 and 4:3 (also rollfilm, the latter from what was known as 645 format), and panoramic formats 12:6 and 17:6, in addition to the 3:2 35mm frame. By contrast, digital formats, small and large, are now principally 4:3 and 3:2, with a variety of the new television standard 16:9 a way behind but gaining in popularity. Note that the more extended the frame, the less comfortable it is to use vertically. 4:3 rotates easily to 3:4, but when 3:2 becomes 2:3 it has a distinctly tall feeling to it. Nevertheless, because of its long legacy in 35mm cameras, it is well-accepted and so gives some interesting opportunities in composition. 16:9 is very rarely rotated to use as a vertical format.

But perhaps the most interesting thing to come out of all this is that skilled photographers can organize an image quite happily inside just about any shape of frame. Simply being given a frame ratio to start with acts like a discipline, and never more so than with the standard 3:2, 35mm frame that continues its life in digital photography as "full frame." Early in 35mm photography's history, the habit started to take hold among some reportage photographers to have their images printed so as to show the rebate edges around the picture. The origins of this go back to Henri Cartier-Bresson, who had strong opinions about composition (which he referred to as the "geometry" of the image) and cropping. He wrote, "If you start cutting or cropping a good photograph, it means death to the geometrically correct interplay of proportions." His decision to print images that showed a thin border was to demonstrate the exactness of his compositions. It was a way of saying "I took the image at that moment in exactly this intended way and no other." It also made an implicit statement that photography was about a captured image, not a constructed one.

▼ THE 16:9 FRAME

Following the trend in television toward this widescreen format, some digital cameras offer this as an option. For composition, it feels more dynamic and alive than fatter formats, playing as it does to the basic "horizontality" of the way we see. Its limitation is that it does not easily lend itself to being used for a vertical frame.

The idea of harmony in the shape of the frame and in dividing it is an old one. Originally it had a strong religious component—Man in harmony with God and the Universe—but there was in any case an observable effect. Harmonious relationships are for most people pleasing to look at, just as harmonious sounds are pleasing to the ear. This sounds like a circular argument—we like things because we like them—but continuing research in neurobiology shows that many of the answers lie in the way our eyes and brain process the information. In other words, harmony does work, and the many components that go into making an image, from harmony (or lack of it), to visual weight and the importance of content, have to fight it out for attention.

Harmony works similarly in frame shape and in division, meaning that a way of dividing can also be a way of creating a frame. The best known harmonious division is the Golden Section, although it is not the only one by any means. Anything said about this needs to be prefaced with the warning that it is not a rule of any sort. It persists because it seems to work on pragmatic grounds, but originally it had a powerful religious significance that came from its unique properties. The uniqueness is that the ratio of the smaller to the larger part is the same as the ratio of the larger part to the whole, and the religious significance needs no elaboration. Not easy to visualize from words, but as the accompanying diagram explains, and it's easy to see how this special unity would appeal to religious art. The ratio works out to 1:1.618, or in percentages 62% to 38%. Another method is based on the two overlapping squares, left and right, that can be found in any rectangle. The idea here is that a square is such a fundamental shape that it "exists" even within a longer rectangle; a method dating back to the Middle Ages in painting. The diagonals from each of these imaginary squares are superimposed and, as the sequence of diagrams shows on the facing page, locate horizontal and vertical divisions where they intersect.

▲▼ GOLDEN SECTION

In the Golden Section, the ratio of the smaller part to the larger is the same as the ratio of the larger to the whole, as this exploded diagram illustrates. This unified relationship is what makes it special. The main divisions of the images below follow the Golden Section, one principally horizontally, the other vertically.

⌃➤ THE SQUARES INSIDE A RECTANGLE

Any rectangle contains within it two implied squares, which may or may not overlap, depending on the aspect ratio. In this photograph, the left implied square has been deliberately used as a guide for placing the tight edge of the window, and all the elements left of this line have a slight but distinct sense of being grouped and united.

WEB SEARCH
- Oskar Barnack
- IMAX
- Academy ratio
- 16:9
- Cartier-Bresson geometry
- Leon Battista Alberti
- Botticelli's *The Birth of Venus*
- Jackson Pollock

Another route to finding harmony is through music. Almost everyone recognizes musical harmony, or consonance, without having to think about it or study it, and as far back as the Middle Ages the idea grew that there should be visual equivalents. This gets a little rarefied, but one way of doing this, used by several painters, was to start with the perfect fifth and the perfect fourth. Together with octaves, these are considered in Western music to be perfect consonances. They are ratios of sound frequency: a fifth is 3:2 and a fourth is 4:3, and whether coincidence or not, these also, of course, happen to be the two most used frame formats in photography. But in painting they were the starting point for extending the frame horizontally, at the same time creating a large-small-medium division. The way they were used by the Renaissance artist and scholar Alberti in Italy is illustrated, right:

As originally intended, 4:6:9 and 9:12:16 are ways of creating long frames, as well as dividing them. In photography, the 9:12:16 is clearly a useful way of dividing the 16:9 format available in a few digital cameras, but these divisions can also be applied to regular formats, such as the 3:2 photograph of the two children shown opposite. And if you like making extended images by shooting overlapping frames and then stitching them, they are possibly even more useful, as the final stitched panorama always needs to be cropped—they can be used in fine-tuning the composition.

Now, this kind of precision may work for painting, but apart from in a stitched image, just mentioned, photography rarely allows the time to think like this. But it's enough to use the principle, which is that, starting from either left or right, the three-part division goes from a square to the smallest part of the three to slightly larger. Another way of thinking about it, and probably the most useful, is that the smallest part can be a harmonious position for a main subject. This is exactly what Botticelli did in his painting *The Birth of Venus*. Her figure, rising from the shell and leaning slightly to the right, occupies

▲ **4:6:9 FROM THE MUSICAL FIFTH**
The first step starts with a shape in the proportions 3:2 or 4:3, and this is divided so that the larger part is a square. Next, the entire shape is extended in the same proportions. In other words, the longer part of the shape becomes the shorter part of the new frame. So, in a 3:2 shape (the musical fifth), the longer side is 1/2 as much again as the shorter, so the new frame is extended 1/2 as much again, from 3 to 4 1/2. The result, in the illustration here, is 2:3:4 1/2, or 4:6:9.

▲ **9:12:16 FROM THE MUSICAL FOURTH**
With the musical fourth, 4:3, the same procedure creates a slightly less elongated frame. The longer side of a 4:3 frame is 1/3 larger than the short side, so the entire shape is extended by 1/3. The result is 3:4:5 1/3, or 9:12:16.

this narrow band in a canvas divided 9:12:16. So, if you were looking for an alternative to the Golden Section as a way of offsetting a prominent subject in the frame, these two are worth thinking about. The Golden Section gives a line, these two give bands.

All of this comes from painting, where it is (or at any rate was) completely relevant. Even Jackson Pollock took a measurable amount of time to work on a canvas. But how can this possibly be relevant to photography with a small camera? It makes no sense to raise an SLR and think "let's put that horizon line 62% of the way down the frame," even if you actually wanted that effect. Well, yes and no. It's important not to confuse speed with intention. Just because a good reportage photographer shoots very quickly does not mean he or she isn't thinking about where things go in the frame. Cartier-Bresson wrote,

"Any geometrical analysis… can be done only after the photograph has been taken." He didn't mean that it didn't matter. Far from it, but it has to be done much, much faster than any classical painter would. On these grounds alone, skillful composition in photography is arguably more demanding than in any other graphic form.

◄▲ DIFFERENT FRAME SHAPES

4:6:9 and 9:12:16 are not only ways of creating long frames, but can also be used to divide a frame. Here, both ratios have been applied to the same image, cropping it digitally to position the subject.

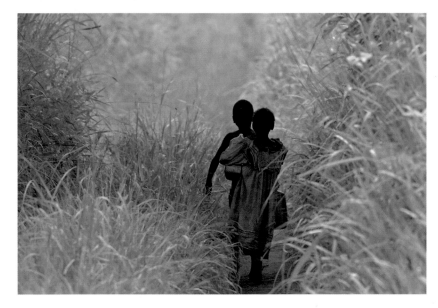

◄▲ 3:2

Applied to a 3:2 format image, 4:6:9 has been used to position the subject. This would also work if 9:12:16 had been chosen.

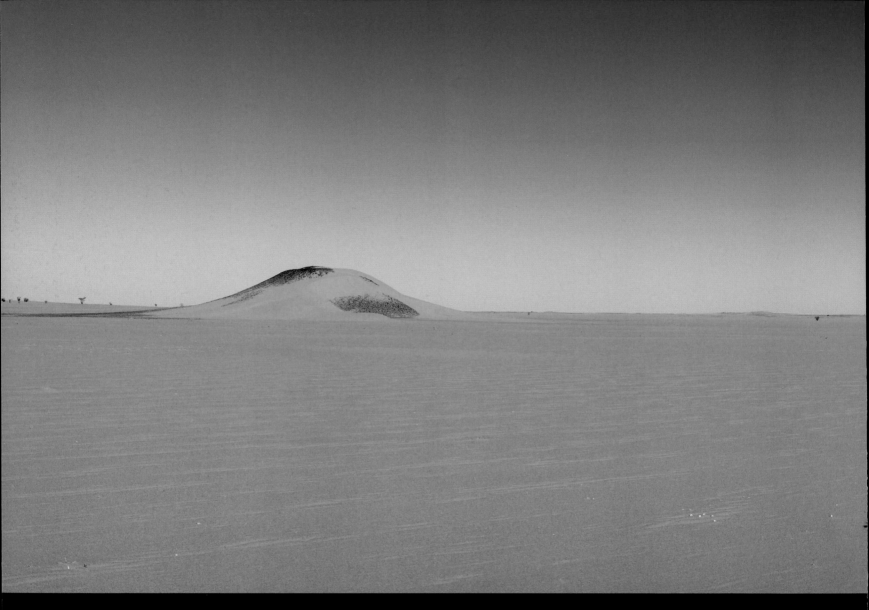

▲ SUBTLE INFLUENCES IN POSITION

This is the Bayuda desert in northern Sudan, and what I'd been looking for was a viewpoint that would communicate the unremitting emptiness and silence. An early idea was to run the horizon line dead center as a way of getting across the idea of empty land/empty sky. Still, I thought I needed to establish scale and distance, so I chose this bush as a counterpoint to the flatness. With a central horizon line, it occurred to me that centering the bush would match this effectively—I actually wanted to deaden the composition rather than inject graphic energy into it. However, the horizon was not completely flat.

Taking the composition a step at a time, it worked out as follows: to compensate for the visual weight of the low hill at left the bush needed to move to the right (as in the first diagram on the bottom row opposite); then to compensate for the smaller hill at right, shift back slightly to the left. The final arrangement is carefully thought out and is, seen in totality, indeed centered.

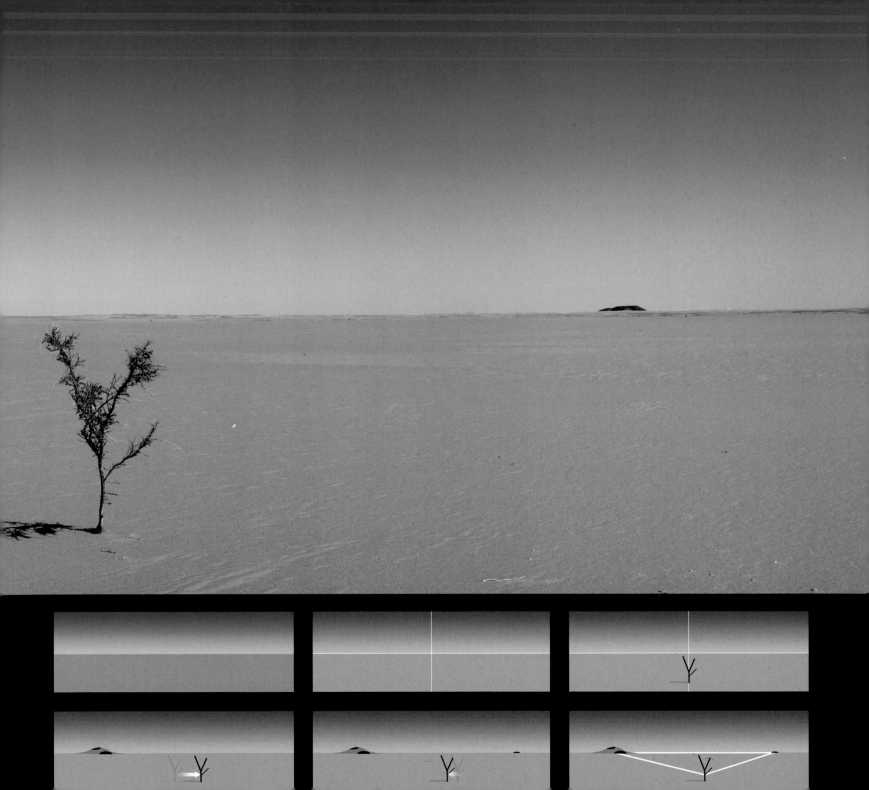

LEADING THE EYE

While decisions about balance and harmony have to be made in all deliberate composition, much less often attempted is using composition to influence the way in which a viewer looks at the image. This essentially means persuading the viewer to experience the image in a particular order, seeing one thing first, then moving on to another. In fact, as we saw in *The Reveal* (pages 66–75), the particular problem is to direct the eye toward a conclusion in the image that is important, but not obvious at the start.

One reason why this is not so common in photography—much less than in classical painting—is that it is a very deliberate process, and most photography happens too fast to allow it much room. Also, the majority of photographers probably prefer experimentation and a more visceral reaction to the scene in front of them. Of course, like many shooting techniques, not having much time doesn't prohibit it, highlighting the extra skill of talented and experienced photographers who can handle it quickly, but making reasonable use of leading the eye is easier in some types of photography than in others. Landscape, architectural, and studio photography all usually allow much more time to think and compose than, say, reportage.

Another reason why controlling the viewer's eye is not widely attempted is that it is a very uncertain process. There is no way of forcing anyone to look at an image in a particular way, short of filming it and moving the view over the image in close-up. If we knew more about how and why people react to images it would be valuable, but surprisingly little research has been done on the ways in which people look at photographs, let alone why. Eye-tracking, in which the gaze is measured by following the rotation of the eyeball, is the technique for recording the sequence in which people look at things. This has a long, if sporadic history and is newly in vogue because of computer screens and the Internet. Yet relatively little work has been done on normal imagery. Alfred Yarbus' work in the 1950s remains the most quoted publication

on the subject, but eye-tracking has since been devoted more to how people view web pages than they do photographs, for obvious commercial reasons.

Among Yarbus' observations in his 1967 book, *Eye Movements and Vision*, the following are worth bearing in mind: First, "Records of eye movements show that the observer's attention is usually held only by certain elements of the picture," so key components in an image have an exaggerated hold on the attention. Second, "The observer's attention is frequently drawn to elements which do not give important information but which, in his opinion, may do so. Often an observer will focus his attention on elements that are unusual in the particular circumstances, unfamiliar, incomprehensible, and so on." This means people look at what interests them individually, not what the photographer might think is important. Yarbus goes on to note that "…when changing its points of fixation, the observer's eye repeatedly returns to the same elements of the picture. Additional time spent on perception is not used to examine the secondary elements, but to re-examine the most important elements." So the eye gets drawn back to the key elements to make more sense of them rather than, as you might expect, taking the opportunity to explore the rest of the image. And finally, something which argues well for a thoughtful approach to making images, "Eye movement reflects the human thought processes; so the observer's thought may be followed to some extent from records of eye movement."

Nevertheless, despite the difficulties, there are times when this is an undeniably useful set of techniques to call upon. Leading the eye from one part of the frame to another has two particular uses. One is to draw attention to a specific feature, and because the attention is going to be forced towards it, you then have the opportunity to keep it small. The other is to create a vector—a movement across the frame that inevitably helps to make the view coherent. When it can be made to work, it adds a new level of interest, even

▼ LEADING BY LINEAR PERSPECTIVE
Linear perspective and lines are exaggerated by a wide-angle lens and lead the eye fairly directly toward the building in the distance. Note that the slightly shallower pitch of the roof at the end of the barn, and the lower part of the tree work to "bend" the linear perspective slightly.

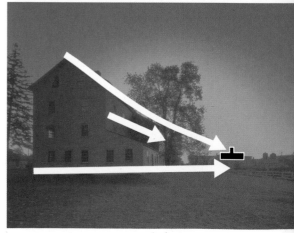

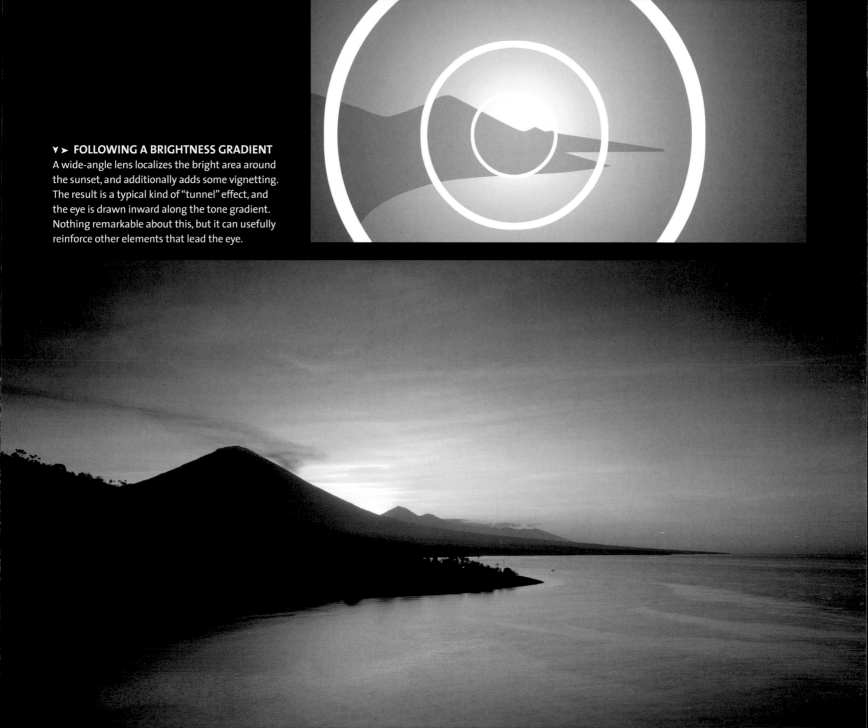

∨ ➤ FOLLOWING A BRIGHTNESS GRADIENT
A wide-angle lens localizes the bright area around the sunset, and additionally adds some vignetting. The result is a typical kind of "tunnel" effect, and the eye is drawn inward along the tone gradient. Nothing remarkable about this, but it can usefully reinforce other elements that lead the eye.

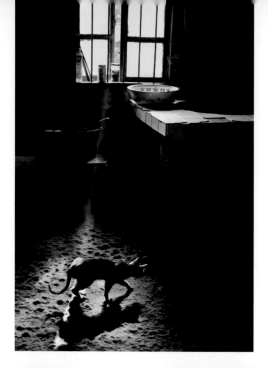

complexity, to an image. And because the idea of leading the eye involves some kind of sequence, starting here then ending there, it brings the extra dimension of time to a still image.

So, on to practicalities. The most straightforward and usable technique for influencing the viewer's eye is "pointing." This means taking advantage of the graphic elements in an image to point toward something that might not otherwise first grab the attention. Naturally, it requires certain conditions, but when you can recognize them in a situation, you have the opportunity to exploit them—or not. Lines, the play of light, perspective, and focus can all have a strong effect. Lines are the most obvious way, hard edges or as implied lines, which include the invisible eye-lines that point from a face in an image. Lines "point" because we see them as having a direction and they encourage the eye to travel along them. One of the features of our visual system is that by nature we are always trying to find simple graphic structures in what we look at; "joining the dots" as the expression goes. The Gestalt rules of grouping explain much of this, in particular the law of Good Continuation, in which the eye links different visual elements to make a smooth contour, such as a straight or curving line, regardless of what these elements actually are in the real world. A tree, a house, a person can together make a line in the mind's eye from a certain viewpoint. This is an implied line, and can "point" just as surely toward something in the frame as can an obvious edge line.

The angle of the line also plays a part. In terms of energy, noticeability, and sense of movement, the strongest is the diagonal and the weakest the horizontal. Verticals come somewhere in between, related to a feeling of gravity, whether up or down. So a definite diagonal with one end close to a corner and the other near the center will almost always help to take the eye inward. Other diagonals leading to the center from other parts of the frame would reinforce this. A set like this is, of course, exactly what happens with a wide-angle lens and straight-edged subjects like buildings—strong linear perspective.

A visible shaft of light, as happens in large dark spaces that have some atmosphere when sunlight pours in through a small opening, is even stronger. It combines a graphic line with the power of illumination to give a "finger of God" effect. And light also has a leading effect because our eyes want to move from dark to light. The light at the end of a tunnel is the perfect example of this, and in this kind of picture it is almost impossible to take the eyes off the bright patch. Note that this effect is strongest when the light area is enclosed within the frame, rather than breaking the edge of the frame.

Optical sharpness also leads the eye, and always toward it from any areas that are unsharp. Sharp is what we expect from seeing, and is "normal," so if there is a large area of the image that is unsharp the eye will naturally move from there toward the sharp elements. It's worth mentioning that the kind of blur that comes from different focus across the field of view is an optical effect peculiar to photography—we don't have that same sense of blurring with our normal vision. You can demonstrate this easily by fixing your eye on one thing, such as one word on this page, but pay attention to your peripheral vision. Around the edges of your vision objects are certainly indistinct, but not soft—you should still have the sense of edges being edges, even if you can't resolve them properly. Selective focus with the camera is probably one of the most obvious ways of leading the eye. In terms of making the eye travel across the frame, rather than simply grab the attention immediately, the soft focus areas need to be much larger than the sharp, and if the progression from blurred to sharp is continuous, the "leading" effect is more definite. A wide aperture is an obvious necessity, and selective focus works most strongly with telephoto lenses and in extreme close-up. As with dark-to-light eye movement, blurred-to-sharp movement is at least partly due to our known preference for images to be brighter and sharper.

▲ LIGHT MADE VISIBLE
Shafts of light need a particular condition: dark surroundings, direct sunlight through a window or small opening, and atmosphere (in this case a little smoke from a stove). The resulting "finger of light" effect is always powerful, and of course can be enhanced in processing by turning up the contrast, clarity, and even saturation.

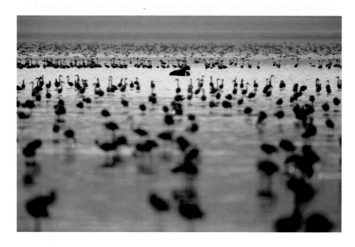

▲ FOLLOWING A SHARPNESS GRADIENT

Here, even with a 600mm lens, the hyaena with a flamingo is almost too distant to be noticed, but the focus gradient draws the eye toward it. The light shading adds to this.

▲ LEADING BY LINEAR PERSPECTIVE

The overall wedge-shape of the white burqa-clad women, reinforced by the diminishing perspective of the two standing, leads the eye right and up. There, the man weighing acts as a stop because of the direction he is facing, and so the eye comes to rest at the scale.

WEB SEARCH
- Alfred Yarbus
- Eye tracking
- Gestalt law

LINES

Lines with a high-edge contrast: Diagonal lines "point" the most strongly.

Eye-lines: Not necessary to see the eyes–the direction a figure is facing also leads the eye.

Light shading: The eye tends to be drawn from dark to light, especially along a continuous gradient; greatest effect when the light area is enclosed within the frame, least effect when it bleeds off one edge (as in a bright sky).

Light shafts: The effect runs counter to light shading and directs attention from the light source to the lit area.

Perspective: All kinds of perspective (linear, aerial, diminishing, overlapping) tend to draw the eye, and in most cases toward the distance; strongest with a wide-angle lens.

Focus: Where there is a difference of focus in the frame, the sharpest focus draws the attention, particularly if there is a continuous focus gradient.

▼ EYE-LINE AND PERSPECTIVE

An assumed eye-line from the foreground figure, added to by the two rather less obvious figures in the middle distance, combines with an obviously strong geometrical perspective (because of an ultra wide-angle lens used from close) to focus attention firmly on the airborne flag.

▲➤ EYE-LINE AND BRIGHTNESS GRADIENT

Again, an assumed eye-line from the bathing girl, this time added to a tonal gradient that takes the eye up towards the just-visible sun through the leaves.

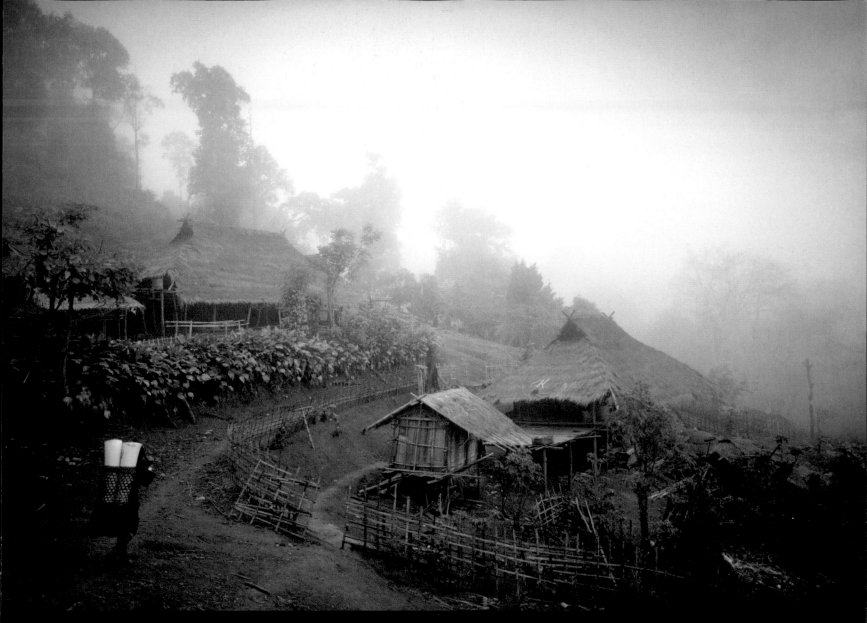

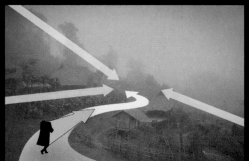
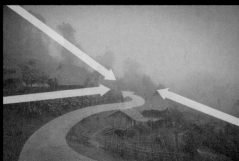

▲ LEADING WITH A VECTOR

Here, the presence of the Akha woman carrying banana trunks and walking along the path makes an important contribution to the dynamics. The lines already converge, as the diagram shows, but the woman, walking, puts it all in motion.

OPPOSITION

Dynamic balance needs at least two contrasting elements to work with, and whatever the kind of contrast, these elements are in some way opposed. Opposition, in fact, is fundamental to balance in most images. The exceptions are static balance, such as a highly symmetrical composition (although even here there is often a sense of two sides that reflect each other), and "field" images in which pattern and texture dominate the composition. Two counter-balanced elements make a stronger opposition than three or more, because the energy within the image moves simply backward and forward, and

to illustrate this I want to look at two situations that are well-known in photography, but not particularly well examined. These are opposition in depth between foreground and background, and opposition in scale between a small figure and a large setting. Both situations are richer in possibilities than they might at first seem.

The idea of foreground and background is obvious enough, but to make use of it in composition we need to think about how connected or separated they are. In this sense, there is a world of difference between a scene in which the near flows into the far, and one in which the near flows into the far, and one

which they appear to be separated into distinct planes. There can even be several planes, as the image of the Thai cliffs and boat below shows, but the division into two gives the strongest opportunity for playing with the balance. The foreground always leads in the conventional approach, because in any deep scene our eyes and senses tend to start with what is immediately in front of us, then work outward from there, toward the distance.

Plane separation is almost entirely in our perception, even if it is helped by natural breaks in the scene. Take landscapes, for example, which

> **CONTINUOUS PLANE**
A schematic representation of the continuous gradient of distance and perspective. All can be seen, and the foreground recedes without break toward the horizon, which most people perceive as a kind of stop, so shown here as a vertical wall.

> **SEPARATE PLANES**
Almost the same situation, but a vertical foreground confronts the viewer, and in one way or another breaks the continuity of the depth gradient. Photographically, the scene is now composed of two distinct distances, which we perceive as separate planes.

> **PLANES IN THE DISTANCE**
A telephoto image shot with a 400mm lens, in many ways typical, that resolves the scene in front of it (in the south of Thailand) into three evident planes. Compression from the long focal length, coupled with aerial perspective from the humid atmosphere, create the effect. The composition works with this, setting the silhouetted foreground at left neatly within the mass of the middle-distance cliffs behind, and then centering the third plane, the most distant, within the opening of the middle-distance. The boatman in the foreground provides the necessary scale and context.

114

are the most common subject for separated planes. That one part becomes a distinct foreground is a matter of viewpoint and how we choose to interpret the scene. A dip in a slope may hide some of the middle ground from view, but the landscape still flows from the camera to the distance. When painters and photographers choose to divide the setting into planes, this is a particular way of dealing with depth, and also a means of persuading the viewer to look at a scene in a particular order.

Convincing the eye that different distances look like distinct planes involves both heightening the contrast between them, and weakening any clues that they are connected. Unexpectedly, one kind of perspective can help. In principle, plane separation works against perspective by taking away clues to continuous depth, but aerial perspective, which relies on atmospheric effects to show distance, tends to accentuate planes. This, however, is a special condition, and in its absence the main available techniques are viewpoint and framing, and dark-light contrast. Viewpoint is critical; finding a camera position that disconnects the foreground is a standard method. One way of doing this is to cut off the lower part so as to hide the ground, another is to frame the shot so that the foreground at least partly encloses the distance. Add to this a dark-light contrast (typically with the foreground darker), and the planes are separated. Treat the foreground as a silhouette and the separation is even more marked. Color differences between planes are much less common than tonal, while differences in focus, which serves other types of balance in composition quite well, here are usually counter-productive: if either the distance or foreground is unfocused it actually works less well as a component of the scene.

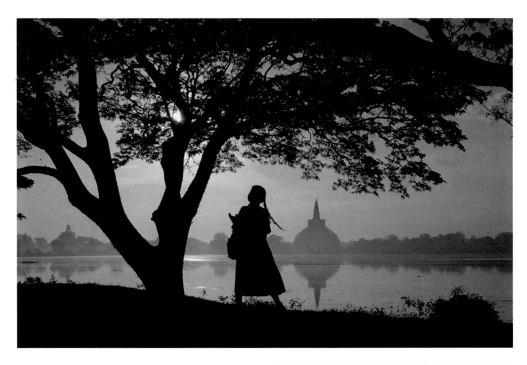

ʌ ➤ SILHOUETTE
This too is a very obvious way of separating foreground from background as distinct planes, through strong tonal contrast. To make the most of it, exposure and processing should render the silhouette as solid.

WAYS OF SEPARATING PLANES
Aerial perspective: Depends on atmosphere and lighting, and is always enhanced by a long focal length. Haze, mist, or fog all work to separate distances into planes by exaggerating the tonal differences and by suppressing detail, all the more so under backlighting, shooting towards the sun.

Viewpoint and framing: Cutting off the horizontal plane, or at least not showing how the planes connect. One method is to crop high, another is making a partial or complete frame out of the foreground. Compositionally this is probably the most usable technique.

Tonal contrast: The classic method is a shadowed foreground and lit background. This dark-to-light contrast conforms to the way we typically look at scenes, beginning near and shifting our gaze outward. A silhouetted foreground by shooting toward the sun is the ultimate version.

Color: On a large scale, it's rare that one plane has a different overall color from another, but differences in color temperature because of the lighting are definitely possible. An example would be a foreground at dusk lit mainly with artificial light against a bluer background.

Focus: Selective focus with a shallow depth of field obviously contrasts two planes, but at a price. The blurred plane loses its detail and so its power to oppose the sharply-focused plane on its own terms. For planes to have equal standing, they need to be in the same sharp focus.

Landscape painting is an important genre of art and, historically, a great deal of thought and attention went into the subtleties of dividing the canvas in depth. Landscape painting for its own sake began in the 17th century; before then, the terrain was used in a subsidiary way, as a setting for the main subject. The first great landscape painter was Claude Lorrain. Before him, landscape was painted in the service of religious or mythic themes. In particular, he developed a number of techniques that generations of later artists used, and his work continued to be admired into the 18th and 19th centuries by painters such as J. M. W. Turner and John Constable. Turner's *Crossing the Brook*, 1815, is a wonderful example of handling planes, a refinement of a classic Lorrain arrangement. A typical Lorrain method was to have a dark, shadowed foreground, weighted and partly framed to one side with trees, then an extension of the foreground, almost as dark, but with the mass weighted to the other side of the canvas so as to take the eye across. From there, the eye was directed back toward the middle, then outward and upward toward a luminous distance and sky, with a hazy sun either in view or just slightly obscured by trees.

The classical landscape painting also needed human figures, often of historical or mythical significance, and both Lorrain and Turner used framing and lighting devices to bring them to our attention, despite their small size. In Turner's painting here, the figures have no historical importance, but they do have a vital rôle in the composition and in coaxing the viewer's attention. Leading the eye presupposes a starting point as well as a destination, and this would naturally fall nearer than further. But the foreground is intentionally dark in order to separate it as a plane. So, Turner creates a pool of light within the foreground-middle ground. The women, being figures and nearby, catch the attention early, and from here the structure of the painting takes the eye toward the distance. It's a subtle but telling effect.

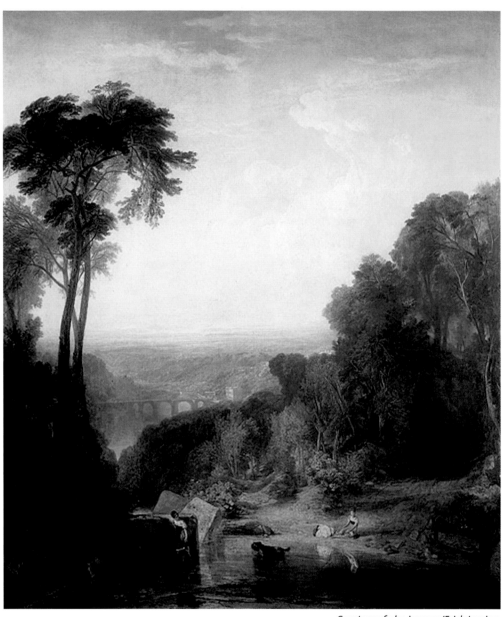

Courtesy of akg-images/Erich Lessing.

▲ CROSSING THE BROOK, 1815, J. M. W. TURNER
For this English pastoral landscape, Turner adapted Claude Lorrain's technique of creating a brighter pool within the darker foreground as a device for catching the attention and directing it outward and upward.

The result of separating the planes by lighting and composition is first to give a solid structure to the image, and second to lead the eye through the picture.

Lessons from painting are often valuable for photography and here is one case that definitely lends itself to translation through the camera. Mimicking the Lorrain technique is one possibility, and there's nothing wrong with that—Turner did it—but for a slightly different adaptation, here's a practical example in which it solved a particular problem. The original purpose of this photograph taken in the ancient Thai ruined city of Ayutthaya was to illustrate the two leaning brick chedis. Standard practice for archaeological and architectural shots is to do a recce well beforehand to get an idea of how the light will fall. As far as the subject is concerned, everything is under control and nothing is going to move. Here, I walked around looking for a viewpoint that would give me some foreground interest with a wide lens, and initially my eye was caught by the head perched on a low wall. Then I spotted the stone Buddha head lying in the grass (Ayutthaya was sacked by the Burmese, who performed major destruction). This seemed ideal—I now had two points of interest. A very low camera position was called for, but what about the lighting? I wanted the head lit, but I also had in mind a classically separated dark foreground to frame and take the eye out toward the two chedis. The exact play of shadows and light was by no means certain, but I planned to shoot just as the foreground shadow was beginning to creep up the head—at the last possible moment, in other words. I framed the shot to anticipate this, and it did indeed work as I had hoped for. The low ruined walls left and right provide the foreground in shadow, and they contain the head in its own pool of light. Being close and a face, it catches the attention first, and leads toward the brick towers.

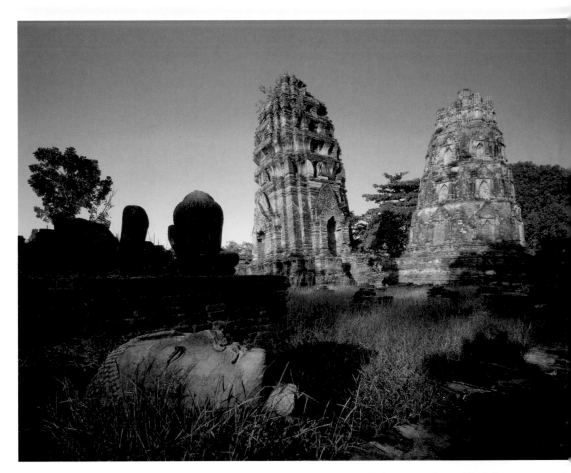

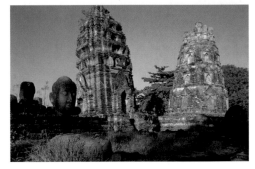

⌃ THE LORRAIN EFFECT

This situation was conceived as an image divided into planes, the purpose being to lead the eye. The presence of a broken Buddha head lying on the ground was the trigger, too good and special to be missed. What needed care and attention was the camera position, and also the lighting—the first controllable, the second not. Key to the whole operation was a pool of light on the Buddha head, set within the otherwise dark foreground. This would be the starting point for the viewer's attention, which the composition could then take out toward the final destination, the two brick towers. The smaller image shows an earlier frame in the sequence.

The classical method that we've been looking at up to now is to separate the planes and balance them in the image in a way that satisfies expectations, with the proportions of foreground and background staying fairly similar. The result is that we know where we are, and there is an understandable movement from near to far. The foreground either anchors or frames the distance. But it's also possible to play with the relationships in interesting and counter-intuitive ways. If we either reduce one kind of contrast, such as lighting, or make the foreground occupy less space, then this introduces some confusion, and the eye has to move repeatedly between one plane and the other in order to work out the relationship. The result is flipping—a to-and-fro change of attention—and this can have a special value because it can hold the attention longer. Of course, make it too subtle or too confusing and you lose the viewer, but in all kinds of departure from the expected this is a normal risk. Included here are some illustrations of ambiguously separated planes, each of which encourage flipping.

WEB SEARCH
• Claude Lorrain
• J. M. W. Turner
• John Constable

▲ FLIPPING FROM TONE REVERSAL #1
A Japanese garden, arranged to include this precise, structured view through an entrance (a common technique in Japanese garden design) has a slightly unreal feeling photographed with the foreground frame lit more brightly than the scene beyond. This is the opposite to what we are used to seeing, and the effect is compounded by full depth of field from a small aperture and an exact, squared-up viewpoint.

➤ FLIPPING FROM TONE REVERSAL #2
A giant Buddha image enclosed in a brick temple, seen through the narrow triangular opening, which conveniently frames the head and its finial. A telephoto lens (400mm) compresses the perspective, a small aperture extends the depth of field throughout, and the brighter frame set against the darker interior all combine to confuse the eye slightly, so that it takes a second or two to work out the subject.

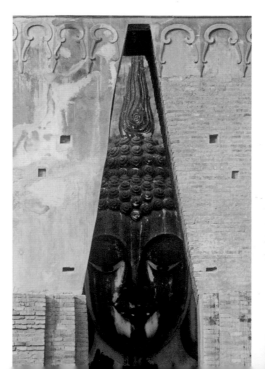

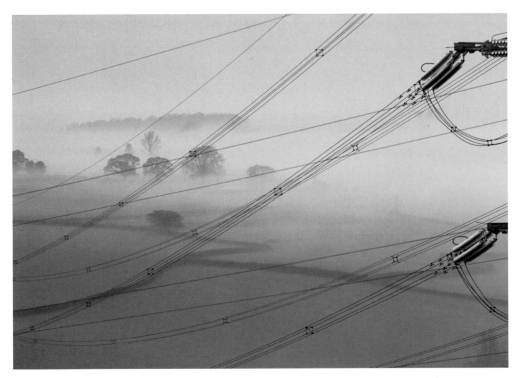

SEPARATION BY LENS AND TONE
A 400mm lens allows the kind of tight cropping needed to cut off the slope of land between electricity pylons in the foreground and the distant landscape in morning mist. This leaves two quite distinct planes or layers, and these are further separated by the light and aerial perspective—the pylon and cables dark, the hazy distance bright. The shapes that draw attention are the two units, right, and the trees in the distance, left, all of similar size. The two groups naturally contrast with each other, and framing the shot in this way creates a linkage as the eye travels down the curves of the cables.

CONFUSING THE PLANES
A reversal of the usual recommendations for plane separation here makes the opportunity for a quick double-take, so as to surprise. Instead of using light and viewpoint to make the separation obvious between foreground (a cormorant employed for fishing) and background (its owner, steering the boat), the lighting is the same for both, the focus is perfect for both (f/11 with a 12mm ultra wide-angle focal length), and the throat and neck of the bird disconcertingly seem to align with the line of the boat. The eye sees both cormorant and man together.

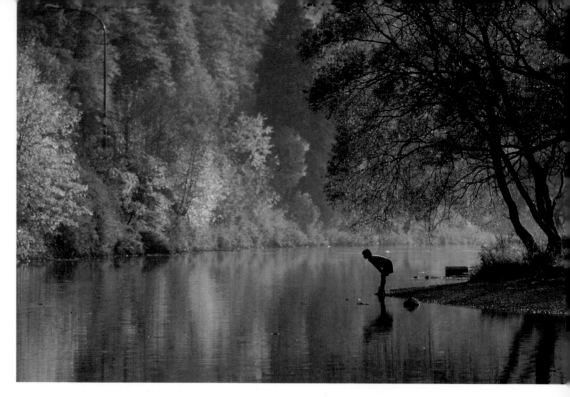

THE DISTANT FIGURE

The second kind of oppositional balance that I want to look at is spatial, but with a lacing of content. The figure in a landscape is almost, but not quite, a cliché of imagery. What protects it from overuse, much as photographers tend to seize on it when they find the opportunity, is that it is a relatively unusual situation. The necessary ingredients are a small distinct figure, occupying as little of the frame as possible while still being visible, and a surrounding that is fairly simple, continuous, extending right up to the frame edges, and which contrasts graphically with the figure.

I call it distant figure rather than small figure because in order to work properly, with the right degree of surprise, it has to be known to be of a reasonable size. The archetype is the human figure, but it could also be a house, or some sizeable artifact like a car. An insect doesn't really do it—we know insects are small, so seeing one in a large setting means little. But a lone person in a view that apparently covers something like an acre, or even more, has something more special to it, because we don't normally see this.

There is an inbuilt element of surprise—surprise that a figure is alone in such wide surroundings, and most photographs of this type tend to exploit this. But they do it in one of two ways, depending on how the photographer sees the situation at the start. This is a matter of preferring the figure or the setting. The starting point can be the setting, such as a landscape, that is given scale and relevance by including a lone figure, or the figure may come first, with the decision being to put it in an unusually wide context. The result may often be the same, but not always. In the image of the woman on the river bank, she is the subject and this is one of a number of varied portraits going into one magazine story. As a result, the positioning is crucial, for good tonal contrast that shows off the pose she chooses. By contrast, the worker climbing the bamboo structure is there just to give scale, and works better in the image by not being seen immediately.

▲ RIVER BANK
The subject's positioning in the frame is crucial.

▼ BAMBOO STRUCTURE
The worker gives scale to this image, making it infinitely more effective; without him the scale would be nearly impossible to judge.

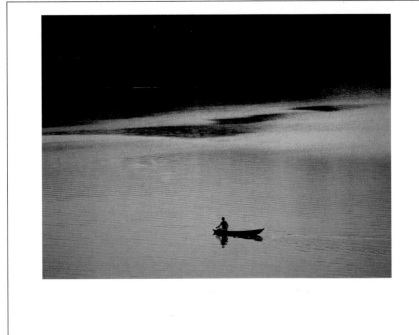

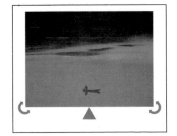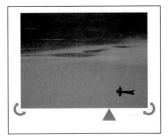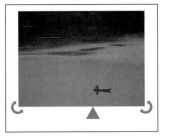

◄ ALTERNATIVE FOREGROUND

Rather than a human figure as in the two images on the left, here a boat is made the smaller subject providing scale and context to the ocean it floats upon.

◄ ▼ THE LEVER EFFECT

Thinking about composition as mechanical balance, with a fulcrum, moving a subject away from the center gives it extra leverage, and so it can be smaller and still in balance.

As we've already seen, a human figure attracts more attention than do most objects in a scene, and so can be used small without losing it from the attention. Also, because in this kind of shot the small figure is usually a counterpoint to the landscape or setting, the balance between the two tends to be more effective if the figure is away from the center. That allows the eye to travel between the two across the frame. But placing a small figure close to the edge means keeping careful control on tonal contrast—dark against light or light against dark. It's worth mentioning that off-center figures gain some visual weight through the lever effect (to borrow a term from mechanics). And, as with opposed foregrounds and backgrounds, it's possible to experiment with the balance in order to affect readability and delay in recognition. This, naturally, takes us back to *The Reveal*, and the two examples on the following pages deliberately push the limits of scale in order to try and be a little bit more interesting, at some risk of losing the viewer.

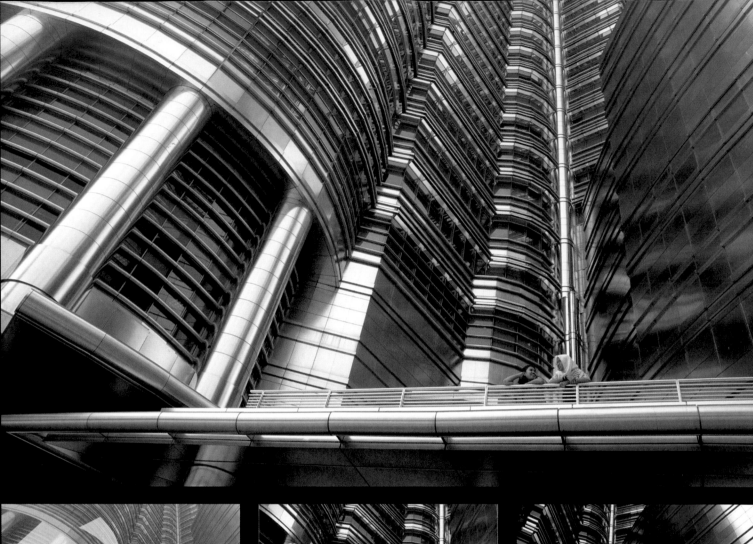

▲ A SLOW REVEAL

Two Muslim women on a walkway of the Petronas Towers in Kuala Lumpur, Malaysia. The subject began as the building, but the contrast of tradition (the women's dress) against the almost futuristic architecture was hard to resist, and I shifted my attention to this. The architecture had to dominate as much as possible, but the question was, how far could the contrast of scale be pushed without losing the impact of the women? In other words, I wanted the attention to be taken first by the building and then, as a slight surprise, settle on the women—exactly the approach described in *The Reveal*. Closing in with the zoom would lose this surprise. The solution was to make use of the lines of the architecture to guide the eye, using a wide angle (20mm) and adjusting the camera position. The large curved mass on the left dominates at first glance. Then the repeated curved lines lead the eye along them inwards and down, where they meet the low baseline of the walkway. Positioning the figures at the base of the thin white vertical reinforces this.

▲ EXTREME CONTRAST OF SCALE

Another exercise in pushing the limits of scale between figure and setting. The subject is a hot spring resort set uniquely in old woodland on a steep hillside, and what I wanted was to convey the sense of a large, dark, mysterious forest. That meant late dusk, keeping the tone dark and its natural blue without correction. Contrast in color comes from the lighting. A carefully limited spotlight picks out the bathing girl, allowing her figure to be very small indeed in the frame, yet noticeable. Framing so as to show the pool edges, and to have no more than a sliver of sky, meant positioning her quite close to the center, which allowed her to be even smaller. Most of the work in this shot went into the lighting, using several large units off-frame. The two smaller versions show the effect of shooting earlier and later—choosing the right time of day to balance the natural and flash lighting was critical.

LOW GRAPHIC STYLE

Artists regularly want to re-invent the medium in which they work, and photography is no exception. However successful and well-liked a particular way of doing things is, for some people it loses its freshness and fascination sooner or later. Boredom, a need to experiment, and an urge simply to challenge the status quo take hold. This has always been the way art evolves: first refining and developing earlier ideas, then overthrowing them. These revolutions are sometimes significant, sometimes not. Impressionism in painting was a major event, conceptual art, beginning with Marcel Duchamp, perhaps even more so. In photography, one of the most radical challenges began in the 1970s, and amounted to a rejection of what until then had been the accepted norms of composition and style. Its proponents would argue that it went much further than composition, to involve a whole raft of post-modernist ideas, but from the point of view of this book, composition was its major effect.

A few key figures in photography combined to inspire a movement that essentially turned its back on smart and forceful graphic style and rich colors, and aimed to leach out personality from images—at least as far as what counted for manifestos declared. In fact, the low graphic style of the New Topographics and New Color movements in the United States ended up quite aggressively promoting personality, elitism, and a new order for composition that was, in its way, as dogmatic as the traditional "rule-of-thirds-etcetera" conventions ever were.

A turning point in the United States was an exhibition mounted in 1975 by the International Museum of Photography & Film at the George Eastman House in Rochester, New York, titled *New Topographics: Photographs of a Man-altered Landscape*. The curator, William Jenkins, declared that the theme was "stylistic anonymity," focusing on content to the exclusion of form: "The pictures were stripped of any artistic frills and reduced to an essentially topographic state, conveying substantial amounts of visual information, but eschewing entirely the aspects of beauty, emotion and opinion." Among the inspirations were the self-published small books of the artist Edward Ruscha, which catalogued subjects as mundane as *26 Gasoline Stations* (1963) and *34 Parking Lots* (1967). The photographers contributing to the show included Robert Adams, Stephen Shore, Nicholas Nixon, and Lewis Baltz. The Bechers were also invited.

All this was quite contrary to the celebratory tradition of photographers such as Eliot Porter, Ansel Adams, and the Westons. Several contemporary photography critics chimed in. Lewis Baltz (as commentator rather than photographer) wrote; "The ideal photographic document would appear to be without author or art," while Max Kozloff airily dismissed Ernst Haas, a popular Magnum photographer firmly embedded in normal compositional style and rich hues, as "The Paganini of Kodachrome."

More important for this about-face in the world of art photography was the influence of John Szarkowski, Director of Photography at New York's Museum of Modern Art from 1962 to 1991, a key period in the artistic development of photography. Coupled with this was institutional support, notably from the National Endowment for the Arts, with grants for those photographers who were hooked into the art-academic world. Also, writers from outside the field, like Susan Sontag, chimed in, and before long there was a whole raft of graduate programs in photography in colleges and universities. The result was a questioning of accepted standards, and for a number of photographers, a dissatisfaction with pictorial attractiveness. In Europe, the determinedly uninflected style was mirrored by the life work of Bernd and Hilla Becher in Düsseldorf, who methodically documented such gradually disappearing industrial icons as water towers and warehouses.

Never destined to be populist, this low graphic style has a significant, if minority, following located in the world of art, and is important because it apparently disowns the honing of compositional skills that most photographers and other artists have worked on. I say apparently, because when we look closely at the best of this work, it shows anything but "a casual disregard for the importance of the images" as Jenkins wrote in introducing the original show. A real rejection of compositional skills would have to be a truly naïve photograph, which is impossible for a trained photographer. This is not a natural style, and has to be learned by unpicking the elements and techniques that go into conventional composition.

➤ **THE EMPTY URBAN HABITAT**
For post-modernists, the built environment is the standard form of the contemporary landscape, and choice of subject matter is inseparable from the compositional devices of low graphic style. There is no special or compelling principal subject in this typical, characterless slice of a contemporary Chinese provincial town, and the composition reflects this in its deadpan treatment, timed for no moment in particular. The hazy light and resulting low contrast contribute to the plain effect. Yet as the wider view shows, even this bland material has its eye-catching elements, such as the girl's face on the poster, the clock tower, and even the possibility, if you wanted to be patient, for catching a more interesting vehicle passing by. Reducing the graphic elements demands its own kind of rigor. Much, or nothing, can be read into the details of images like this, because the apparent absence of compositional interest and effort does not distract attention.

▲ ➤ JUST THE FACTS

Intended as an architectural record, this picture of a 19th-century Shaker building in Kentucky replicates a façade section by careful choice of viewpoint, tight framing with a standard focal length, and even lighting—all with a 4x5-inch view camera to take advantage of its rising front and perspective control. Note, however, that converting it to black-and-white while taking care to lighten the tone of the blue sky, makes it less graphically striking.

If we go through this process now, you should be able to see that low graphic style is in fact highly considered and calculated. Things that we need to take out of the composition are any dynamic elements, and any accepted or clever harmonies. Thus, static balance instead of dynamic, no vectors, no rich color themes, frame shapes as close to anonymous as possible (the passive square frame does very well at reducing excitement and graphic tension, with 5:4 coming in a good second) and divided either equally or inelegantly. Certainly, keep strong diagonals out of the picture. Hence there is a strong preference for frontal, squared-up viewpoints, and the use of normal or slightly long focal lengths, but always avoiding ultra-wide lenses.

And subject matter? Given the post-modernist philosophy behind this style, some subjects are certainly more appropriate, or malleable, than others. Landscape was always going to be ideal for this treatment, which is why it headed the list of genres in the 1970s. This is because first, landscape exists in our heads, not in reality; it is our vision of terrain. Second, the landscape tradition in art has very largely been a romantic one—Lorrain, Poussin, Turner, Constable, Friedrich, and so on—with an idealizing mission. Turner even idealized the beginnings of the Industrial Revolution, while the war artist Paul Nash rendered the horrific reality of the First World War battlefields attractively, despite his anti-war polemic.

The same happened in photography, from P. H. Emerson's bucolic portraits of the Norfolk Broads, through the unashamedly picturesque efforts of the Pictorialists, to Adams and the Westons (Brett, and some at least of Edward). These West Coast photographers may have proclaimed rigorous purity, but they were in love with grand natural landscapes, so that is what they gave us. Landscape was ripe for both redefinition and reinterpretation, and Robert Adams led the way. He was in the New Topographics exhibition, and pioneered the interpretation of the despoiled landscape for what

it was. The Bechers for their part concentrated on the built landscape, and interiors as a subject are a development of this, featuring in particular the ordinary, the neglected, and the abandoned.

The result is imagery that is very low on rhetoric, what art historian and photographer Gretchen Garner calls "...uninflected by either remorse, outrage, or sentiment of any kind." But how realistic are the stated aims of keeping the photographer's personality out of it, and deadening the too-obvious manipulation of composition and the viewer's attention? The clue lies in "too-obvious," because of course, as we've seen, a considerable amount of manipulation is going on. The viewer is being manipulated into believing that apparently plain composition means the plain, unadorned truth. The difference between low graphic style and the normal is that part of its manipulation is taking place at a conceptual level, rather than an openly-declared manipulation of the geometry of the image.

With all this emphasis on reduction, minimalism might seem to be a natural extension, but it occupies an odd position, in a way straddling the two opposites of low and high graphic styles. It certainly fulfills several low-graphic criteria, such as plainness and flatness, but it also has a deliberateness, and indeed a philosophy behind it, as we'll see shortly under *Minimalism*. If an image shows evidence of obvious manipulation of the composition, it doesn't belong here under *Low Graphic Style*. We should also remember that low graphic style in art photography is larded with a good helping of curatorial elitism. It would be a mistake to think that if you carefully learn how to uninflect an image and produce the declared ideal of deadpan anonymity, everyone else will see it as such. More likely is that it will simply be perceived as rather ordinary. Art needs approval.

CREATING LOW GRAPHIC STYLE

Static balance: Symmetrical arrangements and an absence of elements such as diagonals that inject dynamic activity into the frame.

Equality of proportion: Square frames and centered horizon lines are typical.

Passivity: As a general feeling and sense to the image and content.

No surprises: At least, not within the composition.

Elevation and plan views: Squared-up compositions that align precisely to the frame edges are one way of not injecting personality into a composition.

Normal focal length: Standard focal lengths mimic the eye's normal view and so reduce the feeling that a particular lens has been intentionally used. Wide-angle lenses introduce strong perspective and diagonals, while long lenses compress planes, both of them devices that low graphic style rejects.

Modest color: Avoiding rich and vibrant colors, and strong contrasts between colors. That said, an anomaly is William Eggleston's use of dye-transfer printing to deliver strongly saturated colors in some images.

Monochrome: Black and white usefully excludes any possibility of the emotional content of color.

Repetition: By no means a prerequisite, but repetitive patterns and "field" images that are basically a texture are one way of leveling a composition and avoiding excitement.

WEB SEARCH
- Marcel Duchamp
- New Topographics
- New Color Photography
- Bernd and Hilla Becher
- Edward Ruscha
- Robert Adams
- Nicholas Nixon
- Stephen Shore
- Lewis Baltz
- Eliot Porter
- Ernst Haas
- Max Kozloff
- John Szarkowski
- P H Emerson
- Susan Sontag

➤ STRIVING, AND NOT STRIVING, FOR EFFECT

Doors, as subject matter goes, are usually passive, with strict shape and no depth to speak of, so good material for low graphic style. The first image, interesting though the actual door may be, is as anonymous in composition as possible, shot with a standard lens from in front. No photographer's personality comes through and there is no graphic play. A robot could have been programmed to shoot this. Nevertheless, it does its job as a "truthful" record. By contrast, the image of a Hollywood Art Deco doorway makes every effort to be graphically strong. An ultra wide-angle lens has been used (the equivalent of 20mm full frame) to give subjectivity and depth, and an interesting composition has been attempted out of rectangles and trapezoids.

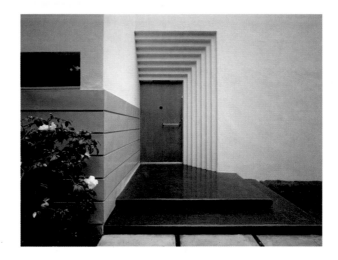

➤ PLAIN PORTRAITS

Portraiture has also been treated in the low graphic style, notably by German disciples of the Bechers. In the search for plainness, this meant both flat and hard-edged lighting—at least not using known "beauty lighting" techniques, and an avoidance of makeup and grooming in general, and expression. With people as the subject, reducing the graphic component means a passive pose to keep shapes and lines simple, avoiding diagonals, and a plain expression. This would favor the first of these two shots. While the frame is the suitably static square, the overall low-graphic effect is rather spoilt here by the strong rectangular division and off-center placement—clear signs of compositional "manipulation."

➤ THE DEADENING EFFECT OF REPETITION

A work by artist Liu Jianhua features a mass of white items of garbage packed into a transparent acrylic box. The repetition of shapes approaches a textured surface with no single element on which to focus. This, and its lack of color and contrast effectively remove graphic interest. What substitutes interest is the sheer mass of white discarded objects. Compositionally, contrast this with the image of plaster models for perfume bottles—this is also white, repetitive and low in contrast, but with a pronounced and rigorous sense of composition that puts it in the category of high-graphic minimalism.

MINIMALISM

The term "minimalism" is so well used, particularly when applied to design, that few of us stop to think what it really means. "Minimalist" implies a rigorous trashing of anything fussy and decorative, and tends to carry a high approval rating, even from those who wouldn't want it in their homes or on their walls. In fact, it has a precise history in art and design, beginning in the 1960s, with influences that can be traced back to the beginnings of modernism. Or, I should say, two rather different histories between art and design. This difference is important for minimalist photography, because it offers two routes: that of choosing minimalist subjects to shoot, and that of making minimal compositions from any subject.

Minimalism has its widest reach to the public through design, particularly in the form of product design, interior design, and architecture, because we are in daily contact with these. Moreover, minimalist home designs have survived and even gained in popularity over a remarkably long time, which suggests a fundamental appeal rather than a passing fashion. Not everyone wants to live in minimalist surroundings, of course, but most people admit to seeing the value of stripping things down to their essentials—which is the underlying theme for minimalist design.

Renowned architect, Mies van der Rohe, declared "Less is more," while product designer Dieter Rams stated "Less but better," and Buckminster Fuller, a structural engineer, spoke of "Doing more with less." These are mantras that are rarely challenged, because they go right to the heart of modernism and to such basics of composition as economy of means, structure, and unification. Above all, minimalism is reductive; it involves paring things away and stripping the result down to the essentials. This means thinking carefully about what the essentials are, and the natural result of this is the modernist principle of "form follows function" (or form follows structural needs). The logic flows on to a rejection of ornamentation and fussy decoration, instead showing a preference for clean and simple geometry. All of this reduction inevitably leaves negative space—large voids whether in surfaces or volumes (such as removing walls from an interior to enlarge and simplify the space), and these are important elements.

In painting, all of the above have their equivalent, as the accompanying grid shows. While art isn't tied to function as is design, minimalism means less subjectivity and a cooler and more distanced execution. Instead of rejecting ornamentation, minimalist art rejects the pictorial and the representational, preferring abstract geometry. Empty areas of the frame take the place of negative space in an interior, and is treated equally seriously. Where design and art part company when it comes to minimalism is that while designers and architects revel in establishing an identifiable, marketable style, most artists resist being identified with this as a movement. Also, designers tend to concentrate on the specifics of each project, looking for the neatest solutions, while in the visual arts, minimalism has a deeper conceptual motive. Simultaneously, all of this sets the scene for minimalism in photography.

If I'm placing what you might think is too much stress on design, it's because this on its own gives a special opportunity for photography. By choosing the right subject material you can get straight to minimalism in the image without having to struggle to clean up and reduce the scene in front of you. You could say, in fact, that there are two routes to minimalism in photography. One is recording and playing with already-minimalist subjects, such as interiors and products, while the other is applying a set of techniques designed to reduce and simplify any scene. Bring the two together—minimalist subject treated minimally—and you have the potential for very graphic, even abstract imagery. In finding a suitable subject, the world of design and architecture is valuable ground, not just contemporary, as the vernacular interior of the oratorio illustrates (see page 131). The natural world also furnishes pared-down scenes, both through elemental topography (the meeting of sea and sky is one obvious example) and through light (such as mist, fog, contre-jour).

MINIMALIST PRINCIPLES IN DESIGN AND VISUAL ARTS	
DESIGN	VISUAL ARTS
SIMILARITIES	
Reductive	Reductive
Stripped to essentials	Stripped to essentials
Form follows function, structure	More objective than subjective
Against ornamentation	Anti-pictorial
Geometric	Geometric abstraction
Negative space	Empty areas
DIFFERENCES	
An acknowledged movement	Most artists reject the label
Personality cult	Opposed to expression
Neat solutions to specific problems	Conceptual

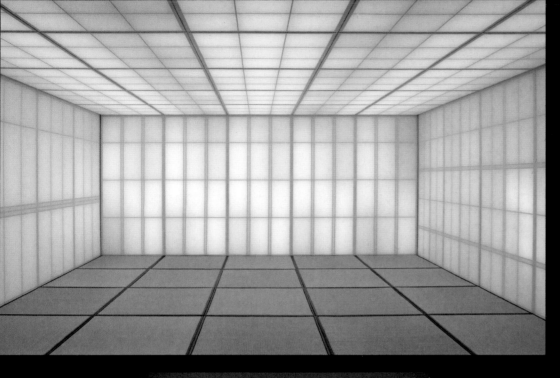

◄▲ THE JAPANESE INFLUENCE

The development of minimalism in the West was inspired to an extent by Japanese principles of simplicity and understatement. These go all the way back to Zen Buddhism and the difficult concept of wabi-sabi, which among other things means a rejection of the elaborate and sophisticated. This Zen meditation space is rigorous in its simplicity, the geometry of the paper walls and ceiling echoing that of the tatami mats. Squared-up and centered seemed the appropriate treatment for such an ascetic room.

◄▲ MINIMALIST SUBJECT

Minimalism arguably has its strongest expression in design, and this is one example: An office interior all in metal, including the floor. One chair was provided—the designer's choice. This, then, is first and foremost a photograph of a minimalist subject. The minimalism in the composition comes from the squared-up camera angle and the near-central positioning of the window and chair. Notice how little difference there is between the photograph and a schematic rendering—this is typical of minimalist imagery.

Whether or not you look for a minimalist subject, the techniques for shooting a minimal image borrow from the same set used by designers and painters. Above all, this means reduction, elimination, cutting out, and an emphasis on clean, simple lines, and shapes in preference to the complex fractal ones often found in nature. This is followed by selection, and can be enhanced by processing in order to keep the inevitably largely empty areas smooth and consistent in tone and/or color. The process, however, is rather the reverse of minimalist painting, because the starting point is a scene in reality that is likely to be messy, rather than a blank canvas. The process usually begins with ultra-careful framing, by choosing viewpoint and focal length in order to find the cleanest and simplest section of the scene. Then, balance and division need to be handled in such a way that the "blank" areas get their due prominence—if there are accents, eccentric placement may be the answer. Yet historically, no declared "Minimalist Photography" movement ever appeared, and the probable reason is that the kind of reduction by framing and cropping out that is needed is something that most photographers do in any case. Whatever the reason, minimalism in photography is generally seen as a stylistic technique—a useful one that can be applied in many situations. It appears at times in *Low Graphic Style*, as we've already looked at, but also, as we'll see shortly, in *High Graphic Style*.

MINIMALIST PHOTOGRAPHY

Choose a minimalist subject: Not essential, of course, but with minimalism so popular in design, one obvious route for photography.

Framing: To cut out elements from the view.

Consistency of tone and color: Many minimalist images have a simple overall theme of tone and/or color. White has a special place in minimalism, so when lightness is the theme, this suggests full exposure just short of highlight clipping, and compressed (low) contrast.

Clean lines: Simple, preferably geometric lines and shapes.

Processing: To unify areas of tone or color, or to heighten contrast with an accent. Contrast, clarity and vibrance controls in raw converters are all useful, as is careful control of exposure, recovery and clipping.

Emptiness: Void and negative areas in the frame are important in minimalism, and call for sensitivity in handling when composing. They typically need to be organized so that the attention will fall on them, and often call for smooth, clean rendering (which may be a matter of processing—see above).

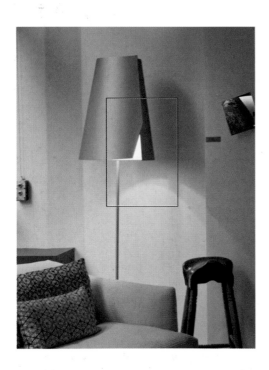

◄ CROPPING FOR ESSENCE
A contemporary lampstand, and two ways of dealing with it. In the smaller image it is shown full height and in its setting: a standard interior shot. But the design of the lamp can be more effectively put across with a much tighter shot. The basic cone shape, thin column, texture, the distinctive cut-out, and even how the light from the lamp falls on the wall are all contained in this one part. By eliminating everything else, we see more of its lines, especially the play of diagonals.

⊼ MINIMAL CONTRAST

Morning mist and a fisherman wades across shallows to his boat, which is out of frame. Fog and mist are good conditions for suppressing detail. Here they are used to isolate just two essential components and show them on the edge of recognizability: the man wading, and the glitter of highlights in ripples to show that this is water. A few seconds earlier, a previous shot, shown here smaller, left out the ripples. This also worked as a minimal composition, but in a different way, leaving the viewer to work out the situation. On balance, I prefer the main shot.

◂⊼ SIMPLICITY IN THE SUBJECT

This is the interior of an adobe oratorio (a small building for prayer) in New Mexico, with a plain mud floor and walls, muted colors, and its only decoration a small drawing of a cross. This was perfect material for a minimalist treatment, which consisted of making sure that the lighting was flat (by choosing the time of day when no direct sunlight entered), a full-frontal squared-up camera angle, and a framing in which the far wall is almost centered. The reason for giving slightly more space to the floor was to avoid showing much of the timbered ceiling, keeping the graphic activity in the picture to a minimum.

HIGH GRAPHIC STYLE

At the other extreme from the intentionally plain, uninflected style in which there is very little rhetoric in the composition, lies high graphic style. It is the opposite, however, only in its rich graphic effect, not in its philosophy. High graphic style has no manifesto, simply a liking for excitement, surprise, and energy. In this sense, it simply takes up the ideas and techniques of classical, well-balanced composition and takes them further. The unspoken argument is that if you like, say, dynamic balance in an image, then you might enjoy a really hyperactive composition.

So, whereas the low graphic style of the New Topographics *et al* has a post-modern, often ironic concept behind it, high graphic style is more fixed on the practicalities of composition and on seeing how far geometry, color, and so on can be pushed. What they both have in common is their motivation to do something different from the ordinary. High graphic style has popped up regularly throughout photography's recent history, and its chief characteristic is that graphics in the image take pride of place. They tend to be noticed before (if only fractionally) you understand what the photograph is about.

Early instances from the history of photography include the constructivist still lifes of Paul Outerbridge and Bill Brandt's experiments with a police forensic camera. Outerbridge relied on precisely angled lighting that was often hard edged and on angular compositions, while Brandt's series of nudes made use of an uncommon optical technology. These two approaches continue to be used—extremes in composition and adopting new imaging technology as and when it appears. Two inventions above all have had a major influence: One is the ultra wide-angle lens, the other is post-capture manipulation. Ultra-wide lenses made their mass-market debut in the early 1960s, and were quickly picked up by advertising and editorial photographers who wanted to have an edge to their imagery. They were encouraged by art directors and picture editors at a time when pop culture was taking off and everyone wanted

visual excitement. Art Kane and Guy Bourdin were two of the best-known practitioners of lenses in excess of 24mm. When fisheye lenses became available, they too were co-opted in a brief vogue.

Manipulation has also played a part in exaggerating the graphics, first enhancing contrast in black and white, then altering and enriching color. This moved from the darkroom (high contrast prints, line negs, slide duplication, and cross-processing) in a spectacular jump to the computer, where anything can be achieved. It's hard to know where photography fits in the fully liberated world of digital color, let alone what can reasonably be done to just the graphic component of the image, and photographers' use of software runs the gamut from extreme caution to "anything goes."

One of the most reliable ways of heightening the graphic elements is to increase the angularity, on the grounds that diagonals impart energy, movement, and direction. There are several techniques for doing this, including the one we just looked at—using an ultra-wide lens. It is not simply the wider angle of view that exaggerates geometry, however, but the viewpoint in relation to near and far objects. Used close, and especially used close to objects with a strong and linear structure, such as straight lines and definite shapes, an ultra-wide focal length exaggerates linear perspective. What might seem to a traditionalist hopeless distortion, becomes to people who like strong graphics, exciting and energetic, with a hint of the unusual. To get the most out of this effect, it pays to experiment with a wide variety of camera positions, particularly strange ones, such as from below or from above.

Angling the camera, either by tilt or pitch, is the other standard technique for introducing diagonals. This works whatever the focal length, but when combined with an extreme wide-angle lens can be very striking. Good depth of field from a small aperture keeps the lines sharp, which always helps the effect. Diagonals that break the frame edges do an even stronger job.

Different diagonals, fanning out, or crossing each other, or converging on a point inside the frame, have predictably more energy than just one. This technique has a longer history than many people would imagine. Two photographers who used it in the 1960s were Robert Frank and Garry Winogrand. I say "used" because neither photographer claimed deliberation; it seems more a case of freedom from the prejudice of needing to keep things straight. Winogrand was often asked about this at lectures, and usually denied that there was any tilting. He said, "There's an arbitrary idea that the horizontal edge in a frame has to be the point of reference. And if you study those pictures, you'll see I use the vertical often enough. I use either edge. If it's as good as the vertical edge, it's as good as the horizontal edge. I never do it without a reason. The only ones you'll see are the ones that work. There's various reasons for doing it. But they're not tilted, you see."

WEB SEARCH
- Post-modernism
- Paul Outerbridge
- Constructivism
- Bill Brandt nudes
- Art Kane wide angle
- Guy Bourdin wide angle
- Robert Frank
- Garry Winogrand
- Cézanne's *Maison Maria with a View of Chateau Noir*
- Erle Loran

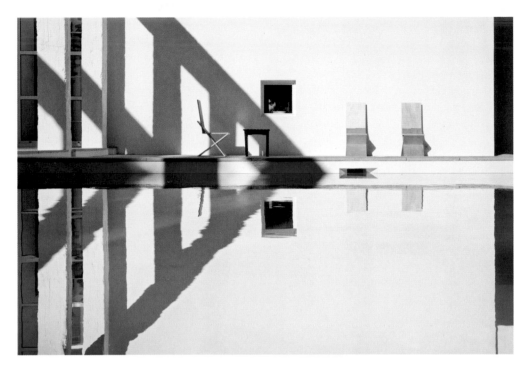

The stark contrast of hard-edged shadows falling on the columns and wall of a modernist villa in Portugal, all doubled and reinforced by reflections in an unruffled swimming pool, make sure that the lines in this image dominate the attention. The diagonals, as usual, attract the most attention and give it its dynamism, but it is by contrast with the verticals that they come across so strongly. Processing for high contrast and high clarity makes the most of this potential. The reality of the scene registers a little later than the graphic design.

▼ EXTREME PITCH AND TILT

Appropriately for a huge religious space that everywhere invites congregations and visitors alike to gaze upwards, the Basilica of St Peter's, Rome, is treated here with a near-vertical pitch and an equally striking tilt that works to the diagonals of the frame.

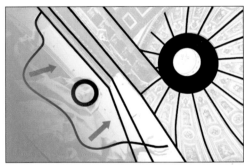

Neither Frank nor Winogrand were the first to invent tilted shots, although it does seem that photography up to the 1960s had been generally content with keeping things straight and correct as much as possible. We only have to go to the painter Cézanne to see deliberate tilting. In his painting, *Maison Maria with a View of Chateau Noir*, executed around 1895, almost all of the lines that ought to be vertical or horizontal lean to the left, with just two tree shadows in the foreground as clues that the canvas hasn't somehow slipped in its frame. The American art historian and artist Erle Loran spent two years in the late 1920s living in Cézanne's studio and photographing the locations of his paintings, analyzing them carefully in his book *Cézanne's Composition*. As he wrote about this painting, "It is obvious enough that the dynamic quality is not suggested by the photograph of the motif, Cézanne has imbued a banal subject with drama … The lifted, suspended feeling in the Maison Maria, for example, derives principally from the leftward axial tipping of its three masses."

Extremes of placement and division are natural tendencies for high graphic style, in effect pushing the limits of dynamic energy in the frame. In *The Photographer's Eye*, I looked at this topic at length, making an arbitrary division of where a main subject gets to be placed: fairly centered, moderately off-center, or extremely off-center. These are just practical categories, but the main arguments are that centered is statically, but not dynamically, stable, while off-center positioning introduces some dynamic balance and can be made to fit any of the several classical harmonies that painters have evolved over centuries. Pushing placement toward an edge or corner increases the dynamic energy of the image, as you would expect, but it also raises questions in the mind of the viewer as to why: The more extreme the asymmetry, the more the viewer expects a reason for it and, theoretically at least, someone looking at such an image will be that bit more prepared to examine it carefully for the justification.

So, according to classical composition, a logical reason justifies placing a key element in, say, a corner. The image of the ultra-modern tea shop is a case in point. The figure of the girl making tea faces into the scene, and it is this interior in green, yellow and white that we want the viewer's attention to hold on to. Her figure helps the dynamics of the image, acts as a right stop, and "points" inward. But in high graphic style, the reasons for very eccentric placement are likely to have more to do with the graphics of the image than with the logic of the subject. The aim is to create some excitement for the viewer, even at the risk of seeming a little perverse. Straying from conventional methods, of course, always runs some risk of being disliked and rejected by some people. The other examples of extreme placement shown on the following pages are more motivated by graphic energy and interest than by subject logic.

Contrast can also play a part by simplifying detailed content into shapes and lines, which is another way of subordinating the subject to its graphic treatment. This works both in the tonal contrast (hard-edged shadows are especially useful, as in the picture of the swimming pool on the previous page) and in color contrast, with deepened saturation. Heavily saturated colors are very energetic, even more so when they oppose each other. Above all, graphic strength takes precedence over content in this style. The search for correspondences of line, shape, and so on, has priority, even if the actual subjects being fitted together have nothing to do with each other. This, of course, is exactly what post-modernists of low graphic style are against—the overt manipulation of composition.

▼ ECCENTRIC WITH GOOD REASON

The stretched frame proportions of 2.2:1 (extended by shooting three overlapping frames and stitching) make the placement of the girl's figure deep in one corner even more eccentric than it would be with a normal frame. Yet apart from catching the attention strongly because of its extreme position, it works without upsetting conventional composition. It does this because of the logic of the subject. The image is clearly about the interior of a highly designed tea shop. The figure of the girl plays the rôle of underlining that this is about tea, and framed against the small rectangle of white wall can be understood to be at the edge of the stage, as it were, very slightly separated from it. She faces into the scene, so acting as a right stop.

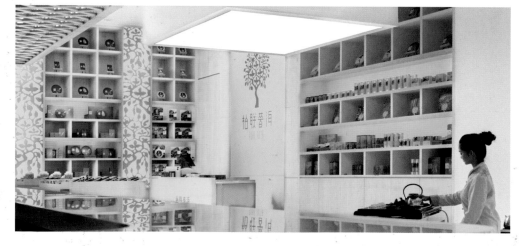

◄ ▲ TILTING FOR DYNAMIC EFFECT

The sequence of frames leading up to the final image gives clues about the process of composing this shot of a Burmese marble carver working on a Buddha statue. The statue was already tilting forward slightly, and as the carver leaned in to his work, it suggested that the two were somehow in unison. This itself suggested tilting the camera to exaggerate this slightly, in order to stress the similarity. But it needed to be done discreetly, without making it too obvious. This worked because there were few significant verticals to draw the attention. In fact, only two elements, the wooden struts framing the man and statue, are possible verticals in real life, and even this is not conclusive from the final image. As well as bringing a dynamic sense to the image, tilting also made it possible to close in more tightly and fit the statue and man more comfortably into the frame, from the Buddha's head at top left to the man's elbow at bottom right, with minimum wasted space. The elements that actually anchor the image are the two arms, which are in roughly similar positions, aligned with the bottom edge of the frame.

⌃ EXTREME PLACE, EXTREME PLACEMENT

At almost 20,000 feet (6,000 meters), the pilgrimage circuit around the sacred mountain of Kailash in western Tibet is exhausting and difficult. A Tibetan woman rests in discomfort before continuing the high-altitude climb. Placing her at the extreme left, using a wide-angle lens, does two things: on a practical level it directs attention to the rocky climb ahead, but on the level of allusion it matches the sense of dislocation.

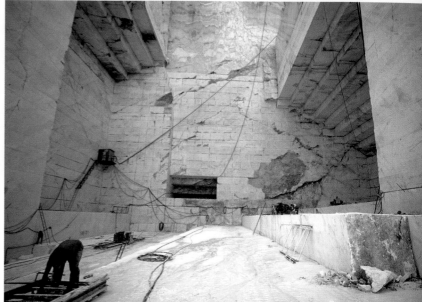

⌃➤ OUTWARD CORNER VECTOR

The marble quarries at Carrara in Italy, used by Michelangelo and countless other sculptors, are on a huge scale that virtually demands a human figure for comparison. The sheer size, and the perspective distortion from a 20mm wide-angle lens tilted upward, set the stage for a composition that suggests extreme dynamics. For this reason, it made sense to accelerate the dynamic flow outward via the small figure in the corner—and also to wait for him to be in a position that points outward.

◄⌃ PITCH AND TILT WITH A MEDIUM-TELEPHOTO LENS

Viewed from an upper deck, passengers board a riverboat in single file along a single plank. The simplicity of the scene—a continuous column of figures against dark water—suggested a simple compositional device, aligning the file of people to one diagonal of the frame. From this overhead view, the tilt to the left is not particularly remarkable, and if anything, adds some directional tension to the image.

EXTREME VISUAL RECIPES
Angularity
Distortion
Extreme placement
Extreme proportions
High contrast
Super-saturated color
Geometry over content

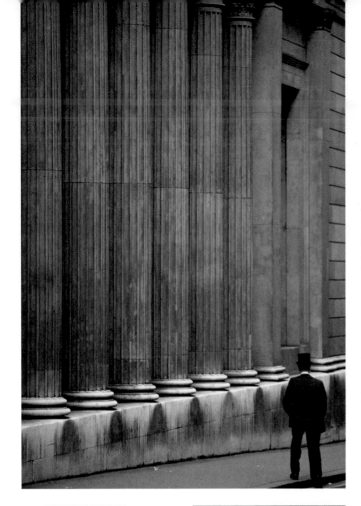

◢ ➤ COUNTERPOINT

In this telephoto shot of the side of London's Bank of England, the row of columns was intended as the main subject, hence the angle and long focal length to compress them into a single unit. Yet the small figure of a top-hatted City broker (this was photographed in the 1970s) was not an afterthought. It was essential to have some action and a counterpoint to what otherwise would have been a rather boring "wallpaper" image. It could have been framed differently or shot from a different viewpoint that would give more prominence to the figure, but the decision was to keep it from breaking into the columns. This almost automatically led to this composition, in which the figure is confined to one edge of a slim triangle at the base of the frame. A possible magazine cover, it was shot with the anticipation of text filling the top of the frame.

◤ AN ACCENT OF ACTION AND COLOR

In some ways, the motivations for this image of the Buddhist temple of Bodh Gaya in India are similar to those for the Bank of England shot. The structure itself is the main subject, but there was a problem in that, at the time, the upper part of the famous building was under scaffolding. I therefore had to find a closer view to exclude the construction work, which in turn meant that some relevant human activity was needed to help out. There were several opportunities as I waited, but this one, of a monk, was for me the most relevant and the most energetic. The color of his robe, set against the yellow-brown color of the building, made it possible to keep him close to the corner and still remain noticeable, while devoting most of the space to the temple.

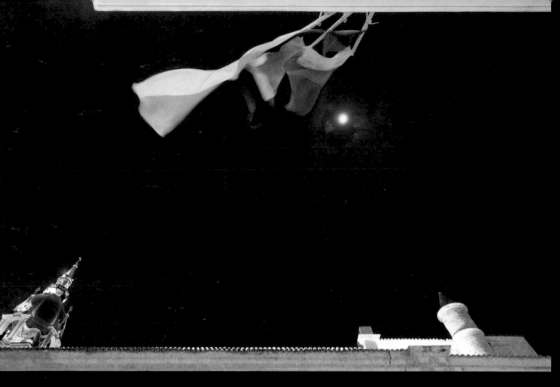

With the camera aimed directly upward, the idea of this shot was to just cover the width of the street in this South American colonial city, using an ultra wide-angle (20mm) lens, and then work into this a triangle. The division of area, therefore, is extreme —a large rectangle of blue sky enclosed by very narrow strips, and the two towers at the bottom are pushed right into the corners to make the central triangle as large as possible.

Note that two elements contribute to the apex of the triangle: the full moon and the Colombian flag. On this windy night, it was obviously worth waiting for the right configuration of the flags, which in this case meant conforming to the left diagonal of the implied triangle.

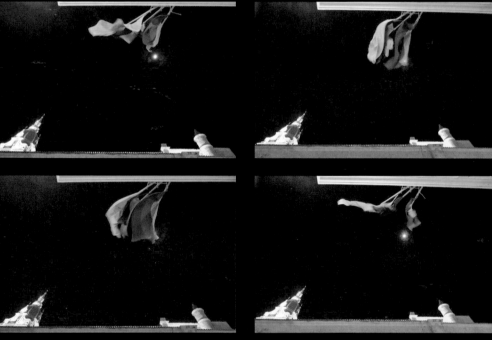

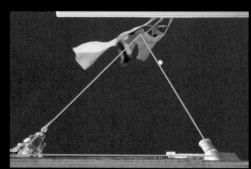

◄ EQUILUMINANT VIBRATION
When two opposed colors (meaning hues on more-or-less opposite sides of the color wheel) are together in the frame but with the same brightness, an optical effect happens called vibration.

◄ ▼ UNRELATED ALIGNMENT
Shooting into hazy, late-afternoon sunshine across a lake made three predictable conditions. One was that there would be silhouetted outlines, the other that there would be exaggerated aerial perspective, and the third, reflections. Also, because the lake separates two planes (foreground and background), the aerial perspective would set dark, close silhouettes against pale, distant ones. The boardwalk provided a platform for things going on in the foreground, and in this shot, the crouching man offered the irresistible opportunity of aligning him with the tower in the background and its reflection. If he had been standing, the reflection would have been obscured and the graphic alignment less interesting. So, a simple horizontal-and-vertical composition makes an ordered image out of unrelated subjects.

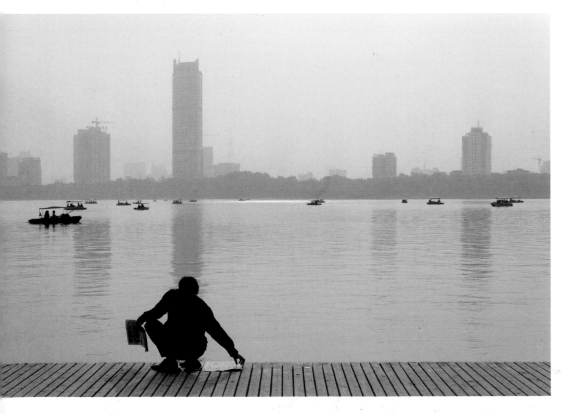

ENGINEERED DISORDER

A contemporary breakaway from classical composition uses individual experiment rather than deliberate policy to challenge the accepted norms. This is less a movement than a common urge among some photographers to find new ways of organizing images—indeed, finding images—that still work formally while flouting some of the basics: such basics as unifying elements in the frame, easy readability, and directing attention toward a main subject. There may often be no main subject other than the composition and satisfaction of playing with unusual lighting. This style makes use of various kinds of fragmentation and cut-offs, high contrast lighting, blocking areas of interest with intentional obstructions, and superimposed layers, all in order to temporarily confuse in the search for interest.

At first glance there is a hint of deliberate chaos—quite the opposite of what conventional composition aims for—but behind this there is considerable effort to organize, just not in predictable ways. The apparent disorder and disconnection is itself an illusion, because for this kind of experimental composition to work, it needs more concentration and imagination than do the expected techniques. Gueorgui Pinkhassov of Magnum and Laura El-Tantawy, who both push this particular envelope in different ways, are typical in that they see this as an entirely personal investigation free of any group mentality, and aim to satisfy their own curiosity. El-Tantawy says, "I very much embrace the concept of being different and innovative and this is probably at the very core of 'the look' in my pictures," adding, "A large part of it has to do with the element of mystery, which psychologically I'm drawn to. With my kind of photography I don't want to answer a lot of questions. I want to engage the people who look at the picture and provoke them into saying, 'What is she trying to do? What am I really looking at ?' I like to engage viewers into thinking beyond what they're seeing."

This statement neatly encapsulates the attitude that composition does not have to solve problems, but can instead provoke and ask questions of the viewer. What's going on here? Am I supposed to discover something in this image? This is tricky ground, and experimental composition can be easily dismissed if not taken seriously. But, if the viewer feels safe in the hands of a photographer who seems to know what he or she is doing—even if it's all a bit puzzling—there is the potential for very rewarding interest. The art historian Ernst Gombrich, in *The Image and the Eye*, written well before this kind of experimental composition, makes the point that the capacity of viewing audiences to read photographs and accept new styles is always increasing because we see so many. So "our tolerance" of things like blur "is due to an understanding of the situation in which the picture was presumably taken." He cites several examples of technique and style in photography that "would not have been acceptable," or "were pronounced illegible," or "would hardly have been selected for publication" in previous decades. This applies to everything to do with style in photography, and has been accelerated by the fact that now millions of non-professionals use cameras that are almost professional.

One frequently used technique is the disconnect. This is my blanket term for various ways of fragmenting or segmenting the image. On the face of it, this runs exactly counter to one of the principles of "good" composition that we looked at earlier—unity. Breaking an image up, instead of tying it together, seems to flout this basic idea. However, as we'll see, this is not that simple. A deliberately disconnected image usually takes longer to read, but the segments themselves can have an order. The most common method is to use hard chiaroscuro lighting—the kind of high-contrast dappling that happens when strong sunlight filters through gaps onto an otherwise shaded area. The examples here make this clear. Many people would consider this type of lighting condition a problem that needs to be solved, or avoided, but it has compelling graphic qualities.

These are richness and contrast, slowing the viewer's response by making it less easy to read (yes, this can be a good thing if not overdone), and creating a group of light patches that can be composed as graphic elements. So, while not unified in a conventional way, disconnects can be highly structured graphically. In fact, disconnects tend to convert recognizable and realistic picture elements into graphics.

➤ **A MATTER OF TREATMENT**
Disconnects can depend on processing, especially those that depend on the hard light of chiaroscuro. This image, of a man smoking a cheroot next to a colorful blanket used as a shade against strong sunlight, illustrates the point. The main image of the three is treated during Raw processing to give a vivid, highly contrasting result, so that the lit areas of hand, the side of the man's face and upper body, and the blanket, become independent units, with no shadow detail at all. This was the effect aimed for when shooting, and its positive qualities are rich color, a vivid sense of texture from the contrast, and that it takes a few seconds to make sense of the scene—in other words, it involves the viewer more by making it less obvious.

The second version has been processed for maximum recovery of detail so that all the shadow areas are opened up and we can see exactly what is going on. Far too much, to my taste, and the image loses interest as well as the intensity of color and tone that the strong sunshine created. The third version is more "normal" (in fact, the Auto interpretation of Photoshop's Raw processor with some added vibrance). From the point of view of composition, the "hard" and the "open" versions are completely different kinds of image.

◄▲ MIRRORED LAYERS

An arrangement of mirror mosaics on a pillar in Rangoon's Shwedagon Temple creates a complex image when shot with minimum depth of field and focused on the distance. Full aperture and a close-to-standard focal length of 62mm make the mosaic design itself unreadable, introducing uncertainty about what is actually happening here, with sky and golden stupas overlapping without apparent reason. Including two small recognizable figures at center-right anchors the reality.

Another technique is the disruptive foreground, often out of focus. There is nothing unusual in selective focus that favors the distance, but in this case the foreground dominates in area and position, forcing the attention to try and look around and behind it. By being out of focus as well, it has the appearance of an obstruction. It can't be ignored, but because we are naturally and strongly drawn to sharpness in an image, our attention is confused. We want to see behind and beyond the foreground element, but then our eye slides back to it because of its size and position. This treatment tends to work best when there is sufficient information for the viewer to understand the foreground element: expression in a face, for example, can easily be read when blurred, and silhouettes can be perfectly legible.

Interestingly, when you are shooting like this, the degree of readability in the blurred foreground is not at all certain, especially if you shoot with both eyes open, as most people I know do. As you shoot, you know exactly what is going on close to the camera, but the defocusing effect of a wide aperture, which is all anyone else is going to see, will be less intelligible. Experimenting and selecting later is the only practical answer, and there is some entertainment in this uncertainty.

A broken frame is another device that can be used to introduce the unexpected. Typically, what would normally be an attention-worthy subject is cut off at one of the frame edges: Faces bisected by the frame edge, or limbs intruding, are common. Again, by conventional standards, this would be sloppy framing or bad timing, but if the object is to challenge ordinary composition through experimentation, the effect can be striking. The argument for this is that it increases the energy in the composition by making the attention jump, and also raises questions about what detail lies beyond the frame—possibly intriguing, in other words. More than most of the techniques listed here, frame breaks are very much a matter of taste, and opinion is likely always to be divided. Some people will never

be convinced that the image is anything other than awkward bad timing, and there's nothing to say they are wrong. In passing, I'd like to draw your attention to one Robert Frank photograph singled out for inclusion in John Szarkowski's influential book *Looking at Photographs*. The image already contains a visual joke, of a tuba taking the place of the player's head, but there are also parts of bystanders' figures cut off left and right by the frame. Here is what Szarkowski liked about it: "The photograph reproduced here is a perfect specimen of what was at the time a new genus of picture. The human situation described is not merely faceless, but mindless. From the fine shiny sousaphone rises a comic-strip balloon that pronounces once more the virtue of ritual patriotism. On either side of the tuba-player stand his fellows, as anonymous and as dependable as he." The "new genus" that Szarkowski referred to included a willingness not to mind about broken frames and even to use them to convey something out of joint about the situation. In passing, it is also probable that Frank was more concerned about including enough of the flag above, and accepted that the part-figures had to be in the shot to make this happen.

Finally, there are superimposed layers of subject. To blend two images into one, especially by using reflections, is again nothing new, but here it is usually done in such a way as to create an early sense of dislocation in the viewer. The image needs some attention to resolve. Extra points are gained for making neat graphic coincidences between the layers. In addition to reflections, screens can be valuable, as indeed can anything that is partly transparent. And also I should include double exposures. I use this rather old-fashioned term because, while nowadays superimposing and blending images is a very overused technique in Photoshop with little originality left in it, doing it on the spot while shooting reflects some skill and creative imagination.

EXPERIMENTS IN COMPOSITION
Disconnects: Fragmentation or segmentation of the image by means of light (such as chiaroscuro), or reflections, or shadows.
Disruptive foreground: Typically out of focus, partially blocking the view, yet relevant and partially recognizable.
Breaking the frame: Key elements breaking into the frame or partly cut by the frame edge. Conventionally a mistake, but here deliberate, pulling the eye outward and creating a question of what else is happening beyond what is visible.
Superimposed layers: Reflections and screens are the two most common ways of layering one subject or scene over another. Tends to dislocate the overall image, but can create interesting juxtapositions.
Extremes of contrast: Commonly used to reinforce some of the above techniques, in particular disconnects.

WEB SEARCH
• Gueorgui Pinkhassov
• Laura El-Tantawy
• Robert Frank tuba

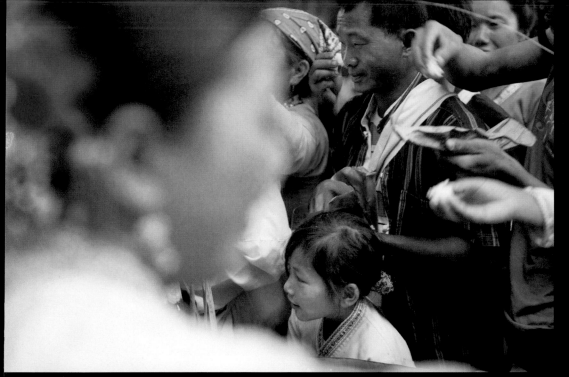

◀▾ DISRUPTIVE FOREGROUND #1

This situation needs explaining. This is a yearly ceremony on a remote tea mountain in the far southwest of China, in which offerings are made to the mythical ancestor who gave this ethnic group the tea tree. Members of the community circle the table of offerings, presenting small handfuls of sticky rice. It is a good-natured affair, and everyone is dressed traditionally for the occasion. Shooting across the offering table toward the crowd on the other side would be fine, but predictable. Stepping back and waiting for the right moment gives the foreground of a woman with flowers in her hair—all of which is readable, even if unfocused. This was selected from many frames, for three reasons: the defocused foreground has all the elements in place (flowers, hair, profile), the little girl fits neatly into the wedge-shaped gap between the face and shoulder, and the disembodied hand offering a ball of sticky rice adds a welcome vector to the scene.

◀ DISRUPTIVE FOREGROUND #2

Another occasion that merits some background information. This is a highly mechanized Coca-Cola plant, and the Sudanese company has a policy of employing disadvantaged people—in this case, with hearing impediments, so they are put to quality inspection on the bottle line. This makes the face of the inspector especially important. The shot is taken through the line, and the unfocused oblongs of light are reflections from the passing bottles. The timing of the shot is obviously critical, and this was one of many. As with the photograph of the tea tree ceremony, it needs a caption, which for some people will disqualify it as an image, but it played a part in telling a larger story of contemporary Sudan.

▲ DISRUPTIVE FOREGROUND #3

A disruptive foreground with a hidden agenda. The assignment was a portrait of one of Japan's leading architects, Kengo Kuma. Here, he is behind one of his designs, a vertically slatted wall painted with Japanese characters. Vertical slatting in various materials is something of a trademark for Kengo, as is ambiguous layering in his designs.

▲ BROKEN FRAME #1

As is typical with this kind of unexpected frame break, it boils down to a matter of taste—liking or not liking. The setting is a wet market in the early morning in upper Burma, the lens 20mm, and I'm walking through. Now, I could have tripped the shutter a fraction of a second earlier and caught the man carrying the basket of fish neatly and completely. But I didn't, because I've done that kind of shot many times before, and have been in countless similar markets. I wanted something different—the sense of being there in the concentrated rush of market day. Cutting the man mid-face gives a more urgent feeling to the occasion, and the feeling that we're walking through the scene—like a still frame from a movie clip. In film this is sometimes called "subjective camera," and a wide angle at eye level does this pretty well. Maybe I also wanted to see more of the fish.

◄ BROKEN FRAME #2

Using rear curtain flash and a 1/13 sec exposure provide the expected combination of sharp and blurred: A girl crosses the road, while a man's arm at left does... what? It provides a balance to the girl (try covering the left of the image with your hand), but you could only guess why it is raised. Even I have no idea, and I took the picture. The real question might be why I like the image, because clearly it is not going to appeal to a number of people. Well, I like the movement, I like the way the girl is set against a matching dark patch in the background, and to be honest, I like not knowing what is going on at left. The picture has no importance, and maybe that's also why I like it.

▲ BROKEN FRAME #3

A sergeant of the Greek palace guard, known as Evzones, makes an eye-level inspection of the traditional fustanella that forms part of the uniform (unwise to call it a skirt in the presence of the wearer), checking for straightness. Cutting him off at the neck makes the point far more economically than including more of the body, and is a little more amusing. As frame breaks go, this one has a fairly obvious justification.

▲ BROKEN FRAME #4

Seen in a different context, you might not think of a broken frame when presented with this graphic treatment of a geometrically interesting design by architect Ricardo Legorretto, yet the strong wedge shape at right makes an essential contribution to the composition. It does this not only by providing a balance to the dominant mass of verticals and high wall at left, but also by offering evidence that there is more to the building, inviting the viewer to speculate. Seen adjacent to the photograph of the Evzones, the two compositions have a surprisingly

➤ SCREEN LAYER #1

A complexly patterned restaurant screen in a shopg mall provides the opportunity to experiment with focus. By opening the lens to full aperture and focusing on the screen rather than the diners, the eye's natural attention on the interior is forced forward. The scene is still completely intelligible. Compare in close up the difference between this and focusing more expectedly on the people, which is visually less interesting.

➤ SCREEN LAYER #2

Another, more subtle, double layer involving a screen. At first glance the view appears strangely out of focus, possibly even an error. However, the tiny square logos in a horizontal line a little below the center reveal that the focus is on a screen. Out-of-focus imagery has some attractive qualities, but it is difficult to convince most viewers that it is not somehow wrong—without at least including something in the image that is sharply focused.

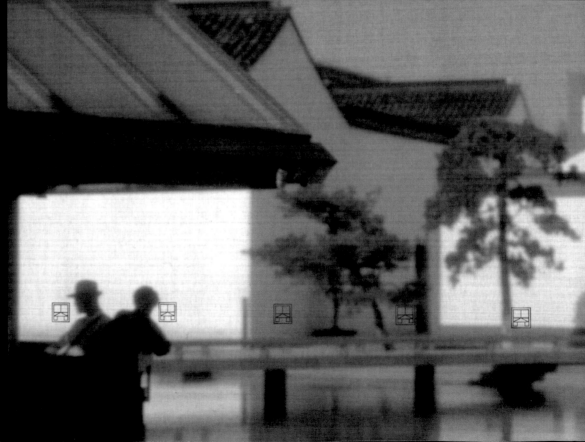

▲ DOUBLE EXPOSURE LAYERS
A double exposure of two near-identical shots taken
11 seconds apart, of a large tank of fugu (pufferfish)
at a Japanese restaurant specializing in this risky
culinary experience (parts of the fish are highly toxic).
A single view (see the smaller version) is already a
swirl of unusual colors and shapes, but doubling it
dislocates it more by adding a layer.

CHAPTER 3
PROCESS

I think it's obvious that in any good photograph the mind, eye, and camera are all connected in some way.

"Instead of photographing what I saw, I photographed what the camera was seeing. I interfered very little, and the lens produced anatomical images and shapes which my eyes had never observed," said Bill Brandt.

Brandt experimented with photographing the nude in the 1930s and early 1940s, but made a decisive breakthrough in 1944 when he acquired a mahogany and brass camera with a wide-angle lens. He enthusiastically acknowledged a debt to the wide-angle, deep-focus cinematography of Orson Welles' *Citizen Kane* (1941). The camera, a 1931 Kodak used by the police for crime scene records, allowed him to see, he said, "like a mouse, a fish or a fly." The nudes reveal Brandt's intimate knowledge of the École de Paris—particularly Man Ray, Picasso, Matisse and Arp—together with his admiration for Henry Moore.

Process is what happens during the making of a photograph. It is intimately connected with what the camera can do and with how you handle it. This is the same as in all artforms, from the sculptor's chisel to the painter's brushes and pigments, but for one reason or another it is the least discussed part of art. One reason why this might be is that during the act of sculpting, painting, photographing, and so on, so much is happening in the artist's mind and hands—and happening so quickly—that taking it all apart and describing it in words takes much, much longer. Doing so runs the risk of making it all seem ponderous and slow, when in reality it's often a rich and streamlined operation, with many strands meshing together. This is the problem with writing about anything that happens quickly: Words just can't keep up.

A second reason is the fundamental difficulty of performing this kind of dissection and analysis, even for the photographer who shot the image. It means going back in time and trying to recall the reasons for everything you did. Many photographers don't want to, they would simply rather get on with shooting and not analyze the process.

Finally, though I know this will sound arrogant and even self-serving, most of the people who write about this end of photography have only a vague idea of what actually happens. If I can't get inside the mind of the photographer who shot a particular image, I can only guess at what went into the making of it. It might be an informed guess, but it is still only a guess, and I'm not convinced that a guess is valuable enough to write about.

The artist David Hockney wrote a controversial book, *Secret Knowledge*, in which he applied his painter's sense to solving a problem in the history of painting. The core issue was realistic representation taken from life, particularly of people, related to perspective. His theory was that many more artists had used optics, especially the camera lucida, in composing paintings than had previously been thought. What made it controversial was that, from the point of view of the art establishment, Hockney had the gall to claim a breakthrough analysis—as a mere artist. But he did it convincingly and practically, unconventionally looking at it with his painter's experience. This is something art historians generally cannot, so do not, do, and most of them predictably rejected Hockney's claims. His title, of course, was provocative; this was the secret knowledge of the artist who does, rather than the critic who doesn't.

I'm certainly not promising any such revelations here, but rather hoping to show something of the complexity and speed with which the photographer's mind solves creative problems at the time of shooting. And at the same time, I would like to promote the idea that this is the way to look at, and appreciate, photographs—from the actuality, not theoretical guesswork.

IMAGE TEMPLATES

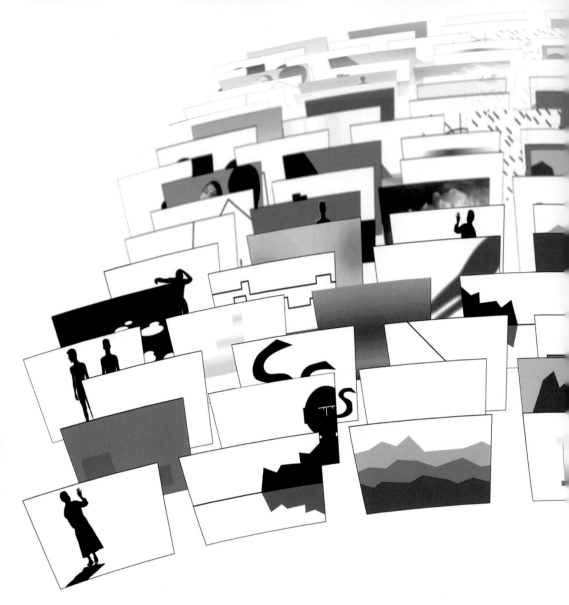

At the time of shooting, photographers look for what appeals to them, obviously, but how do they do this exactly? They may have all day to do this in a studio, or less than a second in the street, but no matter what the timescale, there is still a mechanism. But is it the same mechanism for everyone? Is it the same between slow, planned photography and rapid-reaction shooting? Most of us are too busy dealing with all the variables that go into a shot to think about this as we shoot, but it's clear that the more we know about what goes on in our heads in the moments just before pressing the shutter release, the better use we can make of whatever skills and imagination we have.

As we saw earlier, with regards to composition, there are two conflicting tendencies going on for any effective image. One is balancing, ordering, and organizing so as to satisfy the sense of rightness, the other is injecting surprise and imagination in order to stimulate. At the time of shooting—the process—there are also two opposed forces at work: drawing on what you know works from experience, and exploration and experimentation. Do the first alone, and the image may be workmanlike and satisfy a client's brief in professional photography, but it won't go much further than being just satisfactory. Do the second alone, and you may well get some exciting results, but you're also likely to be wasting valuable experience that you could put to good use.

Every photographer has a subliminal library of kinds of image that work and are preferred. For instance, over the years, I've found a number of things that I simply like visually, and which I'll generally go for if I see the opportunity for them. One, in a reportage situation (less in a studio) is edge-lighting against a dark background. It's not very common, so I haven't become tired of it yet. If you think about it, there are certain kinds of image that will trigger your interest. But of course, most of us don't think very much about this. Instead, these likings just pop up when we're faced with a scene in which they might be relevant. Or perhaps they fail to, and later, looking back on the situation, we regret not having tried for that certain kind of image.

This is not simply a novel explanation, but something that has a solid grounding in cognitive vision, which works as a practical extension of the top-down theory of visual recognition. This sounds complicated, but it means that the way humans actually use vision is to combine the sensory input from the eye with an interpretation that is driven by what the brain expects and knows. Good though the resolution of the human eye is (though several times less than that of a hawk), what it images still needs to be interpreted. So, depending on what we are looking at and what we are interested in, we make sense of things by making them fit into what we already know. What we receive from the eye is bottom-up information, but what sense we apply to the image is top-down interpretation. For example, if we see something a little unusual, we tend to compare it with similar-looking things that we're already familiar with. One reason why people make mistakes in what they remember seeing (think of conflicting versions of an event presented in evidence in a courtroom) is that they expect to see something rather more strongly than the visual information justifies. We do this much of the time, and it's because our top-down visual processing plays such an important rôle.

higher success rate in shooting? I believe we can, by taking a long, cool look at the kinds of image that attracts us personally and thinking about why, and looking at how our taste changes over time. What I'm building up to here is that by making ourselves aware of this store of potential images, we are much better equipped in our imaginations for finding successful pictures in any kind of situation.

The idea that the photographer's mind is an innocent, open receptacle waiting to be filled with chance imagery makes little sense. We are always to some extent prepared, even if subconsciously. Anyone who says, "I didn't think, I just saw it and took the picture" is being disingenuous. Naturally, no-one is being forced to think, and a number of photographers prefer to keep the process mysterious, even to themselves, but then they won't be reading this book. Mystery and magic are great things to have in an image, but good magicians know what they are doing. The process of taking photographs that stimulate our different imaginations may be arcane, but it can still be worked out.

Photography takes cognitive vision one step further and puts it to the specific use of capturing and keeping images. It makes good sense, therefore, to think of photography in a similar way to vision. Photographers choose from what is offered to them as possible images, and always to some extent choose by looking for certain kinds of image that they already like. Even if you make an effort to stay fresh and open to whatever new sights you come across in a day, there is still, in your mind, a set of visual preferences. You may find a particular lighting effect appealing, or be drawn to certain types of subject, or composition. All of this is different from what the next photographer may feel. If, rather than

trying to keep a blank mind about this, you deliberately search for images that you know will work for you, it's likely that you will have an even greater success rate in shooting. To some extent, this suggests that photographers "hunt" for images, and Cartier-Bresson likened it to this quite literally when he noted that "I prowled the streets all day, feeling very strung-up and ready to pounce, determined to 'trap' life..." Hunting for things that are already somewhere in our visual consciousness is very much a top-down way of working.

Well, this is all very interesting, but is it actually any use in photography? Can we make the idea of image templates work for us, to get a

A SHORT GUIDE TO YOUR IMAGE MEMORY BANK
1. Make a selection of your favourite images.
2. Analyse what it is you like about each, using the list of image templates on pages 152-153.
3. Many images will contain two or more of these.
4. Next, from your archives, identify the types of image that you no longer shoot.
5. Think why you have retired these types of image. Is there a common theme to them?
6. Next, identify what new types of imagery are catching your attention.
7. Is there a common theme running between these?
8. If they do have anything in common, does this suggest avenues that you have not yet explored?

An experienced photographer, faced with any new picture situation, usually has some immediate idea of the kind of effective image he or she could make out of it. Situations, lighting, events, and moments all trigger past styles and techniques from the memory bank. These are what I call image templates—the framework for an image. These templates cover the whole range of what goes into a photograph and can be broken down as follows:

▲ MAINLY BALANCE
• Frame-fit • Walking into • Walking out • Tiny main subject • Off-center
• Just touching • Similar separated shapes • Symmetry • Two-shot
• Head two-shot • Frame break

▲ MAINLY DIRECTING THE VIEW
• Line pointing to • Looking through • Recession • Big sky
• Equal figure-ground • Reflection

▲ MAINLY LIGHT
• Edge-cut sun • Chiaroscuro • Edge-lit subject, dark • Perfect golden light
• Telephoto sunset (into the sun)

THE PHOTOGRAPHER'S MIND

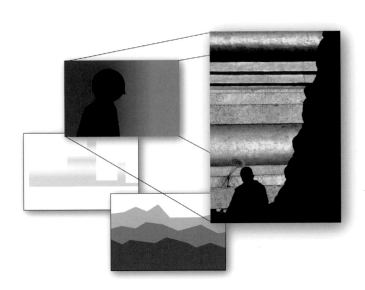

▲ TELEPHOTO STACKED PLANES
• Silhouette against well-saturated background • White-out

▲ MAINLY COLOR
• Small color accent against monochrome • Pink and gray
• Variations on white • All pastel

▲ MAINLY TIMING
• Hovering • Quirky expression • Balletic gesture
• Just-sharp in a swirl of motion • Rhythm

▲ MAINLY CONTENT
• Towering clouds • Delay • Shadow shape • Figure in a landscape • Field of similar

Breaking down image templates like this is useful because most good images have more than one thing going for them. In other words, most photographs have layers of composition. There may be, for example, a balance component, a lighting component, and a color component, and they naturally all influence each other. If, say, the color of an isolated subject contrasts strongly with its background, it will catch more attention than normal, and this will influence where you position it in the frame. We'll look in more detail at how these layers of composition work at the moment of shooting in the following section—*Interactive Composition*.

Now, I know what works for me, and the illustrations on the following pages use my preferences. What works for you may be completely different, but I recommend making at least a mental list of your own preferred image templates. Look at them all together, and you have a snapshot of your own style as it is now.

But we can take this idea further and make it even more useful. Nothing stands still, and personal taste changes with time. Some of the

things I liked when I started photography I don't much care for any more. I became bored with some because I used them too much, others I now find rather clichéd, yet others seem to be too obvious, and so on. So, at the back end of this library of image templates, some are fading away or being actively retired by my imagination, while at the front end, new ones are being added as and when I experiment with some different style or technique and find it works. This, of course, is where the second of the two competing forces that I mentioned—experiment—comes in.

Looking at this flux of image templates, some on their way out, others just arriving, can have real practical value. We don't always realize that we are avoiding certain kinds of image that we once enjoyed, but actually identifying them might teach us something about our changing taste and style. New styles and preferences tend to be more in our minds because they are what we are shooting right now, but equally, making an effort to be aware of them might identify the direction in which our imagination is going.

▼ ➤ STUDY YOUR OWN COLLECTION

A long look at your collection of photographs ordered by date may reveal some unexpected truths. If you can cut through the details of each shot, you should be able to find some common threads—in terns of image templates. For example, opposite are several images from my archive, shot in different countries, different situations and for different reasons, that all have something in common in the composition. They each have elements that are just touching or just about to touch. At the time, particularly with the earlier ones, I was not particularly aware that I was drawn to these "almost-but-not-quite" details, but looking back through old shots brought it more to my attention. A small point perhaps, but valuable for me.

The key question, of course, is whether knowing more about the process of shooting actually leads to better images. Personally, I believe it did for me, in the sense that I would find more images in any given situation because I knew what I was looking for. Perhaps more importantly, looking at the kinds of images that have fallen out of favor with my imagination, and comparing them with new ideas that seem to appeal to me, has helped me think more clearly about the broad direction in which my taste has been changing. And that prompts me to look at why.

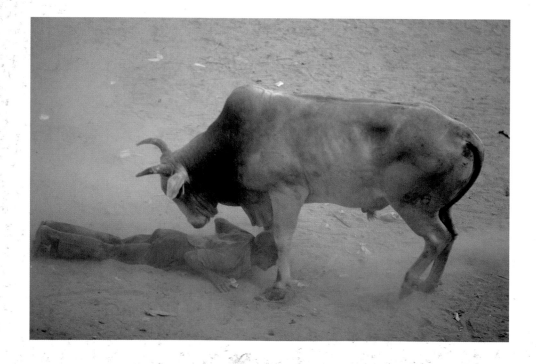

INTERACTIVE COMPOSITION

You could argue that time and the occasion affect composition much less than the personality and skill of the photographer. However, the moment itself can take over, so that even a photographer with the most distinctive style and technique is pushed to react in certain ways because of what is happening in front of the camera.

There are only two situations in which a single composition decision is applied just once. One is a pre-planned shot to fit a layout, which happens in advertising. The other is when there is only a split second in which to react, as in much street photography. For everything else, there is the opportunity for composition to evolve as the situation changes or as your reaction to it changes. It may be just as tiny adjustments, such as a step to the right or zooming out a fraction, but it's important to see composition as a dynamic activity, not a fixed decision at one point in time. Yes, certainly, you might just see the exact composition that you want in one go and not change your mind, but in practice that is rare.

There are two components involved: the changing situation, and your changing ideas about it. Although impossible to generalise, it's easy to see that many situations are fixed in an overall sense (the scene, a small range of viewpoints, the general course of action and movement), but changing all the time in the specifics and the details. This is obviously going to depend on the kind of photography, on a scale from fully controlled (such as studio) to absolutely out of control (for example, street photography). Here is one example, in St Peter's, Rome. The early morning light, with shafts falling from the end windows onto the bright, reflective marble floor, was magical. Here was definitely a case of needing to find a subject in order to exploit a special lighting atmosphere. And one was not short in coming—two nuns having a conversation. I immediately had some possibilities in my mind's eye, but as this was no art-directed shot, I had to keep my options for composition, framing and timing open, and be prepared to dance around the subject, as it were.

So, you can already see that we've distilled the general situation (nice light in St Peter's) into a tighter one (two nuns), and it's a situation that we know will change. And already, the second component—the photographer's changing ideas—has begun to kick in. From now on (for the next seven minutes as it turns out), these two components of changing situation and my changing ideas are interlocked. It quickly becomes obvious that the two nuns have just come across each other, and so will go their separate ways when they've finished talking. That moment may be the one I want.

At first, I'm thinking about backlighting and exposure, but the angle for the first eight shots doesn't make quite as much of the possibilities as it could. I move to the left, circling around to get as much reflected backlight from the floor as possible (shot 9). This means the bright door will be behind, and I try to do something with that, framing the right-hand figure against it. It almost works, but not quite, and in fact the pair are actually in shadow. Perhaps, if they keep talking long enough, they will soon be fully backlit. Meanwhile, a quick one-shot experiment with zooming back (12), but this doesn't work.

At this point, a tourist comes right into my line of view and stays there. Worse still, the woman has a camera, and I think she noticed that I was shooting—and wants to take a similar photograph, so remains hovering around. There's absolutely nothing I can do about this, just hope that she tires and gives up before the two nuns, whose conversation seems to be extending, part company. When I move to the right for a clear view, she does too! After almost two minutes she does tire, and drifts off. That problem out of the way and no others in sight, I look to refine my camera position. One good thing that comes out of this delay is that the reflected backlighting has moved left, and I can move a little further to the right to exclude the distant bright doorway for a cleaner background (shot 24 onwards). I'm hoping for an improvement in the interaction of gesture and expression, and shot 29 isn't at all bad. As a precaution, I'm keeping both eyes open so that if a passer-by interrupts my line of sight, I can dodge quickly to accommodate it. I notice two other people pausing to talk on the right—can I make something out of two couples, two sets of shadows on either side of the door? A quick couple of horizontal shots, rapidly zoomed back, then back to the two nuns, who really do now seem to be about to say goodbye to each other. Yes, that's definitely happening (shots 33 to 35), but the handshake is nothing special. Then the taller nun crosses left, which is not what I was expecting or wanting, and shot 36 is a failure. But wait; a few seconds later she turns to wave. Two things make this, number 37, the shot: one is that the other nun's raised arm is perfectly within the door frame, the other, even better, is that hovering moment as her right foot is just off the ground. And that's it; the last shot is the best, which is by no means always the case.

THE IMPROVEMENT CURVE

Many, though not all, situations have enough time and potential to make it worth continuing to shoot in the hope of improving on the first image. Anyone familiar with street photography or wildlife photography—which have much in common—knows the kind of situation in which things in the frame are almost there, but not quite. There may be a few seconds in which the subject may move, or you may be able to shift to a better camera position. Across this time frame, whether it lasts for seconds or minutes, the same basic image has the potential to improve, and that is what you work at. One way of thinking about it is as a curve that you hope will rise.

There are, in fact, two curves: one is the potential, the other the actual. Imagine a scene in which the subject stays in more or less the same position, but performs an action every so often, and this is what will make the shot. It could be, for instance, someone at work, using a hammer, and what you are trying to catch is a precise moment as it rises and falls. Or it could be an animal such as a lion, at rest but every so often opening its mouth and yawning. In either of these cases, the potential curve would be as shown here; with a series of spikes where the "ideal" action happens. The actual curve is your reaction to it as you try to catch the moment.

The improvement curve is unpredictable, but begins in one of two ways, as illustrated. In one, your first shot is good enough, but you think it might be possible to improve on it, so you wait and possibly make some adjustments to the camera position or focal length. In other words, the curve starts high and you work at it to raise it even higher. In the other curve, you see the potential in the situation and frame it, but it doesn't quite work as it is, and needs something to change. In street photography it's the kind of situation in which you say to yourself, "this would be perfect if only that person would turn around." So, the curve begins low and you hope it will rise.

At one end of the scale the composition is decided at the start and doesn't change, while at the other end all is possible and flexible, with only the photographer's self-discipline putting a final seal on the composition. The time issue is obvious, but of course it's not absolute. If everything is under control, including the light in a studio situation, you might have all day to work on a shot—and a complex shot may need it. By comparison, a few seconds may seem insufficient to make any worthwhile changes, but in reportage this may be all that's available, and an experienced photographer can make good use of it. In fact, using whatever time is available to think, adjust, and refine the composition is part of what successful shooting is about.

As for the demands of the assignment (and I include self-assignment in this), it turns out to be a little more involved than expected. One end of the scale is a completely pre-planned shot, where the subject has been decided in advance and the intention is to make a clear record of it. The archetype for this is an advertising shot that has already been drawn up as a layout by the art director, and the photographer's job is to follow this exactly. At the opposite end of the scale is having no idea what you might shoot, so you remain completely open as you set out to see what turns up, with no preconceived idea as to how you might treat it, which is what happens in much street photography. In between are all the variations of planning and spontaneous reaction.

▲ **A FEW SECONDS ONLY**
An event, or opportunity at least, occurs without warning, and the photographer has to go into full reaction mode. Priority one is capturing the moment, and how quickly the photographer can then start exercising compositional skills is the real measure of success.

▲ **COMPOSING TO A BRIEF**
An example of a pre-planned shot. The problem here is that inevitably things happen or suggest themselves on set, and though the photographer may be sensitive to this, the client may not.

19299_06.arw 19299_07.arw 19299_08.arw 19299_09.arw 19299_10.arw 19299_11.arw
19299_12.arw 19299_13.arw 19299_14.arw 19299_15.arw 19299_16.arw 19299_17.arw
19299_18.arw 19299_19.arw 19299_20.arw 19299_21.arw 19299_22.arw

▲➤ ANTICIPATING A REPETITIVE ACTION

The example here is tea picking in Assam, and the contact sheet shows my progress. The two bar charts at the left of each frame show success on a ten-point scale for timing and for framing. Right moment (hand raised) but bad framing (hand partly breaks the top of the frame) disqualifies. Actually, the woman's movement was extremely fast and sudden, and I learned quickly that I needed to judge when she would raise her hand to throw the leaves into the basket on her back by assessing how full her handful of tea leaves was. Also unexpected was that as the leaves left her hand to fall in the basket (the moment I had earlier assumed would be the best timing), they were indistinct against the rest of the green, both the field and the already-picked leaves in the basket. The first two frames were for learning. As often happens in this kind of situation, the best frames are near the middle of the total sequence (frames 5 and 9), as you try to improve on what you have, until you finally realize that it probably isn't going to get any better.

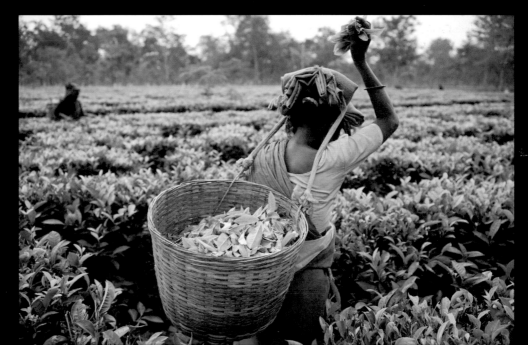

TIME AND MOTION

The shutter is such a basic camera control, and in principle so simple, that there might seem to be nothing new to say about it: the shutter opens, lets more or less light through according to the speed set, and the result is a darker or brighter image. Short shutter speed freezes the action, long speed blurs the action. Period.

But it is no longer quite so simple, for a couple of reasons that have recently, but slowly, crept up, largely unnoticed. One is the acceptance of motion blur as a normal feature of photography. The other is that slow shutter speeds are no longer forced on us by necessity, but can be chosen or avoided. Maybe not earth-shattering news, but the net result is that there is now a much wider range of ways in which we can express movement and action in the frame.

The first reason, that motion blur in a photograph is now much better tolerated, even liked, than before, has come about because most people are completely familiar with why and how it happens. We already touched on this in *Engineered Disorder*—what was formerly seen as a mistake, or just plain perverse, becomes accepted over time because we get to understand the process. If you doubt that there has been a sea-change in the acceptance of motion blur, just take a look at a range of published images from, say the 1960s or 1970s. With the odd exception of blur being used deliberately and strongly for graphic effect, almost all showed movement captured sharply. It was widely agreed that there was a "right" minimum shutter speed for every kind of action—a car driving across the frame at a certain distance, a horse galloping towards you, a just-kicked football. So most photographers religiously chose that shutter speed, along with the film speed that allowed it, and most picture editors chose the sharp results. There were two classes of image in this respect: the majority "sharp-as-they-ought-to-be," and the minority strongly blurred to be different. I suspect that this way of treating motion blur has persisted in most people's minds, even though the situation has changed.

▲ ONE SUBJECT IN THE FRAME

Nor is this a trivial point. There is a strong argument in art, widely subscribed to, that each art form should be true to its own medium. The influential American art critic, Clement Greenberg, for instance, wrote that "the unique and proper area of competence of each art" lay within what "was unique in the nature of its medium." It should not borrow from others, and in this way would "purify" itself. He was writing about modernist painting, but the same applies perfectly to photography. Photography has a few unique graphic qualities that set it apart from painting and illustration, and one of them is motion blur. We don't see like

that, and it is only through the way in which a camera works that this very particular way of smearing parts of an image becomes visible. At a root level, photography is about isolating a moment from the continuity of things, and this has been highlighted even more strongly by the new capacity of digital still cameras to capture video. But despite this being promoted by manufacturers as an enhancement of digital cameras, still imagery is not a poor relation of video. Far from it. Photographs treat moments differently, and can now do so in a surprisingly large number of ways.

▲ SHARPLY FROZEN

▲ MASSIVE OVERKILL BLUR

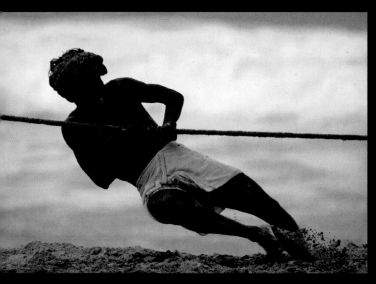

▲ SLIGHT LOCAL BLUR

▲ REAR-CURTAIN FLASH

WAYS OF TREATING MOVEMENT 1

SUBJECT MOTION BLUR
· Range from frozen to unrecognizably smeared.
· Range from a small part of the subject blurred to blur that covers most of the frame.
· Rear-curtain flash with slow shutter speed adds a sharp finale to motion blur.

▲ SLIGHT PAN

▲ WALKING THE CAMERA

◄ CAMERA MOVE AND REAR-CURTAIN FLASH

WAYS OF TREATING MOVEMENT 2

CAMERA MOTION BLUR
• Panning to keep one subject sharp against a smeared background.
• Random camera movement to smear entire image.
• Varieties of z-axis blur: racking the zoom, walking with the camera. The result is radial blur, increasing outward from the center.
• Rear-curtain flash with camera movement.

The second reason for motion blur becoming a normal part of photography is that digital imaging makes it possible to control it precisely and to a very fine degree. In film-based shooting, the emulsion rules, with its fixed sensitivity to light dictating if and when there is going to be motion blur. Not so with digital. Variable ISO settings can keep pace with failing light, and while there may be a noise penalty, this is becoming less and less as sensor technology improves. When the ISO range goes from around 100 to

the several thousand, it frees up the choice of aperture and shutter speed, so in many situations you can choose from a wide range of exposure times. Couple this with the instant feedback from the LCD screen and you have the recipe for precise control over this basic image quality. If an important part of the frame is anchored in sharpness, almost any amount of blur is accepted by most people.

The result of all of this is that, at the moment of shooting, motion blur is an extra dimension

that you can select, from minute to gross. It can, as some of the examples here show, make a crucial on-the-spot difference to the composition. The important thing is not to treat blur as an either/or quality—either an inadequacy that you might just be able to live with, or a special effect—but as a perfectly normal feature of photography. In fact, once we start treating motion blur as normal and as a scale rather than divisions, a detailed look at many images that at first sight seem to be "frozen action" reveals that

▲ **COMPOSITED TRANSITION, SHADING DIGITALLY LEFT TO RIGHT**

100 percent sharpness is rare.

There are varieties of motion blur, and in particular, there is a major difference between blur because the subject moves and blur because the camera moves. Beyond this, images can be sequenced in steps that show how the action progresses, and this can be done frame by frame, or as a result of combining everything into a single, composite image.

▲ **SUPERIMPOSED SEQUENCE, USING MULTIPLE LAYERS AND MULTIPLE SOFT-BRUSH ERASING**

➤ **SUPERIMPOSED SEQUENCE, USING MASKING**

THE LOOK

Finally, here is a part of the photographic process that is a little different from the rest, and which in the digital world is a late choice, after the image has been shot. There's an irony in that it took digital processing, with its over-precision, to stimulate real interest in one of the most difficult-to-define qualities in a photograph—the look of an image.

The word itself is imprecise, and all the better for it. "Look" is to do with a feeling projected by an image, a sensibility for it, and even though creating a look involves technical adjustments to qualities such as contrast, color, and saturation, the goal is always a total impression. You can measure every element of an image and it will not necessarily get you close to the essence of its look. If this seems a little contradictory, it's only because this is part of the usual conflict in photography between art and ideas on the one hand, and technique and technology on the other. For looks to be useful, we first have to understand the impression they create, and then work out the technicalities, not the other way round.

We can start by eliminating what is not included in a look, and it's a significant list: content, idea, shooting style, in fact all the qualities of an image that lie beneath what used to be the emulsion. The look is about surface and presentation, a combination of the particular qualities of the medium and the processing. That said, some styles of image and some subjects bring out the best in certain looks. If you examine the work of American photographer Dave Hill, for example, you will see a photographer whose look is distinctive and widely followed. His energetic and exaggerated style of portraiture meshes very well with the hyper-realistic look, better than it would if applied to a passive landscape, for example.

Here, I've assembled some of the better known photographic looks into four broad classes, each of which aims in a particular direction, with its own broad sentiment. Hyper-realism is enjoying a special vogue right now, helped by the fact that many new digital imaging techniques make it possible. Enrichment shares some of its qualities, but is more photographic in its effects, less illustrative, and more focused on color. Drained is more or less the opposite of this, a look in which colors and tones are in some way leached out of the image. Finally, the luminous look gives the impression of light coming out of the image, glowing and often with a sense of haze. These are far from the only looks and there are probably as many looks as anyone cares to find, but this quartet cover the basic ground, although I should point out that these looks can be combined. I've intentionally not included the many looks of antique processes and prints, because these are too specific and really fall into the category of genres or pastiches.

Like a number of subtle visual qualities that are built up from many small things, the look of a photograph is hard to express simply and directly. It tends to get pinned to some concrete instance and then left at that. In the days of film, looks were more fixed, more easily categorized and definable. Kodachrome, for instance, had a distinctive look, and this is its legacy to photography even though it is no longer made. But search for a useful description of that look and you will probably be disappointed. Terms like "inimitable," mean nothing. A closer investigation reveals two things: One is that we need to strip away a few elements, including that handling the physical slide itself is part of the experience, and also its formidable professional reputation, the other is that Kodachrome was at its best in the color saturation of its dark-to-mid-tones. Essentially, Kodachrome was good at being rich and dense because of its special chemistry in which it was shot as a silver black-and-white film with the color dyes added later. Its extra sharpness, due to the emulsion being thinner as it did not have to carry color layers when exposed, added to this rich sense, but basically, we might be better off calling this a rich and dense look, rather than the less informative "Kodachrome Look." This makes added sense now that looks can be generated digitally.

The whole question of digitally reproducing the look of specific film stocks raises argument. Some reject the idea on the grounds that it is simply imitative, and there is validity in this if we go back to one of the criteria for good photography—being true to the medium. On the other side, the case is that photography is now mostly digital anyway, so why not create looks that people have admired for good reason? Another distinctive film look was the integral-pack Polaroid (aka the SX-70 and its descendants). What was it about a Polaroid that made it special? Words don't do as well as you might hope and, like Kodachrome, the SX-70 look is rarely analyzed. Once again, though, software methods of replicating it have mostly worked it out, combining elements of pearly, milky, soft, and cross-color. The magic of the SX-70 look was further enhanced, no doubt, by the fact that a Polaroid was a truly original photographic image (almost everything else was made to be reproduced) with an image encased in a framed plastic window.

To go back over what will be for some well-trodden ground, any image generated by a digital camera needs to be processed at some stage in its life. It might be immediately, in the camera, or much later, by a photographer on the computer. As captured, the raw image is not in a fit state for viewing and needs to be processed with three important steps, all of which are up for different interpretations. The first is to decode the RGB Bayer matrix pattern, the second is to apply a tone curve to the linear data so that the image has the kind of brightness and contrast that the human eye would expect it to, and the third is to interpret the colors according to a set profile. The combination of these operations is what gives a particular "look" to a freshly-processed digital image. I say freshly-processed, because there are infinite ways of adjusting, tweaking, and altering it further.

CLASSES OF LOOK

HYPER-REALISTIC
Crisp: Local enhancement of detail gives crispness and some impression of sharpening. Verges on an illustrative feeling.
Equalized: Tonally, the entire image is opened up, with a full range of highlights, shadows, and midtones. This aids the illustrative impression.
Metallic: Heightens the impression of intense highlights without clipping, by lowering the color key in the bright tones (actually a draining effect–see below).
Gritty: A textural effect that derives from the associations of high-speed film, in particular black-and-white film.

ENRICHED
Vivid: High color key in the brighter tones of an image.
Rich: High color key in the darker tones of an image, especially favoring warmer hues such as red and brown.
Dense: Solid blacks and good density in shadow areas.

DRAINED
Bleached: Desaturated and often lightened bright tones, which can include complete loss of detail in the highlights.
Muted: Low color key throughout the tonal range.
Pale: High tonal key combined with low color key.
Grimy: A slightly dirty look with emphasis on grays and browns, particularly in the midtones. Generally desaturated.
Cross color: The color range crosses from one side of the color wheel to the other between dark and light tones–an effect of cross-processing film.

LUMINOUS
Glowing: In combination with shooting into the light, and particularly with a color cast in the highlights, has the effect of flooding the image with light.
Hazy: Other terms are veiled and flared. A diffusing effect in which detail is preserved. Uncoated lenses give this, as does a traditional etched-glass diffusing filter, with subtly different results.
Milky: Other terms are pearly and creamy. As if a very light wash of warm white had been overlaid on the image.
Soft: Blurring of detail and edges by various means. This alone hints at a diffusing effect, which suggests luminosity.
Smooth: A textural impression that is the opposite of detail-enhanced hyper-realism, achievable by lighting, choice of subject, and software algorithms that control local detail. Edges and large-scale detail, however, are preserved.

▲ **HYPER-REALISTIC**
Crisp (see pages 166–169)

▲ **ENRICHED**
Vivid (see pages 176–177)

▲ **DRAINED**
Bleached (see page 182)

▲ **LUMINOUS**
Glowing (see page 184)

HYPER-REALISTIC

CRISP

This is not the same as simple sharpening, although the crisp look does have a sharp appearance. Instead, it is the enhancement of micro-detail, which gives the impression of heightened presence and realism. It is very much a digital-processing feature, with advanced software algorithms that will enhance micro-detail to an extreme degree if needed. The visual result has some of the impression of an Andrew Wyeth tempera painting or a Dürer engraving, and one frequent criticism of photographs with this look is that they are similar to illustrations. What is often, but wrongly called an "HDR" look, frequently has this over-processed quality, which comes not from the HDR image itself, but from common ways of tone-mapping it. One of the most interesting things about detail enhancement is its powerful effect on our perception, as it encourages extra attention and tends to convince us that the realism is heightened.

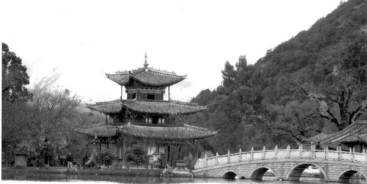

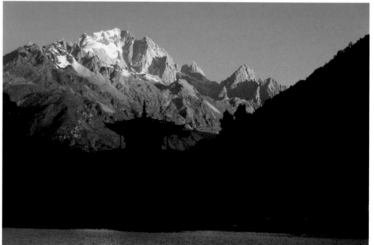

⌃➤ A BY-PRODUCT OF HDR TONE-MAPPING
Because the local tone-mapping operators used in software that compresses HDR images from 32 bits per channel to viewable 16 or 8 bits per channel work on the pixels surrounding each pixel, they easily enhance detail. This can be controlled by the user. Here, a popular program called Photomatix has been applied in a fairly aggressive way to this image.

⋏ ➤ ENHANCING TEXTURE

The weathered hands image featured on page 165, also treated with LucisArt to accentuate the veins and texture, which are the main point of the image.

◄ ∧ CONTACT PRINTING
Removing optics altogether from printing was one way to
ensure that every fine detail of the film negative was preserved.
Naturally this needed a large negative or glass plate to start with.

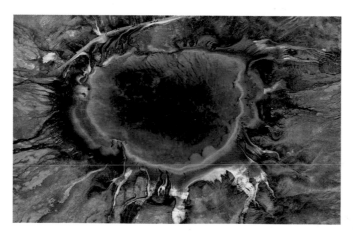

◄ KODACHROME'S CRISP RESOLUTION
Among its other qualities (see *Enriched* page 176), the now-
discontinued Kodachrome film had superior sharpness because
the emulsion was so thin. Color dyes were added during
processing, and not present during shooting. This, of course,
appeared best when coupled with appropriately crisp lighting
and a high-quality lens, as shown here in this shot.

BEFORE

AFTER

◄▲ **SOFTWARE BASED ON DETAIL ENHANCEMENT**
This software, called LucisArt, uses an algorithm originally designed for enhancing detail in scanning electron microscope images.

169

EQUALIZED

The term is more technical than I would have preferred, but it is precise. Equalization in imagery has the effect of opening up all of the tonal areas, while simultaneously giving them good contrast. This is an important, even essential, quality of hyper-realism, in that everything in the image can be seen clearly and brightly. A great deal of digital photographic processing aims to do just this, particularly for the mass amateur market, where manufacturers assume that people do not want murky shadows or blown highlights. There are different ways of achieving this, but histogram equalization is a classic. This is a way of distributing the histogram and flattening it so that all of the tones in an image are given close to the same importance. It is particularly effective at opening up shadows. Complex lighting during the shoot can, of course, do the same thing.

➤ REVEALING ALL
In controlled situations such as a studio, and with sufficient care, time, and lighting equipment, the entire scene can be lit for this opened-up effect. This is very much a stylistic choice.

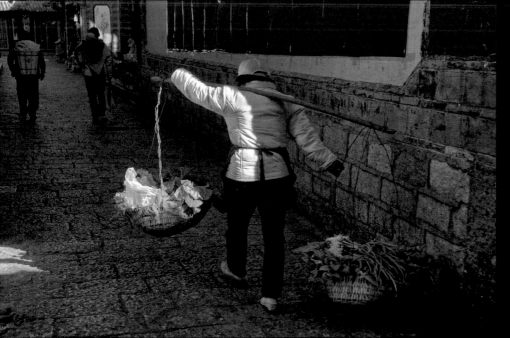

The professional rather than artistic purpose of high dynamic range (HDR) imaging is to contain all visible detail from the darkest to lightest tones in a single image file. There are now many ways of processing this so that it becomes viewable on an 8-bit monitor or as a print, and each proprietary software application has its own recipe.

◄ EQUALIZATION SOFTWARE
This consumer software, called imphoto, uses a special form of equalization to recover and enhance shadow detail realistically.

METALLIC

A true metallic look relies on a shifting point of view to reveal changes and reflections in the highlights, but in a still image much of the effect still comes across when only the highlights are desaturated. Both Michelangelo in *The Holy Family*, and El Greco in *St. John the Evangelist*, desaturated highlights to achieve this kind of metallic effect.

➤ ACTUAL METAL
Vehicles in a car park lit by fluorescent light are metallic in actuality (the car paint), and also visually because of the cold greenish highlights from the broken spectrum of this kind of lighting.

Image courtesy of Photo Scala, Florence/Courtesy of the Ministero Beni e Att. Culturali.

⋏ ➤ METALLIC EFFECT
Michelangelo's *The Holy Family*, c. 1506 (above) and El Greco's *St. John the Evangelist*, c. 1600 (right) are examples of the use of desaturated highlights in painting to achieve an almost metallic effect.

Image courtesy of White Images/Scala, Florence.

▼ DESATURATING HIGHLIGHTS

There are several ways of selecting and isolating highlight tones in a digital image; Photoshop provides several tools and procedures. Once selected, desaturation of color can be applied, as here, and the result is to metallicize the silk embroidery.

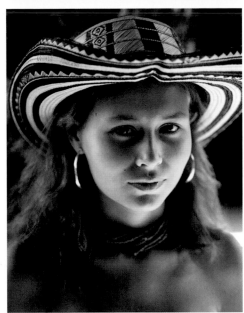

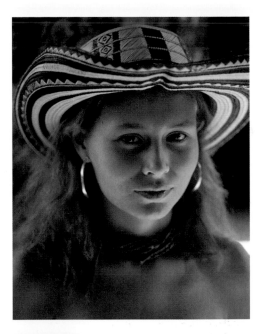

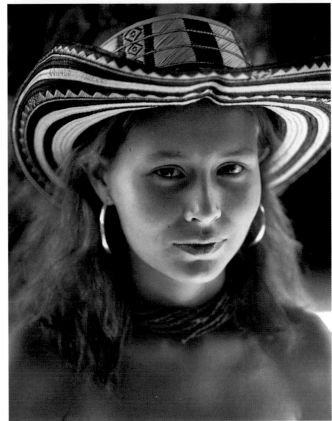

◄▲ POST-PRODUCTION DESATURATION

Essentially the same procedure here applied to a portrait. Note the similarities in effect with the simulated bleach-bypass effect discussed in *Dense* on page 180.

GRITTY

The texture of film grain, and especially sharp and structured graininess, became associated with photojournalism through 35mm photography and the use of fast film. Kodak's Tri-X was a particular favorite of photojournalists, thanks to its fast speed (ISO 400), flexibility (it could be push-processed successfully when needed), and attractive grain structure. The legacy is that this kind of visible gritty structure remains associated with realism and reportage, with its very imperfection giving it a sort of legitimacy and actuality. Digital noise is not the same as grain, even in appearance, and is less well tolerated by photographers. Conceivably it may eventually become accepted as part of low-light photography, but for now, the usual way of bringing grittiness to an image is in the processing or post-production. One method is software that emulates film qualities; another is through tone-mapping.

◄ ▲ POLAGRAPH
This instant 35mm slide film from Polaroid possessed a very high contrast and, in the very narrow midtone range, strong distinctive grain. To an even greater degree than the Tri-X look, the stark contrast aids the gritty appearance.

➤ KODAK TRI-X

This all-purpose, high-speed film saw service with photojournalists from the 1950s through the 1970s. The tightness and sharpness of the grain (what can be seen as actually grain clusters, not individual grains of silver) was visible in any print sized 8x10 inches or over, and actually adds to the impression of overall sharpness, as well as giving the gritty feel.

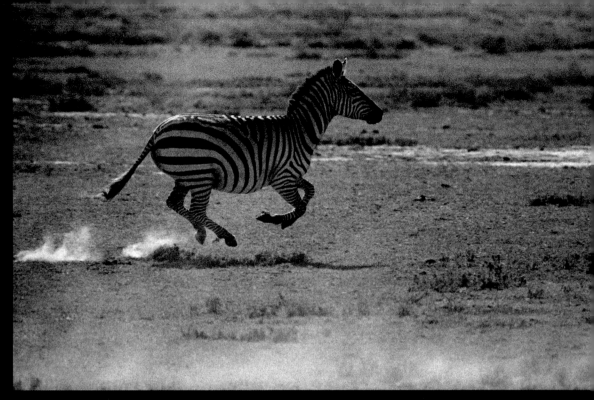

➤ EMULATION SOFTWARE

This program, Exposure 2 from Alien Skin, reproduces the visual effect of Tri-X by, among other things, adding graininess in a sophisticated way that differs according to the tones and colors. The software manufacturer first analyzed the properties of this and other films in order to be as accurate and convincing as possible.

ENRICHED

VIVID

There are many terms that people use for color, and the reason for this is that of all visual qualities it is possibly the most subjectively perceived. More than the effects of light and tone, color carries emotional and cultural values. The vivid look is not simply a high color key (well-saturated colorfulness), but a high color key that favors the brighter tones in the image.

◄ BRIGHT COLORS

The two colors here are both high value, and this distinguishes this effect from the richness associated with underexposed Kodachrome.

▼ TONE-MAPPING

This tone-mapped HDR image shows high saturation in the lighter tones, and this is a feature—at times even a fault—of many HDR local tone-mapping procedures.

▲ OVERALL VIBRANCE +40%

▲ OVERALL SATURATION +40%

◄▲ **PROCESSING VARIATIONS**

From the normally processed original, the upper 50 percent on the tonal range was here selected, using Photoshop, and three different procedures applied to strengthen the colors in just this range, leaving the lower 50 percent of the tonal range untouched. In the first version, overall vibrance was increased by 40 percent, in the second saturation was increased by 40 percent, and in the third version,

RICH

In contrast to a vivid look, which concentrates on the tones that typically catch the eye first (mid-to-bright), a rich look's strength is in the mid-to-dark tones, which is slightly less expected. Kodachrome is the exemplar of the rich look, at least when slightly underexposed or in scenes where there are significant dark areas of color. Kodachrome was particularly strong in this way for reds (including brick, umber, sienna), but less so for greens. A rich look gives the image solidity and presence.

➤ **KODACHROME'S "MUTED RICHNESS"**
Digital reproduction by scanning can only hint at the deep saturation of darker colors visible when viewing a slide. The overall visual impression of a medium-to-dark Kodachrome was that the shadow tones stayed strong and rich—a positive quality.

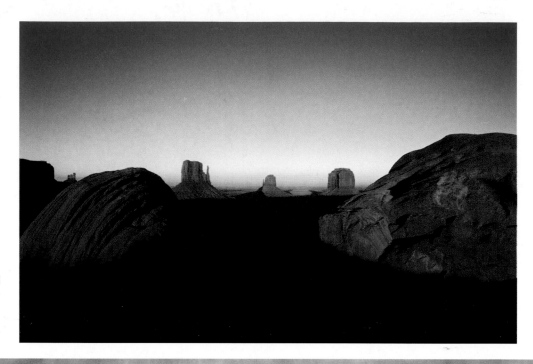

➤ **EMULSION SOFTWARE**
Any scanned or digital image can be given the Kodachrome look digitally.

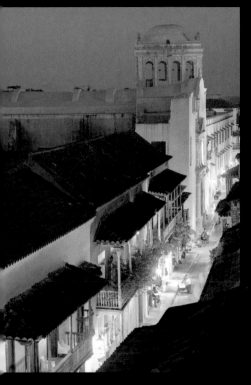

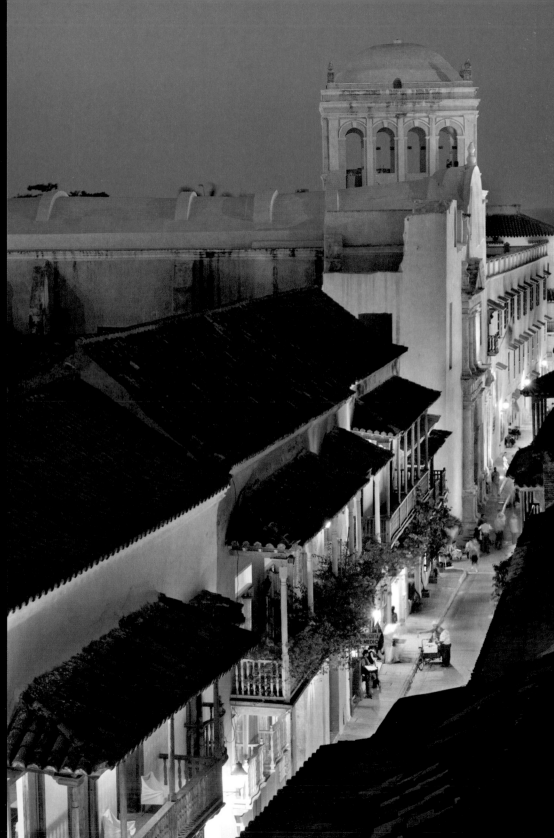

◢ ➤ RICHNESS FROM 32-BIT DODGE AND BURN

By taking a 32-bit per channel HDR image, assembled from a full range of different exposures, and treating it to dodging and burning manually with brushwork, intensity of color at all levels of tone can be brought out. Currently, this technique is slow and painstaking, very labor intensive, but as processing software like Photoshop improves, this will become easier in the future.

PROCESS

DENSE

Usually, density goes hand in hand with richness, certainly so in the case of Kodachrome. Dense images have what in film is called a high D-max (D-max standing for the maximum density, as in slide film rebates). They reach a solid black somewhere, and have significant shadow areas close to this. In the Zone System, it means a significant area taken up by Zone I. One specialist film processing technique from the motion picture industry is a "bleach bypass" in which the step for removing the silver from the film by bleaching is skipped. The result is a denser black, accompanied by higher contrast and muted colors. Most processing advice cautions against blocked shadows (as well as clipped highlights), but this is really a matter of personal choice, and intentionally clipping the shadows can enhance the impression of density.

➤ MORE DENSITY TO DEEP SHADOWS

Selecting the lowest range of tones above black, then darkening these further with a tone curve and adding a touch more contrast, is a standard digital method of improving density.

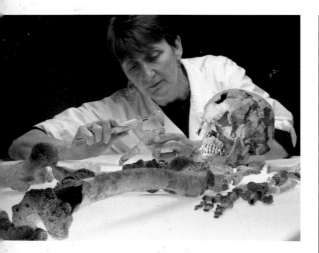

⌃➤ SIMULATED BLEACH BYPASS

With strong shadows already in place, you can heighten the visual impression of density in these areas by lightening the other tones. Although the actual density of the shadows remains the same, it seems stronger relatively. This is achieved here by making a duplicate layer in Photoshop, lightening and desaturating it, and setting the blending mode to Multiply to effectively mimic a bleach bypass effect.

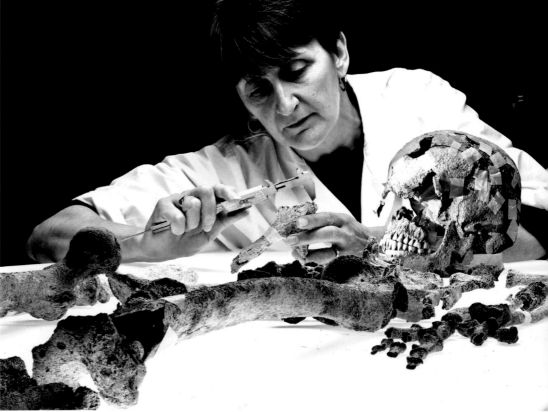

⌃➤ EXPANDING SHADOW CLIPPING
A different approach to density is to clip more of the image at the low end, so shadows are blocked up, rather than darkened. Compare the effect with simply deepening shadows without clipping.

DRAINED

BLEACHED

The term expresses the look very well. Technically, it means that either the entire range of tones or just the brighter ones have been lightened strongly—to the point where detail is lost, or almost lost, in a significant area in the upper range. This can be through intentional overexposure at the time of shooting, or lightening and clipping later. Inevitably, there is a high-key impression.

˄ HIGHLIGHT CLIPPING
Some subjects do better than others at "bleach" processing, and this misty, already almost monochromatic scene of ancestral arches in Anhui, China, is one of them. The recession into pale mist lends itself to exaggeration to the point of disappearance.

➤ TAKING WHITE TO PURE
A hard-lit still life of white shelving with a splash of color, processed normally and also lightened in the Raw processing to the point at which the white areas are clipped. There being no significant detail here anyway, this does no harm, and indeed gives a graphic, pure impression.

MUTED

Muted images display a low color key, which is to say desaturated. This is throughout the image, favoring neither highlights nor shadows, and is often accompanied by less-than-average contrast. The look can at times appear muddy if colors are not bright to start with, especially if the hues are gathered around grays and greens.

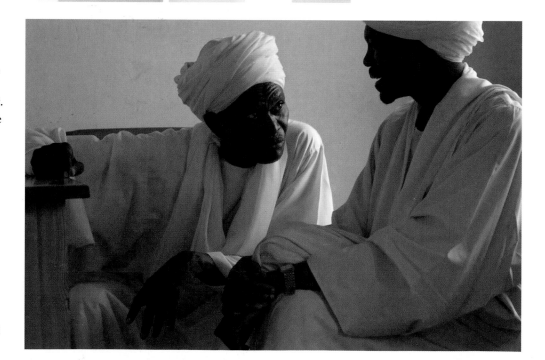

➤ NATURALLY DESATURATED COLORS
Lack of color has its own appeal, particularly if it is suffused with a color monochrome, as in this candid shot taken in Darfur.

PALE

Similar to muted, but with a higher tonal key. Another term is pastel. A pale look often tends to be seen as being more attractive than muted.

◄ **A LIGHT RANGE OF HUES**
Just after sunset, the chromatic range of the sky and its reflection drops sharply. The white stone of this Burmese pagoda picks up the sky colors; the subtle paleness was held by a full exposure.

GRIMY

A look that favors browns and grays, so in that sense the grimy look is naturally desaturated. There can also be some added "dirtiness" through the use of texture, with carefully chosen subject matter also assisting the overall impression.

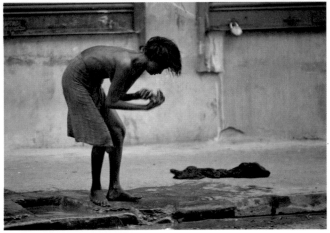

◄ **A COLOR EFFECT TO MATCH THE SUBJECT**
Brown and gray, and an all-important hint of green in the shadows, tend towards a "dirty" impression, and this perfectly well suits the subject in a Calcutta slum. Yet this works by feeding our expectations—the same scene in bright sunlight would seem less grimy, but in reality would be just as bleak a situation.

CROSS-COLOR

As with equalized, this is rather too technical a term, but it is specific and well-known. It comes from a vogue in the 1970s and 1980s for intentionally processing one kind of film in the chemicals designed for another—slide film through negative film chemistry, and vice versa. This was known as cross-processing and the result is that the shadow areas acquire a color cast in one direction while the highlights drift in an opposite direction, possibly with an overall color cast. As a look, it is intentional, but of course color crossover can also be a processing mistake. Indeed, some poorly processed Kodachromes would exhibit magenta shadows and green highlights. This can be achieved by adjusting the curves of individual color channels.

◄ **SIMULATED CROSS-PROCESSING**
To achieve the effect of film cross-processing, there is a number of techniques, the simplest being to apply contrary S-curves to different color channels, as in this post-production example.

LUMINOUS

GLOWING

In this look, the impression is that light is pouring out of the frame, which involves shooting toward a light source and encouraging lens flare. The effect is strongest when the glowing area of light is enclosed within the frame rather than spreading beyond the edges, as this heightens the contrast between dark and light. The optical performance of the lens has a major effect on flare (older and uncoated lenses show it more), and there are many subtle differences between individual lens designs. A slight color cast can help add to the effect, such as golden or bluish, but a danger is the sharp cut off that often accompanies highlight clipping. Ideally, any glow should fade off smoothly and gently at the edges, which may call for special care in the processing of a digital image. There is a number of software filters which will add flare artifacts to enhance the effect, although these are easily overused.

▾ A KIND OF LENS FLARE

Shot on 4x5 transparency film with a wide-angle 65mm Schneider lens, while taking care to control the sun star partly behind leaves, this image of Mexican mangroves has an appealing combination of glowing lens flare without veiling the rest of the image. A more efficient modern lens coating would not give this effect—and it happens to be an effect I like.

▾ POLAROID GLOW

The halation within an SX-70 windowed print produces, under into-the-sun circumstances like this scene by the Ganges in Calcutta, a flared glow. Some overexposure is recommended for the full effect.

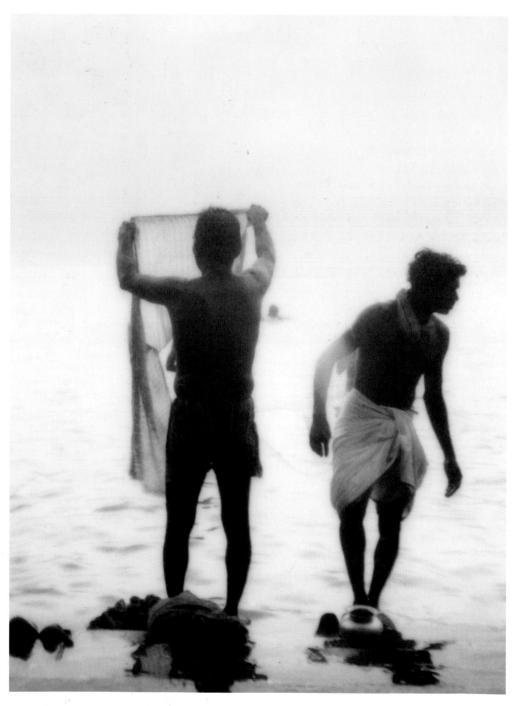

HAZY

Usually the result of flaring of one kind or another, this look gives the appearance of haze overlaying the image, made up from flatter contrast and a hint of diffusion around edges. Quite apart from the very obvious flare artifacts such as polygons created when shooting into a light source, generalized lens flare comes from internal reflections in the lens assembly. Modern lens coatings take care of this, but old lenses were susceptible. A well-known example of re-creating this look optically was the filming of the movie *Saving Private Ryan*. The cinematographer, Janusz Kaminski, emulated the look of old footage by having the lenses stripped of their protective coatings. He said in an interview, "Interestingly, when we analyzed the lenses, the focus and sharpness didn't change very much, though there was some deterioration; what really changed was the contrast and color rendering. The contrast became much flatter. Without the coatings, the light enters the lens and bounces all around, so the images become kind of foggy but still sharp. Also, it's much easier to get flare, which automatically diffuses the light and the colors and lends a little haze to the image." Soft-focus diffusing lens filters, designed for a particular style of portraiture, give this effect less destructively, as does any kind of smearing on a plain lens filter. One proven method of adding a hazy look digitally is to overlay the image with a version in which the highlights have been blurred, as shown here.

◄ SOFT-FOCUS FILTER
A front-of-lens filter with an etched surface is designed to give this spread to highlights while preserving darker detail.

► DIGITAL DE-FOCUS
A digital filter from developer Alien Skin, appropriately called Bokeh after the Japanese term, gives a calculated and optically realistic out-of-focus blur, which can then, by layering, be isolated to particular areas of the image.

MILKY

This refers to an overall milkiness or pearly appearance, with reduced contrast, pale shadow areas, and sometimes a very slight overall warmish or creamy color cast. Polaroid SX-70 images have this look, often in combination with cross-color.

➤ MORE EFFECTS FROM POLAROID
Yet another special quality from the remarkable Polaroid SX-70 technology, a milky, pearly wash.

SOFT

The polar opposite of the crisp and gritty looks. The softness extends to fine detail, and when taken to an extreme really does look blurred. This lowered all-round sharpness sets it apart from the hazy look, in which edge detail is preserved. Flat, enveloping lighting and low contrast in the subject help. Defocusing creates softness, and digitally there is a number of filters that do a similar job.

➤ FOG AND MIST
These natural light conditions inevitably soften the view and using a telephoto lens (here 180mm) enhances the effect, especially if everything is at approximately the same distance from the camera.

SMOOTH

This is a textural impression in which large areas lose crisp detail. The lighting and subject matter can also play a part. Smooth differs from soft in that edge detail remains sharp—it's just that there are fewer edges in the image. Different software filters can add this look, particularly tone-mapping operators that have smoothing algorithms.

➤ SURFACE LIGHTING
Taking defocusing to extreme shifts the look from hazy to something else. This kind of softness is difficult to use effectively, as it depends on the overall shape and substance remaining recognizable. Note that the outline is smoothed out. The effect can be optical or digital in post-production.

INDEX

INDEX

ACKNOWLEDGMENTS, PICTURE CREDITS & BIBLIOGRAPHY

My continued thanks, following *The Photographer's Eye* and its phenomenal success, to Alastair Campbell and Adam Juniper at my publishers, Ilex. Also to Tom Campbell for his continued support, advice and suggestions from the earliest days on the previous book and through the gestation of this one. And to Yukako Shibata for her contribution in processing images and in illustrative work.

p28 Leonardo da Vinci, *Vitruvian Man*, Dover Press; p95 Vincent van Gogh, *Night Café*, 1888, Courtesy of Yale University Art Gallery/Art Resource, NY/Scala, Florence; p116 J. M. W. Turner, *Crossing the Brook*, 1815, Courtesy of akg-images/Erich Lessing; p172 Michelangelo, *The Holy Family*, c. 1506, Photo Scala, Florence/Courtesy of the Ministero Beni e Att. Culturali; p172 El Greco, *St. John the Evangelist*, c. 1600, Courtesy of White Images/Scala, Florence.

SELECT BIBLIOGRAPHY

Arnheim, Rudolf. *Art and Visual Perception.* Berkeley, Los Angeles, London: University of California Press; 1954.

Berger, John. *About Looking.* London: Writers & Readers; 1980.

Berger, John. *Ways of Seeing.* London: BBC/Penguin; 1972.

Bouleau, Jacques. *The Painter's Secret Geometry.* New York: Hacker Art Books; 1980.

Cartier-Bresson, Henri. *The Mind's Eye.* New York: Aperture; 1982.

Dexter, Emma. Weski, Thomas. *Cruel and Tender.* London: Tate Publishing; 2003.

Eauclaire, Sally. *The New Color Photography.* New York: Abbeville Press; 1981.

Evans, Harold. *Pictures on a Page.* London: William Heinemann Ltd.; 1978.

Frank, Robert. *Peru.* Washington: Steidl / National Gallery of Art; 2008.

Freeman, Michael. *The Photographer's Eye.* Lewes: Ilex; 2007.

Garner, Gretchen. *Disappearing Witness: Change in Twentieth-Century American Photography.* Baltimore and London: The Johns Hopkins University Press; 2003.

Gombrich, E.H. *Art & Illusion: A Study in the Psychology of Pictorial Representation.* London: Phaidon; 2002.

Gombrich, E.H. *The Image and The Eye.* Oxford: Phaidon; 1982.

Gregory, Richard L. *Eye and Brain: The Psychology of Seeing.* Oxford: Oxford University Press; 1998.

Haas, Ernst. *In America.* London: Thames and Hudson; 1975.

Haas, Ernst. *The Creation.* Harmondsworth: Penguin Books; 1971.

Jacobs, Karen. *The Eye's Mind: Literary Modernism and Visual Culture.* Ithaca and London: Cornell University Press; 2001.

Kerouac, Jack. *The Americans.* Washington: Steidl/National Gallery of Art; 2008.

Koestler, Arthur. *The Act of Creation.* London: Hutchinson & Co. Ltd.; 1964.

Livingstone, Margaret. *Vision and Art: The Biology of Seeing.* New York: Abrams; 2002.

Loran, Erle. *Cézanne's Composition.* Berkeley: University of California Press; 2006.

Irving Penn. *Still Life.* London: Thames & Hudson; 2001.

Rothenstein, John. *The World of Camera.* London: Thomas Nelson and Sons Ltd. 1964.

Shaw, Philip. *The Sublime.* London and New York: Routledge; 2006.

Smith, W. Eugene. *The Camera as Conscience.* London: Thames and Hudson; 1998.

Sontag, Susan. *On Photography.* New York: Farrar, Straus & Giroux. 1973.

Hiroshi Sugimoto: *Time Exposed.* London: Edition Hansjörg Mayer; 1995.

Szarkowski, John. *Looking at Photographs.* New York: The Museum of Modern Art; 1973.